PRAISE FOR CARLA STOCKTON

In *Too Much Of Nothing*, Carla shares a candid review of her journey—from the highs of meeting a Mahler-loving, kindred spirit, to the lows of generational trauma, the pressures of societal expectations, and the relentless pursuit of identity. Throughout, Carla's resilience shines through. Join Carla on a reminder that true fulfillment often lies beyond the illusion of perfection.

<div align="right">

ALEXANDRA BOGDANOVICH, HISTORIAN, MEMOIRIST, AND MOTHER

</div>

My first thought as I finished this book was that I found parallels that gave me the words to voice what I could not express without the extreme guilt of feeling like I've been the failure. I, too, have come a long way from how I was programmed to be. The book's honesty is freeing. I am grateful.

<div align="right">

MARYANN MATTHEW AUBIN, VISUAL ARTIST

</div>

Good books give us new insights into ourselves and others. Carla Stockton's memoir does just that. Her open self-inquiry is bone chilling. Despite the hidden injuries of being born a girl in 1947 USA to a Jewish mother who survived the Holocaust, Ms. Stockton is no victim. She rises above all barriers with her triumphant memoir. A fascinating woman. A fascinating life. Ms. Stockton lets it all hang out and becomes a new voice for women. Her book follows in the tradition of Doris Lessing, Anais Nin, and Simone de Beauvoir.

GAIL GALLAGHER, PBS PRODUCER - WGBH BOSTON

Too Much About Nothing is the kind of very special memoir that will be highly relatable to a large cross-section of people, everyone from activists to academics, from nomads to homebodies, from Boomers to Zoomers. Carla Stockton has crafted a deeply personal and honest book that, through writing frankly about her life, tackles some of life's toughest questions: who am I and where do I fit in?"

E. B. BARTELS, AUTHOR OF *GOOD GRIEF: ON LOVING PETS, HERE AND HEREAFTER*

Carla Stockton's voice is passionate, powerful, poignant. She speaks to all our experiences, even if the details of ours differ from hers... she tells an Everywoman story yet is precise and particular in outlining her own life. And in the process, she crafts such elegant phrases, sentences, paragraphs, that the story she tells elevates itself on the scaffold of beautiful telling. This book is a must-read for anyone open to understanding the move from brokenness to wholeness.

MARI BONOMI, LANGUAGE ARTS
TEACHER, THEATER ACTOR/DIRECTOR,
QUILTER SUPREME, AND WRITER FOR
CHESAPEAKE STYLE MAGAZINE

The author's fantastic journey through three waves of feminism, the complications of marriage, intermarriage and motherhood, emboldened to make major life changes midstream, makes for a compelling, compassionate, highly recommended memoir.

THELMA ADAMS BESTSELLING AUTHOR
OF *THE LAST WOMAN STANDING*

TOO MUCH OF NOTHING

NOTES ON FEMINISM, WOMANHOOD, AND IDENTITY

CARLA STOCKTON

Too Much Of Nothing: Notes on Feminism, Identity, and Womanhood

by Carla Stockton

Print ISBN: 9781952430947

Ebook ISBN: 9781952340930

Publication Date: 2024

Publisher: Mountain Ash Press

Publisher's Address:

Mountain Ash Press

Crozet, VA

This is a work of nonfiction. Names, characters, places, and incidents are either the product of the author's imagination or used fictitiously. Any resemblance to actual events, locales, or persons, living or dead, is entirely coincidental.

Cover Design: Deranged Doctor Designs

Printed in the United States of America

First Edition

For more information, visit https://mountainash.press.

❀ Created with Vellum

If this book does for others what my granddaughters say I have done for them, then I have contributed. May all our daughters and granddaughters and theirs be armed with the wisdom to know themselves.

In the days of long confessions, we cannot mock a soul
When there's too much of nothin', no one has control
Bob Dylan

SURVIVAL 'N' ME

I am, like so many people born in the 1940s, a first-generation American, the direct offspring of a marriage between the violence and hate of WWII that drove so many families out of their homelands and American WASP salvation. I am not unique. I understand the sense of longing, the unerasable fear, the embedded nostalgia that comes with inherited PTSD.

My Jewish family Robinson did not choose to be American. In 1939, when they wrested themselves from everything they loved and set sail on the *Île de France* to make their home in the new world, they did so because they were not citizens of the homeland they loved. On their birth certificates, in bold letters, the word *Israelische* identified them as interlopers. Author Stephan Zweig, their contemporary, wrote that the worst thing that happened to the Jews of Europe was the dissolution of the Hapsburg Empire and the concomitant return of Nationalism, patriotism that enabled all-out persecution of the Jews.

My mother was a teenager. When she was dying at age 76, she made notes for me about having been wrenched from her motherland. Things she had never told me before, thoughts and feelings she had withheld, she said, to avoid facing them and to avoid involving her children in her pain. Exile angered her. The

torturous deaths of uncles, aunts, cousins, and friends enraged her. She wanted to go to Israel. Her father forbade it, and she resented his insistence. She came to the United States under protest and found that the only way she could tolerate her new life was to settle into it. She no longer railed against injustice, no longer fought to be heard. She tucked her dissatisfactions away and became the good girl, the high-achieving girl, the acquiescent one. She was what so many of her people were, the ones who walked away without suffering the indignities of the camp – a survivor deprived of the title. She found no solace.

In truth, Mom was a survivor of deep loss, of tortures no one could see. Her closest sister, her near-twin, died before they quite reached puberty. The toddler son of her older sister died in a freak accident less than a year before they escaped Europe. Her favorite aunt and a beloved uncle were among the many relatives assassinated by the Nazis. The family left their closely-knit circle of loved ones in multiple graves around Europe and lost contact with countless others who fled to faraway continents. They fell apart in subtle ways, ways that no outsider would recognize as dysfunction.

Like millions of people before and after them, the family walked away with no visible scars. The result was devastating to them.

Society has strident requirements for recognizing Survivorship. If the near victim can show signs of suffering or can describe a harrowing enough flight, they qualify. For those victims of Hitler's Grand Plan who were not underfed, overworked, unsanitized in camps, not marched off to a cemetery to be tortured or shot, not subjected to the degradation of being less than lice, the post-war ignominy was in some ways worse than wearing a yellow star. For them the shame of having survived without heroism, of having dodged the bullet with life, limb, and even sometimes fortune in some kind of tact meant being marked with a Scarlet D for desertion. **Certainly I am aware**

that no one suffered as much or more than the actual victims. But the pain endured by those who were consigned to being bystanders, to being powerless to save people they loved, to knowing that they had by an act of fate they had somehow managed to escape the tortures was incalculable as well.

It's a universal story, one that is seldom discussed. It recurs in every kind of holocaust.

Attitudes might be changing somewhat these days. There might be a glimmer of recognition that running away sometimes takes as much courage and fortitude as staying behind and being subjected to the rack of torment. Psychological research and developments of new treatments do provide sufferers with the means for self-forgiveness. For my mother, there was never redemption.

She and her sisters lived daily with unrelenting remorse. Mom's guilt manifested in an inability to cleave to her children and later took the form of a kind of abstruse self-destructiveness. She loved all her children deeply, but she was hard-pressed to express that love until much later. And when she did, my brother and I, her two oldest offspring, found it disingenuous.

Her innate self-punishment seeped toxically into my generation. She accepted every terrible thing that ever happened to her as punishment meted for her crime of having sailed out of Europe on a cruise ship with her clothes, her immediate family, and her beloved cello intact. She saw herself as an interloper, one who did not survive her sister's death so much as facilitated it by being healthy, one who killed her nephew by being too busy to babysit the day he died, one whose college education somehow caused her younger brother's death. She saw herself as bearing the mark of Cain for having eluded capture and gas chambers that swallowed her relatives and friends. In her youth and young adulthood, she lived out her self-deprecation by giving up her dreams, by subjugating herself and her desires to those of everyone else in her life.

I wish I had been astute and sensitive enough to recognize

her pain, to understand her detachment. I might have responded without rancor to the many ways she rejected me. Reading her notes made me ache to hug her and tell her I understood. Yet, it was reading her notes that made me see why she could not talk to me. "Every day I would I ride my bike to the cemetery to visit Thea," she wrote of her lost sister. "She was the only person I ever trusted because she was the only person who let me be me. No one else ever did."

After I read Mom's aborted memoirs, I was consumed with remorse and wrote a monologue in the voice I imagined was hers.

To Thea
I feel you in the music of the clouds
When the rain keeps rhythm in my heart,
Or when my soul can't breathe. You left me, sister,
Here under mother's rueful gaze, her pain
A poison I no longer fear, now loathe.
Remember? You mocked me when I called you
Foe, your frailty my rival. I prayed
For illness, sought to suffer like you did
Knowing mother loved your infirmity
Resented my health, my robust, boy-like
Strength. I wanted all you had and were.
While mother wanted nothing more than you
And a son, the treasured son I cannot be.
You alone said, "Nonsense. You'll be brilliant.
Just find a concerto of your own."
Now you're gone, and who will help me string my
Bow? Who will turn my pages, make me smile
Through Dvorak, Schumann, and the rest? No one.
My cello is buried here. My music was you.

In later years, Mom's self-loathing manifested in frequent freak accidents, in gross denials, and in terrible omissions of judg-

ment. She broke her hip, her arm, her nose, her shoulder, and she could not succor the children who needed her more in adulthood than they had in their youth. On her deathbed, she lamented that she should have done more with her life. I realized later that what she really meant was that she had not been punished enough, that she had not suffered sufficiently to make up for her great sin, the sin of having evaded rather than surviving .

I was born damaged . . . or that's how it felt. Of course, I can't tell how much I learned or how much I inherited from her, but I know my psyche adopted her unspoken fears, resentments, and misapprehensions. I absorbed her pain as my own fault, my responsibility. I only realized after her death, when I was in my early fifties, that what I took to be my low self-esteem was, in fact, far more invasive, more destructive. I felt guilty to be alive. I somehow believed that the road to my life was paved with the bodies of people who deserved my time on earth more than I did. I buried a gnawing suspicion that by being born I had somehow caused the loss of all those family members who died miserably long before my second x chromosome was even thinking about moving out of my father's little army.

I grew up to be a flitter. I was unable to settle into any rela-tionship or niche. I knew I could write, but I doubted my ability to say anything worthwhile. So I hid in the shadows of men or occasional women. Later, I disappeared behind a husband and even children, where I was able to avoid confronting the ugly truth that I did not deserve to live.

HELMER.

[walking about the room]. What a horrible awakening! All these eight years—she who was my joy and pride—a hypocrite, a liar —worse, worse—a criminal! The unutterable ugliness of it all!— For shame! For shame! [NORA is silent and looks steadily at him. He stops in front of her.] I ought to have suspected that something of the sort would happen. I ought to have foreseen it. All your father's want of principle—be silent!—all your father's want of principle has come out in you. No religion, no morality, no sense of duty—. How I am punished for having winked at what he did! I did it for your sake, and this is how you repay me.

NORA.

Yes, that's just it.

HELMER.

Now you have destroyed all my happiness. You have ruined all my future. It is horrible to think of! I am in the power of an unscrupulous man; he can do what he likes with me, ask anything he likes of me, give me any orders he pleases—I dare not refuse. And I must sink to such miserable depths because of a thoughtless woman!

A Doll's House by Henrik Ibsen

IN THE BEGINNING WAS
OUR END

I once went out on a date with a man who had been married to the same woman for nearly forty years. If I chose to enter an affair with him, he said, I would be the third woman with whom he had had relations on the side. I probably should have been appalled, but I simply nodded in recognition. Long marriages are hard, and every person has to choose how to cope . . . or how to accept that coping is not an option, that leaving is the only way to go on living.

Before I left my marriage, I never thought I could do it. Pick up, walk away from the secure life I'd been living more than half my years, give away my rights to all that was in our four-bedroom-brick-and-wood Cape and its two-car garage. When I was married, singledom was a stigma, a curse. I knew of no precedents to guide me.

People call me gutsy; I wasn't, really. At the time, I was, rather, simply broken. I had lost myself somewhere between "I can be a good wife and mother" and "I should never have been born." I wanted more than what I had, but I was not entirely sure what that was. And the barriers were solidly placed so I could not ferret out my truth. I had that so-called Einstein's Theory of Insanity running through my head, "When you keep

doing the same things over and over hoping they'll get better, and they don't, but you carry on, that's insane." There was nothing left unshattered inside me, and I was never going to be able to glue myself back together. Instead, I had to rip up my life and begin a new one.

It wasn't like I woke up one day and decided to leave, but if you ask the husband I was "abandoning," he would tell you that's how it felt to him. He wasn't aware of how unhappy, how exhausted I was, and that was the problem. From my perspective, he had stopped seeing me at all, was unable to show me any appreciation, could not understand that I was suffocating. I felt unloved, unvalued, unable ever to do enough. I chronically failed to satisfy his demands and felt damaged by his demeaning verbal abuse. But to the extent that there was no build-up to my decision – I basically blurted one morning that I was about to depart – his shocked surprise was justified.

Our life had turned into vignettes where I felt increasingly extinct-ed.

Hindsight allows me to see that the vignettes began almost immediately, from the moment of our decision to marry. My children love to point out that their father and I grew up together, and that is accurate. We embarked on a happily ever after at an age when we were probably far too young to determine who we would eventually become, and in that way, my development was stunted then and there. Richard was just 21, an engineer, with a clear purpose and direction, and I was 24, a failed actor, an aspiring writer, a creative, abstract, random thinker with no clue as to what my capabilities were. In 1973, when I got married, I was no different from most women, who were not taught to be self-sufficient. We were raised to let our fathers govern our lives until we found husbands, and then, we were to turn all decisions about the business of the household over to them. Women who were not wealthy or ultra-successful were required to have co-signers on bank accounts and were not allowed to own credit cards.

I had no smarts where money was concerned, could barely balance a checkbook. Though I was always very frugal, I didn't understand the concept of a budget. Richard, on the other hand, had a relationship with money similar to an anorexic's with food: he understood that so long as he deprived himself, he would always remain in control.

Clearly, we completed each other.

When I was an actor, I wanted more than anything to play Nora in *A Doll's House*. I discovered the play as a teenager, and the protagonist Nora exemplified for me the strongest kind of woman. Married for all of her adult life, Nora is convinced that her husband Torvald's incessant demands will eventually lead to his making the ultimate sacrifice for her. She adamantly believes that he will forego his honor and social status in order to save her from ignominy. Her transgression, for which she fears societal punishment, is that she did a very unwomanly thing and forged her father's signature in order to borrow money to save Torvald's reputation. In Nora's mind, Torvald will realize his enormous gratitude and will do whatever he must to keep his "little squirrel" happy. Over and over through the course of the play, it is obvious to the audience that what Nora persistently refuses to recognize is that Torvald will do nothing to compromise his own comfort and complacency.

Like Nora, I was used to being charged with making adjustments and compromises. As the oldest of seven children, I was expected by my parents to be responsible for all the younger kids. By the time I reached the seasoned age of 17, I understood how desperately a woman might crave liberation. My father and mother taught me to bend my will to accommodate the needs of others, and it has taken me nearly my entire lifetime to realize I was in an endless cycle of co-dependency.

On the eve of my 25th anniversary, I begged Richard to do something special with me, to spend two days in London or New York City. "Actually," I argued (I thought) reasonably, "It

makes sense to go to New York, to return to the place where we began so we could rediscover one another."

He laughed at me. "No," he said definitively. "I don't do New York."

"But this would be different. We could stay in a hotel for a night, go to a show, just be at large in the city. Like we were when we were kids, except now we can afford more than a shared beer and burger."

His eyes flared and became instantly bloodshot. "Stupid. So stupid. You know me better than that. I won't throw my money away like that. I don't see what's wrong with going camping."

And that is just how we celebrated our milestone anniversary: camping in a lovely park near my hometown. While I did not dislike everything about that weekend, it did nothing to revitalize my enthusiasm for being Richard's wife. And on our way back to Connecticut from the sojourn, I remember thinking, "I'm Nora. He's Torvald. What happens now?"

It was at that moment that I realized our marriage was approaching its endgame. But I wasn't ready to let go. After all, things weren't always as they had become.

In fact, it began quite sweetly.

UNTITLED

NORA.

It is perfectly true, Torvald. When I was at home with papa, he told me his opinion about everything, and so I had the same opinions; and if I differed from him I concealed the fact, because he would not have liked it. He called me his doll-child, and he played with me just as I used to play with my dolls. And when I came to live with you—

HELMER.

What sort of an expression is that to use about our marriage?

NORA.

[undisturbed]. I mean that I was simply transferred from papa's hands into yours. You arranged everything according to your own taste, and so I got the same tastes as you—or else I pretended to, I am really not quite sure which—I think sometimes the one and sometimes the other. When I look back on it, it seems to me as if I had been living here like a poor woman—just from hand to mouth. I have existed merely to perform tricks for you, Torvald. But you would have it so. You and papa have committed a great sin against me. It is your fault that I have made nothing of my life.

MAHLER MAKES ME SIGH

Technically, Richard was not my first husband though the fact that I got through the first one without losing my virginity says everything there is to know about that. I had dropped out of school to follow some ill-advised urge to pursue an acting career in New York and had married a gay man in order to get an apartment without risking illegal cohabitation.

That escapade lasted three years though the mask of marriage faded in less than ten months. I adored the man. I knew he was gay. He told me. But I was a naif, had no real knowledge of what sexuality was, let alone homosexuality and how it would affect the love we shared. I had never experienced any kind of sexual desire, and I thought that we would cuddle and be happy. It never occurred to me to consider what it would feel like to want him and to be rejected. I never imagined his nighttime forays cruising the Greenwich Village piers, the clandestine bars, the secret assignations with closeted others would hurt me as they did. After he left, I wallowed in self-pity for nearly a year, then eschewed the company of men for another year. By the time I met Richard four years later, I had dated, had finally lost my virginity, had dodged a wedding proposal from a mama's boy with serious OCD, and had

managed to survive the casting couches of tawdry LA. My self-esteem was in so many shards I despaired of ever liking me again. I had drifted into a dead-end job in New York City, where a friend loaned me her shrink. After two sessions, I saw clearly that he was a genius.

"You'll be fine, you know," he said, "once you go back to school and remind yourself of how intelligent you are."

The doctor told me about Columbia's School of General Studies, a program designed originally for GIs returning to school after service and had evolved into a welcoming institution for prodigals like myself. Then, he wrote me a letter of introduction to the college's dean. Within a few months, I was working full time in the Mechanical Engineering Department of Columbia's School of Engineering and earning enough money to support myself while I took the two free classes full-time employment afforded me. I supplemented my tuition waiver with a student loan so that I could take two additional classes, which added up to a full-time class load. Thus, once I had a semester under my belt, Columbia gave me free tuition and a job in the Dean's Office of the Engineering School. After that, I was able to increase my load to eighteen credit hours a semester, and I finished my Bachelor's Degree in three years.

That's when I met Richard. At a party. Where I was among 18- and 19-year-old engineering school sophomores, feeling very out of place. One of the kids asked me in an awestruck voice, "Are you really 20?"

"No," I answered disdainfully. "I'm 21."

It was true. I was already approaching 22 and had been at loose ends since my 18th birthday. I felt old and jaded and used up, and then, Richard approached me and asked me if I liked Mahler.

Just like that. "Do you like listening to Mahler? Most people don't."

It was such an endearingly nerdy way to open a conversation that I think I knew right away I couldn't resist him. He was

barely 18 and obviously brilliant and cuter than the men who usually pursued me. Also, he was tall.

For a big girl, which is how I defined myself, tall was a must. I would have preferred that he had more meat on him so I didn't always feel so wide standing next to him, but I didn't have any design options. He was fine. And despite the fact that I wore a size 18, had a broad back, long arms, mannish hands and size 10 feet, he found me attractive. That was intoxicating.

I was hungry for security, in search of a refuge. My job and classes were validating, but I knew that with a Bachelor's in Comparative Literature, my options would still be limited when I left CU. Besides, it had been a long time since anyone interested in anything so delicious as Mahler, whose music I loved and loved to argue about, was also interested in me as a possible partner.

We sat on the couch all evening singing phrases to one another.

"I still can't listen to the *Lied von der Erde*," I remarked, wondering if anyone listening thought we were the most pretentious idiots at the party. "It makes me cringe."

"But it's gorgeous," he said earnestly. He sincerely loved Mahler.

Which was one of the many things that made him exactly the man I needed. The fact that he wasn't a man yet had not eluded me. Still, I was drawn to him. He was gentle to the point of near shyness, smart, well-read, and both respectful and ardent in his pursuit of me.

So I sent him away.

For the rest of that school year, I insisted he date other people. I even fixed him up with my sister, and they went out for a while. I have never felt right about that, but I was a child myself, despite my illusions of maturity. It seemed to me that I was keeping us both safe from a terrible mistake, and I was glad for my decision to avoid him.

When summer came, I took stock of my finances and saw

that there was a goodly amount of money left from my student loans. I decided to go to Europe. Fares were exceedingly low, and student rail passes, which provided unlimited travel throughout Europe, were even cheaper. For ten weeks, I wandered, at first fairly aimlessly, around Belgium, France, Germany, Italy; in Italy, I met an American on his way to study mating habits of lizards on an island in the Jugoslav Adriatic, and I followed him. We had a lovely, very brief affair during which I lived on his boat and listened at night to his Croatian crew reciting epic poetry over gusla accompaniment, which is where I found my calling to Serbo-Croatian literature. I also found my inner Isadora Zelda White Stollerman Wing.

I hadn't read *Fear of Flying* yet because it had not yet been published, but when I did, I recognized my European persona immediately in the protagonist Isadora. She was the woman my European self aspired to be: a liberated woman ever on a quest for the zipless fuck, the sexual encounter that caused no guilt, no commitment, no harm, no foul. Out there in the continent of my mother's birth, far from the harsh judgment of my father's Protestantism, I found my groove. I joined the sexual revolution with ardor and formed fleeting relationships with young men in Austria, Germany, Switzerland, the Riviera.

Then one day, I decided it was time to go home. I was exhausted and ready to process all I'd seen and learned. Upon my return, however, I was chastened.

The minute my feet touched the tarmac at the airport I reverted to my repressed self. Something about being at JFK – to which I still referred as Idlewild because I couldn't reconcile myself with the reason for the name change, which still stung like a new wound – made me feel guilty, and I wanted to be clean again.

The next day, when I reported to work in my office, Richard was there. Waiting for me. In him, I saw my redemption.

Richard represented every kind of safety and dependability I could never have provided for myself, and he was an innocent.

He still had the scrubbed look of the Catholic Boys' School scholar he had been only three years before, and he insisted that we marry when I said I would prefer to just live together for a while.

"I believe in making a commitment," he said in his pitch to get me to say yes. "If you're willing to live with me, you should be willing to marry me." After too much flitting from man to man in a time when common wisdom recommended "if you can't be with the one you love, love the one you're with," his words were smooth, liquid reassurance. Absolution.

Besides, I had no real faith in my ability to do anything that would pay the bills. Acting had been my avocation, and though I was a talented writer, I had no confidence. Or any real clue how to pursue a career. Though I had been successful at Columbia, I was pretty naïve about self-promotion. In fact, I thought it was folly to promote myself. What I really dreamt of was writing a column, a book and drama review column, where I could show what I knew, which was substantial, and bask in the pleasure my brisk writing style gave my readers. Unfortunately, I had no idea where to start to make that happen, and I certainly didn't trust myself enough to believe I could succeed. I was terrified of facing my future of bill paying alone. It is possible that if I'd had had female friends or if I had known anyone in exactly that same boat in which I found myself, I might have talked myself out of the idea of marriage, but I didn't.

None of my friends could help. There was the Engineering professor I dated until I took up with Richard. A brilliant player, he found me amusing but was not about to settle down and at the same time not about to treat me platonically. Even at his most objective, he'd counsel me to remain his playmate. My closest friends were a married couple, who decidedly disliked Richard. I could not trust their judgment. I tried to get the husband to explain their negativity toward Richard, but what he offered sounded unfair, like empty judgment. If I had been more mature

and more confident, I might have pressed for more specificity. I might have admitted I needed guidance. I did neither.

My boss in the Dean's Office was someone I might have consulted. But she was having an affair with a married professor and at the same time indulging herself with every grad student who claimed to love her. She was desperate to be married to a promising young Mechanical Engineer. Every word of advice she offered had a decidedly, untrustworthy green hue.

Among my own classmates, I had found only one with whom I had anything in common. Like me, she was a former actor, whose experience was similar to mine. She had, by then, embraced Jewish Orthodoxy and was dating a law student, whom she had promised to marry. They were set to pursue a religious path, which took them to Israel. Another perspective on which I could not rely.

Finally, I had two roommates, whom I adored, in my downtown flat. One was a brilliant but entirely self-absorbed poet and the other a genius alcoholic, whose suicide I prevented just before I started at Columbia. Neither had the requisite insights to help me in any way.

With no one to dissuade me, I was determined to stand by this man, who was not only brilliant and good looking but possessed of a future. He would find a job.

I agreed to marry him. Why not? I loved him, and I am sure that I believed I loved him enough. I hope I did. I am even sure that I believed he loved me enough to sustain a life-long commitment. I know he did.

UNTITLED

Winnie: *I used to pray. (Pause.) I say I used to pray. (Pause.) Yes, I must confess I did. (Smile.) Not now. (Smile broader.) No no. (Smile off. Pause.) Then ... now . . . what difficulties here, for the mind. (Pause.) To have been always what I am - and so changed from what I was. (Pause.) I am the one, I say the one, then the other. (Pause.) Now the one, then the other. (Pause.) There is so little one can say, one says it all. (Pause.) All one can. (Pause.) And no truth in it anywhere. (Pause.) My arms. (Pause.)*

Happy Days *by Samuel Beckett*

INTERFAITH MARRIAGE

I t seems downright arcane these days to talk about interfaith marriages. The days when the mainstream was dominated by couples of the same religion, same culture, same ethnicity are over. Today it would be strange to hear someone say, "I can't marry that person – they don't go to my house of worship." But when I was young, my family was the odd one out.

Even before they fled Europe and hid themselves in carefully assimilated ambiguity, my mother's family had accepted an outsider into their Jewish mix. My mother's older sister was fifteen when she fell in love with her brilliant piano teacher, and the fact that he was of Serbian Orthodox faith and culture was never an issue for my grandparents. That he was a painter and a piano teacher with few prospects for financial stability was far more troubling. There was a moment, in fact, when he might have been banned from the home, but that was entirely because he insisted that there was no need for him and my aunt to emigrate. He argued that antisemitism was not a problem in Yugoslavia. "She is safe here with me."

My grandfather's reply was simple. "Fine. You stay here, and I no longer support you."

They emigrated, and my uncle was free to adhere to whatever belief he chose.

My mother's younger sister met the non-Jewish love of her life at a bowling alley. He picked her up, they fell in love with one another, and neither ever questioned which religion they would choose. He was an avowed atheist, and she adhered to no proscribed beliefs. Their children would never lose their weekend freedoms to religious instruction. Their shared prejudice against organized religion made them oblivious to any disapproval that might have come from his far-off relations. There was none from his parents, who adored my aunt.

When my mother met my father, they were both needy, broken, lonely people. They gravitated toward one another, and there was never a question that Dad's religion would be the dogma of choice in their home.

Knowing what I know today about Dad's WASP mother, I fear she may have had some reservations – good high-born Protestant women were impelled to support integration and voting rights for the formerly enslaved, but they were predisposed to reject Catholics and Jews. Dad would have been fueled by his mother's disapproval in the same way he was when he married his dearly departed Irish Betty.

Mom had no need to rebel. Her father had already renounced Judaism along with the God he said he could no longer trust. Her mother, anesthetized in an alcoholic fog, was sanguine at worst. Mom must have felt safe hidden in Dad's milky American persona. Knowing that her future children would never be forced to suffer the ignominy of antisemitism was incentive enough to bury her Ashkenazic roots deep below his.

Until I met Richard, I was naïve enough to believe that in the liberated 1970s, all American families were as heterogeneous or at least as enlightened as mine was. My naivete still makes me blush to admit.

Richard's family was decidedly Polish Catholic. They went to confession then to mass, and they took communion every

Sunday. They conflated their Polish culture – the songs, the dances, the food, the alcohol – with the Church, and they were sure they would all find a place to sit together once they all reached Heaven. That their Richie was aligned with a divorced woman of mixed cultural heritage – a Protestant and a Jew, of all things – was manifest blasphemy.

They never got over the shock. Or the resentment. The last time she visited before she died, even Richard's grandmother, our beloved Babci (sic) admonished me for teaching my children a heathen religion.

I was singing my infant daughter a song called *Dona Dona*. It was one I often sang, a song demanding a stand against oppression. I actually learned the song from Joan Baez and not from any Jewish relative. Hearing the plaintive minor key, Babci left the living room, where she was visiting with my husband, her doted-upon grandson, and stood by the children's bedroom door.

"You have to sing that song?"

"I love it," I whispered. "When I sing it, I see ancestors my kids'll never know."

"Well," Babci huffed. "They have Christian ancestors too."

PARENTAL PERSPECTIVES

From the moment Richard announced to his family that we were a couple, the deep schisms between his world and mine raised alarms.

Richard's parents were appalled that he would want to marry someone older than he was, that he would choose a non-Catholic. After all, as far as they knew, he had wanted to be a priest as recently as the year before.

To be clear, Richard's father never wanted him to be a priest. But pre-teen Richard was determined. He spent his early childhood fantasizing about the priesthood, nearly swooned every time he donned his altar boy robes to assist the parish priests. His father insisted he would be an engineer, something stable and concrete. His mother, on the other hand, saw in his journey to the priesthood her ticket to heaven, her special pass to Mary's right hand. As smart as he was, she thought, he would undoubtedly one day be a bishop, perhaps even a cardinal.

Richard's father's hopes began to materialize when Richard was accepted to Regis High School, a private Jesuit school on New York's Upper East Side, which offered scholarships to male students graduating in the top 2% of the upper echelon parochial elementary schools in the New York metropolitan area. The

teachers at Regis were Berrigan disciples, Jesuit iconoclasts. Richard's favorite teacher modeled '70s style obduracy that young priests became known for. He encouraged his students to march zealously in protest against the Vietnam War, to burn their draft cards or seek humanitarian-centered alternate service. When the Church chastised him and his fellow dissenters, he, like many others, left the order to marry a drop-out nun. The father's last year at Regis was the year Richard graduated third in the class of 1968.

Though Regis had previously had a tradition of not allowing their graduates to attend non-Catholic colleges, their policy changed while Richard was a student there. He had no trouble getting into Columbia College and the School of Engineering. He promised his father he would defer seminary until after graduation, and before he got that far, he changed his own course of his own volition. He was never articulate about what changed his mind. He seemed to lose faith in the precepts, but he never stopped missing the ritual, a fact I did not know until years later.

All I knew was that before he met me, Richard had entirely abandoned his religion. He attended church when he visited his family in Clifton, NJ. He celebrated the holidays as the good Catholic boy he had always been. But he no longer believed, no longer obeyed the strictures of the religion. Because he was such a good boy, however, his parents were unaware of any of it and had no forewarning.

The fact that their son aligned himself with a Protestant Jewish divorcee was more than Richard's parents were prepared to tolerate, and looking at it now with all the hindsight I have acquired, it is clear that, for Richard, choosing me was an act of outright rebellion. We embarked on a serious dating path the week before Thanksgiving, and he chose to spring the news that we were dating just as they were carving the turkey.

"You've spoiled my holiday season," his mother told him.

"Son," his father said, taking him aside and offering him a

cigar. "What happens when you're at the height of your career, and you take her to a cocktail party? People will wonder why you're bringing your mother . . . or worse, your grandmother."

As I have always done, I tried to remove myself emotionally from the fray. I went home to Saranac Lake for the weekend and returned a day early so that Richard and I could see each other Sunday night. I laughed when he told me what his parents had said. They inhabited a world I could not envision.

It was so much easier to laugh than to allow myself to feel the real emotions their vitriol stirred. I wanted to be angry, but to whom would I complain? They had decided already that they despised me. I was frightened. Here was a star I had hitched my wagon to, and they threatened to slay the unicorn pulling it. And I was confused. How could human parents be so dismissive of a love their child professed? My own family had not prepared me for rejection of any kind. My family was, in fact, too quick to accept too much. They never said no to any of us. Not really.

Which was odd and totally expected at the same time.

Religion had never been a criterion by which we judged others, but religion was the cornerstone of my father's existence. Yet, I could not even imagine he would legislate our choices of partners on the basis of anything so mundane as religion.

In my father's house, we were expected to adhere to all the precepts of his strict Methodist creed, but there were no consequences for breaking them. Alcohol was not allowed in the house, and we did not play cards. Yet, when Dad was not at home, we danced with abandon, and sometimes we dared dance with him in the room, and he joined in. Sex was not a topic of conversation. Yet, when my brother David went drinking with his buddies and was too drunk to drive home, Dad fetched him and offered no punishment, no chastisement. When David was obviously having sex with his older woman girlfriend, Dad parked in front of her apartment to wait to drive David home. I would never have dared to break the rules the way David did, yet the way Dad treated David's transgressions

fueled my determination to choose my own paths once I left home.

David's first wife was the daughter of a Methodist minister, and Dad might have held her up as example of the person we should all aspire to, but he did not. As a 20-something, I attributed his abiding acceptance to a kind of holiness I thought he bore. I believed he was a true believer whose faith in God extended to his belief in God's creatures. I don't agree with my young self anymore. Now I am more convinced that my father's life had beaten the faith that he desperately wanted to hold onto out of him. But I could not have known that yet at the time I was preparing to marry Richard. I trusted that my family would love him because they were charitable souls, liberal thinkers.

Once I was out of the house, my folks were dispassionate about anything I chose. In fact, at times, their disengagement verged on benign neglect. They rarely raised objections or criticized my choices. They had never once made race or religion or personal past conditions of acceptance in our house. My father often brought homeless "tramps" to the house and invited them to stay as long as they needed to get themselves back on their feet. I hated the intrusions, but who was I to object when my role models were so willing to embrace even these humans whom I found, frankly, intimidating.

In general, I might have wished for more guidance, but I was grateful for my parents' all-abiding tolerance, which I didn't even try to understand.

In truth, Richard was everything they had given up hoping I would choose in a man, and deep down, my mother was a terrific intellectual snob. She would fall in love with his GPA. I also knew that though she had never stopped believing Judaism, her native religion, for her, religion was an enemy. Religion had robbed her of a homeland, of friends and beloved family members. Religion was expendable. It was something to be forfeited in the interest of safety and security.

I was right. When I took Richard to Saranac Lake for New Year's, my mother fawned all over him.

"Thank you," she said to him the second day he was there. "I never expected Carla to find anyone like you." When we told them that we had decided to marry, my mother, rarely one to show overt emotion, clasped her hands in front of her mouth and became teary-eyed. "Oh, thank you, Richard," she reiterated. "Now I know I can expect to have brilliant grandchildren."

Richard was afraid to break the news to his parents and waited until we had a long weekend in March. After he told them, he was so distraught over the nastiness with which they received the news that he locked himself in his bedroom in their house in Clifton and didn't communicate with me for three days.

On the first evening, I called, and his sister answered.

"Hi, Denise. I'd like to talk to your brother," I said.

"Richie's asleep," she replied. "And he told me not to wake him for anything. I'll tell him you called."

I hung up, devastated.

I called again later, and his mother answered. "Richie doesn't want to talk to you," she snarled.

The next morning, when his sister again rebuked me on his behalf, I simply sighed and said, "OK. Don't bother him. Let him sleep."

I didn't hear from him until he returned to the city the next day. Surely, I thought, if he loved me, if he truly wanted to be with me, he would have returned to the city rather than staying there and letting them legislate his despair.

I wondered—neither for the first time nor the last—if we were not making a big mistake. I should have been more proactive. I should have then and there walked away or taken some action on my own behalf. But I was programmed to believe two very important untruths of my day: 1. A woman who is unmarried is without respectability and is doomed to a life of scraping by; and 2. Richard was cuter and smarter than any man I had ever dated, and I was sure I would never ever find another man nearly as

good who was willing to take me on. I swallowed the negativity, went along with the surreptitious planning, and remained silent in response to the accusations and aspersions.

Easter Sunday weekend, we went to the Stockton family house for the holiday, and I turned down my last best offer for reprieve.

We had begun to plan the wedding by then, and his grandmother, whom I adored, had told both his mother and his father to step back and "Let Richie alone. He's a man now, and you can't tell him who he can love." They were outwardly cordial, as were the extended family members, who congregated for ham and kielbasa, perogies, beer, and crème de menthe. They congratulated us heartily. After dinner, Richard's father asked me to go for a ride with him.

He took me to Eagle Rock, a nature preserve with an overlook in Montclair, where he parked the car. He said he had to talk to me, and he sidled over from the driver's seat to put his arms around me. I was nauseated by the strong odor of the beer, the liqueur, and a layer of Scotch as he breathed into my face, but I kept telling myself that he was just making an awkward attempt at fatherliness. My inner monologue insisted that all fathers were not as physically distant as my Calvinist, repressed father, that this was probably what Polish Catholics were like; he was just being affectionate. I don't think I believed it exactly, but it was easier to accept than any alternative theory. Nonetheless, I was not very sweet to him.

He became agitated.

"Look," he said after a while. "I brought you here because I really want to convince you to leave my kid alone."

"He wants to marry me."

"He'll do whatever you tell him to do. I hold you responsible. You're the mature adult; you're in control. He's a wimp. You can walk away, and he'll be better off."

"He loves me."

"He is a child. And a fool. Look, what if I offered you. . . "

He pulled out a check, made out to me, endorsed by him, in the amount of $25,000. "Why don't you take this and disappear?"

$25,000 was a lot of money in 1972. It would have bought me a mortgage-free house, four years of Ivy League graduate school, or a car and a boat and a closet full of clothes. I have always wondered if the check would have bounced had I accepted. I didn't.

We returned to the party, where I asked Richard to make a formal announcement that we would marry in May. His grand-mother gave me a hug.

"I can't wait for this wedding, Carla. But please promise me two things: you'll get married with a priest, and Richie'll wear a suit and tie.

We were married by the Catholic chaplain in St. Paul's Chapel on the Columbia campus. Richard did not wear a suit. But he did wear a tie.

"As the world changed, so did intermarriage, so did Judaism, and so did I. Society now welcomes us without asking us to diminish our identities and encourages interaction across backgrounds, enabling us to live proudly as Jews in the big, diverse world. I realized it wasn't only inevitable that Jews would meet and fall in love with people from other communities, but also that Jews would want to enjoy those relationships without sacrificing their Jewish lives."

Rabbi Adina Lewittes in *Tablet Magazine*, February 2015.

"Respect that your in-laws may have an issue with you being in your spouse's life at first and make an effort to allow them to get to know you and see why your spouse fell in love with you despite the difference in your religions.

"Diocese of Trenton, in "Ten Tips to Strengthen Your Interfaith Marriage."

MY MISHUGA MISPACHA

At the time, I didn't stop to think about how sorely I missed the import of the choice I was making in marrying into Richard's family. In fact, I didn't really stop to think about the ramifications. I got busy building a marriage, raising a family. I had taken the interfaith thing for granted, but it took me years to examine the layers of meaning in our multiplicity. None my extended family, in our oh-so-liberated reality, ever fit snugly into any cultural or ethno-religious norm. We were a people apart, and while we all believed we had found a way to straddle multiple worlds, what we had done was to paint ourselves into a circle where we might have been the only ones who understood us.

I only became aware in 2003 when my extended family gathered for the last time. Just weeks after her 50th birthday, my cousin Adriana came home to the States to get married.

Adriana moved permanently to Italy when she was 21 and returned only once a year for short periods of time. It was easy for us to idealize her. She seemed to be the truest light among us, so blithe, so carefree, so peaceful.

In preparation for the upcoming nuptials, however, I was not thinking about Adriana. I was thinking about shoes. So three

days before flying to San Francisco, where the festivities would take place, I contemplated shoplifting. It was the kind of escapade one imagines as a teenager, not as the nearly senior citizen of 56 that I was at the time. I was possessed by a midlife crisis: I needed a pair of shoes.

I had found the perfect pair. They were elegant: low-heeled, round-toed and comfortable for dancing yet black velvet and impractical for winter walking in New Haven, where I lived and worked, the kind of shoes my money-obsessed husband would never let me buy.

I must interject that while we were never poor – he was a well-remunerated mechanical engineer, and I classroom teacher, who took on multiple extra-curricular activities that paid me nicely. So long as he had complete control, so long as he treated it as though we were destitute, he could breathe. The minute we began allowing ourselves luxury items like fancy clothes or electronic devices or anything beyond the necessities, he became angry, verbally abusive, impossible to be around. Luxury items were unthinkable.

Those shoes would be my emancipation proclamation. I had spent thirty-three years believing, like innocent Nora in *A Doll's House*, that if I acquiesced perfectly enough and long enough, eventually the "most wonderful thing" would happen, and I'd be rewarded with an act of magnificence that would enable me and my beloved to live happily ever after. By the time of this particular crisis, it was clear to me that my miracle was never going to happen, and stealing those shoes would be a way of saying to my husband, "Hey you get off-'o' my cloud," a way to affect my liberation from the oppression of hope as much as from him.

I tried them on. Pure podiatric bliss. I furtively surveyed the store. No one was near. If I just walked out, who would see me? I headed toward the exit; a salesclerk stopped rearranging the handbags on the periphery of the shoe department and stared at me. I turned around, pretending I was merely giving them a trial

walk around the store. She went back to her work, and I took off the shoes and waited a few moments before opening my back-pack and sliding them inside. I hadn't seen a beeper tag. Surely I could pull this off. Again, I headed toward the exit, but as I rounded the corner near the checkout line, I saw myself standing in handcuffs, an army of my students past and present staring at me in disbelief, looking betrayed but pointing and laughing at the same time. I couldn't do it. The shoes went back to the shelf, and I left the store dejected but resolved. If I were going to be held captive in this life for the duration, I should at least main-tain my integrity.

I wished it did not seem so terribly important for me to look good. I'd be among family, after all. But while Adriana had eloped twice before, this was to be her first wedding. It was momentous. Adriana's dad and my mother had died within a few months of one another just a year before, and the idea of gathering now for an affirmation of life was exhilarating.

Besides, *he* would be there.

"I knew him when he was an apple tree," my grandmother used to say about him, with a mischievous glint in her eye, begging for someone to say, "Hunh?" so she could launch into an interminable Yiddish story about a farmer who sold the wood to a sculptor who made the crucifix that adorned a new church. When the delighted villagers oohed and ahed over the beautiful figure suffering on the cross, the farmer poo-poohed them, declaring, "Feh." Here she would pause and take a breath before she continued. "He's nothing so special." She'd blink. "I knew him already when he was only an apple tree." I still wish we had chiseled that punch line into her headstone.

Inevitably, Grandma told that story while she primped – applying makeup she wore only on the most special occasions, donning her best jewelry that rarely emerged from the safe, tipping the delivery boys who brought a lavish spread of choco-lates and bagels – and prepared for his impending arrival, always at least an hour later than promised, in a stretch limo,

which would roll up her driveway and park in front of the uncurtained window through which we could watch the approach. Then, before he could emerge from the car, she would shoo us out the back door so that she could have her private audience with her grandson, The Director.

My cousin, the family hero, would be making an appearance at Adriana's wedding, and I felt I had let myself down by not getting those shoes by whatever means necessary. Without them, I remained the second-rate second born. Oh, well, I consoled myself. It's only a wedding. A wedding on San Francisco Bay, where people will be looking at Adriana and *him* and the scenery, not necessarily in that order and definitely not at my shoes.

To get to the wedding from New Haven was an arduous trip. I'd be staying with Adriana's brother Rene and his wife, who lived in Oakland, and I knew I would be on my own getting to their place late at night after embarking in Providence, RI, making stops in Baltimore and Denver, and arriving eight hours later at Oakland International. By the time I arrived, exhausted and hungry, I actually wished someone had met my plane.

Some flawed families, recognizing their defects but believing in the healing power of love, find exciting, even challenging ways to be together. Ours, recognizing its debilities and adhering to a cynical ritual of denial, found ever more creative ways to remain apart.

The next day, however, I was, like everyone else, swept into the exhilaration Adriana, the youngest of the Gandolfi branch of the family, brought to the impending party. She had been a dancer and had borne no children, which left her a remarkable youthfulness both spiritual and physical. Her genuinely positive exuberance was contagious.

Adriana's mother, my mother's younger sister Ruth, was overjoyed to preside over this affair, which provided her a convenient way to manipulate Adriana into remaining Stateside for an extended period. Planning and executing a wedding

required time together, and Ruth felt she deserved a lot of Adriana's time.

They had chosen Tilden Park, a sylvan setting atop the misty seaside promontory, as the site of the ceremony that would bind Adriana to her new love Marco, an engineer from a rural area outside Bologna. Despite the fact that the wedding would be small – family and close friends only – it would be spectacular. While she made the preparations, Ruth's health, already frail and now weakened by her grief over the passing of her husband and her last remaining sibling, her two best cohorts and constant companions, improved in a way that was nothing short of miraculous. Marco remained in Bologna until just a few days before the big event, and Ruth kept Adriana to herself, hoarding her affection and keeping the rest of us away. Seeing her at the wedding would be something of an unveiling.

Ruth was already at the venue when I arrived at the grand ballroom-like Brazilian Room with its wall of sliding glass doors that let in the dazzling sunlight and spectacle of San Francisco Bay below the park. She rode high in her wheelchair, ordering her granddaughters and her daughters-in-law about, directing the traffic of chairs and tables and ceremonial altar set-up. The ravages of her thirty-year battle with cancer that now necessitated twice weekly dialysis were overridden by her zealous attention to the details of her masterpiece. A constant stream of FedEx, UPS, and local deliverymen, like self-regenerating magi, brought gifts from faraway relatives, last-minute details for the wedding, and assorted decorative accouterments. René led the most recent delivery of flowers directly to his mother's chair for instruction as to where they should be placed while his wife Steffi and I just stood there marveling at my aunt's unbridled enjoyment of the frenzy.

Ruth was something of a second mother to me. Her firstborn Johnny and I grew up together; he was born nine months after I was, and when we were young, our mothers could not bear to be apart for more than a month at a time, so we saw each other

often. Whenever our mothers took us out together, people remarked what a striking pair of children we were – I, a plump little towhead with blue eyes and he a lean, dark little prince with blue/black hair and almost ebony eyes. For the first few years of our lives, Johnny and I actually lived intermittently together in our grandparents' house in Bayside, Queens, and when we reached our late teens, each of us gravitated toward the other's parents for stability. After a six-month incarceration in the Suffolk County Jail for dealing drugs during his junior year at Stony Brook, much of it in solitary confinement for what the guards called "insolent behavior," Johnny decompressed by being a more frequent resident in my parents' home than I was. Conversely, I was inclined to retreat to the basement bedroom in his parents' home when I needed to feel safe.

"I thought my parents loved you more than they loved me," I once told Johnny. "They were so uncritical."

"They just didn't have any expectations," he replied matter-of-factly. "They let me be myself, and nothing I did got under their skin."

"Your parents weren't quite that way for me, but the expectations part was the same, that's for sure. "

"My mother wasn't as open with you as yours was with me though. What was it about our house that kept you coming back?"

"That's easy," I laughed aloud. "It was in New York."

Ruth's voice barked orders in perfect Italian at her granddaughters, who jumped to attention. "She loves to do that," one of them laughed. "I wish I knew what she's saying," the young woman admitted, pulling up her over-long skirt and preparing to run. "But I guess I'll figure it out."

I stood by, waiting for an approachable moment; when I saw it, I jumped in and hugged my aunt. The last time I had seen her was at Christmastime, right after Freddie died. She was still ambulatory and cooking and convinced me to eat her homemade pork ravioli despite the fact that I was and had been for

twenty years a vegan who had always eschewed pork even in my most carnivorous days. Aunt Ruth had a power of persuasion that was downright maniacal. The light of micromanagement still gleamed in her eyes that morning, but as I wrapped my arms around her, she felt flimsy, almost gauzy and void of substance. Like my mother and their mother before her, she had begun to disintegrate, to give the impression of simply melting away.

Just as I thought I might get sentimental, Ruth said, "I'm glad to see you're keeping the weight off, Carla. Getting old seems to suit you." That was a relief. I usually got a lecture as to how pretty I would be if only I were thinner. I reasoned that my being over fifty actually freed her from the burden of caring.

I never failed to be amused by Ruth's Italian accent; she, like her sisters and parents, had lived in Vienna and Zagreb, where they spoke German and Serbo-Croat. Italian was the language she acquired in order to speak with Freddie's parents when Freddie brought them over from Genoa just before the war. It was the language she still foisted on her children and grandchildren. She spoke it like a native, and her English was accented more by Italian than by her first languages.

The band arrived. Well, not a band exactly, a small chamber ensemble. As they set up their instruments and sound system, I felt a wave of deep sadness. Freddie would have reveled in this moment; his princess was marrying a handsome *compatrioto, un campagnolo,* who subscribed to many of Freddie's more socialist political beliefs and to music that he had taught her to love: classical and operatic. The group began to practice, and a dulcet soprano blanketed the hall with a Handel aria.

As I listened, I imagined my mother and Uncle Fred arguing. "She sings like Tebaldi," Freddie was shouting, his words hissing as his tongue tripped on his dentures.

"Only not quite so rich." My mother's voice boomed, somehow more masculine than Fred's. "The timbre is far too light to be Tebaldi. But she is luminous."

"You can't use luminous to describe a voice," he snapped, "Where's Johnny? He can --"

Mom replied, "It's how I see it. Carla, am I right?"

Suddenly, another voice, Mom's older sister Herma's rich mezzo rendering carefully enunciated, nearly accent-less words, intervened: "I wish they'd tune that cello."

I missed them. And I felt lonely for the company of my own family of origin, particularly that of my brother David.

David was nearly three and a half years younger than me, and we were the first of seven offspring in the Protestant branch of this family tree. A gifted athlete in his youth, despite being sick most of his life, first with childhood illnesses and chronic bronchitis and then with asthma and eventually diabetes at age 13, David wasn't at the wedding because he was healing from the amputation of his right foot. Nothing less would have prevented his being there.

David and I never remembered things in the same way, and we often argued over the way our fragile memories played back different versions of the most important moments we shared. But at least we knew the same set of parents, lived in the same houses, watched with the same sense of wonder as the family expanded. We both grew up believing we were part of an indissoluble unit, together for better or worse, invariably there to be one another's buffers against the world. Thus, we were sorely disappointed to find ourselves, after the death of our dad Alfred in 1984, splintered from a dispersed group of disassociated siblings who didn't really like one another very much. Now that David is gone, the memory of missing him at that wedding pulls more insistently at my heart.

A diminutive blonde woman in a cumin-colored one-piece robe/dress and carrying a Mary Poppins carpet bag entered the hall and asked me where she could set up her altar. "I'm Reverend Herschberg," the woman explained, and before I could offer any guidance, Ruth careened over from the other side of the room and ushered the woman to the dais at the center, where

the reverend began to set her stage. First, she laid out a minia-
ture Ganesh, the dancing Hindu god with an elephant's head
atop a lithe male body, the god the faithful call upon for help
leaping over obstacles. How did she know?

Next, Japanese burning bowls were set around the statue,
and into them, Rev. Hirschberg placed chunky nuggets of
incense, which she lit and which immediately transmitted the
smell of orchids and pine. Aromatherapy.

Then, she reached into her satchel and pulled out collapsible
rods with rubber feet and pointed tips, which she inserted into
the cloth canopy she also extracted from the bag; in no time, she
had constructed a free-standing, instant huppah, the Jewish
wedding canopy. Onto the table, next to a lovely set of brass
chimes, she set a painted icon, the face of the Virgin Mary.

I left the room and walked out onto the grand terrace in front
of the hall and climbed the hill behind it to look down at the
small fishing boats crawling about the bay. From up there, I
could also watch as guests flowed into the ballroom, including
my sister Sarah, whom I did not rush to greet.

In the month after our mother had died, Sarah had stopped
talking to me and most of our siblings. After that, we fell apart.
Brothers ceased speaking to various sisters and vice-versa. There
had been differences among us before that, but the aftershocks of
Mom's passing caused a seismic rift, and the tightknit assem-
blage of neurotics we once were became a disparate band of
warring eccentrics.

Mom's death left us emotionally crippled. At a time when we
most sorely needed one another, we found ourselves cast adrift.
Mom loved us. We never doubted that. But she was somehow
incapable of any outward show of affection. Her style of family
management divided us; she dealt with each of us individually,
encouraging us to see ourselves as being apart from the whole. It
was my father whose sense of community had held us together,
but with Mom we were – as she would describe us jokingly – her
"seven only children." Our harbored resentments and envy were

tacitly encouraged rather than addressed. It took me a long time to realize that our mother had been so damaged by her own life that she had never developed a trust that the people she loved would not leave her. She was convinced that her love drove people away, and she imbued in us the same misgivings. Looking around as my siblings and cousins arrived, I realized that we had all learned to detach rather than cleave to one another.

Fortunately, Sarah and I were by then too civilized to make a scene, so no one was ever forced to choose sides. In fact, the thing I appreciated most about our non-relationship was that we didn't fight at all. Ever. We just stayed out of one another's way, and when forced to be in close proximity, we simply nodded and smiled blankly at one another, so no one ever needed to fear being caught in crossfire.

David and I fought. Often. That felt more like love. I would never bother fighting with someone I didn't love.

Just as I was feeling anxious about encountering Sarah, I was swept upwards into a gargantuan pair of arms. Thank goodness. My brother Alfred, making his usual dramatic entrance!

I have always been grateful for Alfred's huge, massively masculine presence. I stood for a moment holding onto him, aware that the steely toughness of his musculature came from a combination of the working out he did in the gym and the heavy lifting he did as an emergency room nurse, moving patients twice his size in and out of bed for eight-to-fourteen-hour shifts at least five days a week.

That Alfred has made this life for himself was remarkable. As a very small boy, he was labeled both marginally retarded and clinically hyper-active because he couldn't read. He was held back twice in elementary school before my parents finally took him in for a thorough clinical evaluation, whereupon doctors discovered he was actually compensating for double vision.

It was only after he joined the Air Force hoping to learn to fly that Alfred learned that his vision would prohibit piloting. He

enlisted anyway. A gifted mechanic, he quickly found his niche maintaining and repairing airplanes until he was mustered out. Honorably. Then, he used his GI Bill money and went to college, coursing through high school math and community college into a state college nursing program, where he evolved into a gifted practitioner.

He became a Rolf enthusiast, controlling his ADHD demons by meditating frequently and by expending energy in extensive travel abroad and/or adventurous motorcycle road trips into the mountains around his west coast home and by buying real estate. He is the wealthiest of my siblings. One who never let anything stand in his way.

By the time of the wedding, Alfred had already lived with full-blown AIDS for five years. All evidence of the disease had disappeared, and as the sores and the weight loss were abated, he was again the physical reincarnation of our father. Whenever he was told how much he resembled Dad, he was wont to reply, "I know. I look in the mirror every morning and see this face staring back at me, and I ask, what are you doing here, old man? I thought you died!"

Any stranger attending the wedding would have had no doubt that Alfred and I were closely related and might have surmised that we were from a different tribe altogether from the rest of the cousins. My siblings and I more closely reflect our father's WASP features than our mother's, which were dark, Semitic. I was perplexed by this in high school when my genetics lessons taught me that dark genes were dominant, but Mom explained that, in fact, her own maternal grandparents were Russian Ashekenazim – Northern European Jews – who were blue-eyed blondes. Her recessive gene had bonded with Dad's and forced her dark traits into submission.

I had always adored my brother Alfred; he belonged to me. When my mother was carrying him, her fourth child, she told me that I would not have a birthday celebration that year. "You don't really need one," she told me. "You're eight now, a young

woman. The baby will arrive sometime around your birthday, and that will be your gift."

Alfred lifted me up and twirled me around. "Namaste!" A few minutes later, his impish Vietnamese partner Tam, who was just ten years younger than Alfred but looked thirty years younger, joined us and initiated a group hug. "How are you, guys?" I asked, truly interested in the answer. "I am what I am," Alfred replied loftily. Alfred was very fond of new age pseudo-Buddhist rhetoric.

"Every human being is the author of his own health or disease, and I guard my mind against negative thoughts. I am wondrous. I am spectacular. I am beauteous."

Tam craned upward to whisper in my ear, "Sometimes he believes he's the Buddha. Might be the cocktail kicking in."

The hall was nearly filled when we went down the hill and took our seats inside. We had seen Johnny secretly guide Adriana in through a rear portal, and we had watched René usher each friend and relation to the appropriate seat, as he did us now. He placed us next to Steffi, Alfred on one side of me, Tam on the other. The orchestra played the Pachelbel Canon, and the incense irritated my nose and eyes.

The ceremony was to have begun already, but Ruth refused to give the signal to commence. I wondered if anyone else in the room knew what we were waiting for. Steffi leaned in and said, "It's so sad that the rest of you couldn't be here." I nodded, guessing she was fishing for gossip. I didn't comply. My husband was unwilling to spend money to travel for something so frivolous as a wedding, and my children were tethered to their lives as budding adults. There was no story worth telling. The missing were always far more remarkable than those present at family gatherings. Alfred sighed.

The little orchestra nervously shifted to something by Handel. The soprano cleared her throat several times. We waited. I think Aunt Ruth had already relented and was about to order that the proceedings begin when a huge stretch limo

pulled up right outside the entryway. The chauffeur jumped from the driver's seat and marched over to the sliding door at the back of the car. The door opened and out came my cousin Peter Bogdanovich.

He unfolded himself from the car like a portable walking stick, stretched upward to his full 5'10" height, adjusted his fedora to the side of his head, tightened the silk cravat at his neck, straightened the overcoat riding on his narrow shoulders, and strode in like Orson Wells or the Pope or Karl Lagerfeld, his right hand raised in benediction. The house was hushed. The musicians stopped playing.

If life had been different, my filmmaker cousin might have been Francis Ford Coppola – he has so many cousins, one more would have been easy enough to bear. But instead, I got Peter, the one-time boy genius, who had directed *The Last Picture Show*, *Paper Moon*, and *What's Up Doc*? in the 1970s. Here he was, the son of my mother's older sister Herma, the family grandee, making a rare appearance at a family function.

Even after Peter became one of those talents more revered in France than at home, he was convinced of his great importance. When he did deign to be with us, somehow, we all responded with preconditioned, reverential obeisance.

In the last years of her life, my grandmother had lived in a house Peter built for her on Herma's property in Scottsdale. She and Papa had supported him during his hungry days between dropping out of high school and becoming Peter Bogdanovich. He had had many hard financial times in the ensuing years, and because Ruth was closest to our grandmother, my mother asserted, she and Fred had loaned him money as well. He frequently paid them homage and attended their rites of passage.

Peter bent to kiss Aunt Ruth, to touch her cheek and smooth her hair. She was in ecstasy. "Oh, Peter. Peter, my darling. You came!!! You came!!!"

I told this story years later to Peter's daughter. Her reaction was priceless and echoed exactly what I was thinking.

"What an asshole," She said.

He sure was.

At last, the wedding.

Ruth motioned to Rev. Hirschberg, who cued the musicians.

The little chamber group stopped playing and tuned their instruments. The soprano cleared her voice. The minister, holding her hands clasped in front of her, nodded, and the oboe led the musicians into J.S. Bach's *Wedding Cantata*. We all stood, and René walked down the aisle with Marco, who fixed his smiling face straight ahead, looking neither left nor right, meeting no one's gaze without once changing his expression. Next, Johnny's daughters Anandi, Liana, and Jessie, brown-eyed buxom beauties with garlands of baby's breath in their raven hair, fairly pranced down the aisle in their matching dresses, which Ruth, a gifted seamstress, had spent weeks creating. They, too, were smiling. They looked over at their assembled cousins and friends and giggled, giving each other looks that let everyone know that they shared secrets with one another. When they reached the altar, each took a corner of the huppah the reverend had assembled earlier, and Jessie took up the remaining post as well. René pushed Marco into the center.

The soprano's voice swelled as Johnny led Adriana in on his right arm. He wore a powder blue shirt with a bright red tie under a very natty pinstriped suit, and he was barefoot. No one noticed. We were transfixed by Adriana, who wore another of Ruth's creations – a creamy colored, lace-bordered cotton gown adorned with a miniscule floral print – as she stepped down the aisle like the snow queen on demi-pointe, one little bourrée after another. She was incandescent.

My sisters and I always accepted that both Ruth's and Herma's daughters were far more beautiful than we were– they were thin and dark, where we were thick and blonde – but no one

ever disputed that Adriana was by far the loveliest of all. She was lithe, and lean; her legs and arms were sinewy, graceful and long, extending to expressive hands with shapely, poetic fingers and narrow feet that always seemed to dance her into a room. She had wide, almond-shaped brown eyes with thick, lush, endless eyelashes, topped by blue-black eyebrows over a pert nose beneath which her cherubic cheeks dimpled perfectly whenever she spoke or smiled and tossed her wavy, black, lustrous hair. Coming down the aisle that morning, Adriana must have seemed to Marco the embodiment of perfection; she could have been The Beloved in the *Song of Solomon*, and her radiance warmed us all. Marco received her with an appreciative sigh as the soprano ended the song, and Adriana joined him under the huppah.

Hirschberg stepped forward and held out her hands. Marco took one, and Adriana took the other. And then she said, "I share with you a poem by the great lover of life, Rumi. "'The minute I heard my first love story, I started looking for you. . .'" Adriana fixed her eyes on Marco's and translated, "In momento in cui ho sentito la mia prima storia. . . ." When the poem was finished, the priestess said she thanked God for the poet's deep wisdom, and she proceeded to perform a multi-religious ceremony that ended with Marco's breaking a plastic wine glass under his foot. There was a simultaneous explosion of *Mazel Tov* from the assembled guests and the chiming of Tibetan prayer chimes. Marco genuflected and kissed his thumb and forefingers.

As soon as the two were married, they skipped hand-in-hand to the end of the room, where a door opened to reveal an abun-dance of food spread out on multiple tables and waiters standing at attention ready to meet our every need. Adriana and Marco formed a two-person reception line. I hung back, wanting to be last so I would have a few minutes to talk to Adriana and Marco before the reception got underway. Johnny joined me, and then Peter did as well.

There we were, the triumvirate. The first first cousins, standing together, bound by blood. Peter said, "I miss Fred.

Don't you miss him? He should be here." I nodded and answered, "It's hard to have a celebration without his silly rants. And what's a family gathering without baseball or opera sermons?"

"Dahlink, you do care!" Peter erupted in Uncle Freddie's voice. He launched into a pitch perfect imitation, complaining about back pain, the Yankees, the color of a sky obscured by too many trees and the difference between Puccini and Verdi all in a single breath. Then, from behind, another version of Uncle Fred's voice added a treatise on the pronunciation of Desdemona's name. "Americans. Why do they fight it? The accent's on the first syllable, not the second or the third." We turned to see that an old friend of Uncle Fred's had come to challenge the mimic.

Peter rejoined, and before long our entire mixed-cultural family of Swett, Gandolfi, and Bogdanovich attendees were cheering together for the dueling Freddies. Adriana was in pure glee as she put her arm around me and whispered in my ear, "I am so happy right now. Happy you're here. Happy they're here. Happy we're laughing at my daddy. I want this minute to last forever." I hugged her back.

Peter broke the spell by saying it was getting late. He had to head back to LA. Ruth said, "Wait, Peter. One picture. One family picture before you leave. Johnny, get the photographer." No one could say no to Aunt Ruth. Peter stayed right where he was.

"She doesn't quit, does she?" Adriana said, hugging her mother to her. "She's such a pain, but you gotta love her. Thanks, Mommy, for a beautiful day."

Ruth beamed.

Adriana hugged me again. "After the pictures are finished, let's all go dance. Let's dance for the rest of the day and all night, too."

"It's your party. You can dance if you want to."

We assembled for the photograph. And for a full ten minutes

we were all a family, the children of the Three Sisters. No one bickered or complained. We stood calmly, our arms linked to one another's waists, clasping, holding on for dear life. Then Peter left, and the rest of us dispersed into the dining hall to eat and dance.

It was Peter's father Borislav, a Serbian painter of some renown, who taught Peter to keep his distance. Borislav had been passionately disciplined about his work and rarely left his easels to attend any kind of family function. A deep schism had emerged between the Bogdanoviches and the Robinsons during the time of their emigration. The Bogdanovich mythology portrays Borislav as the savior who got the family out of Nazi Europe. It was he, they said, who convinced the family to flee just in the nick of time. The Robinson story, corroborated by nearly everyone who ever knew them, contended that my grandfather Henry coerced Borislav. He simply threatened to cease supporting his painting, his wife, and the child she was carrying, who, of course, was Peter himself. Neither version is exactly the truth, but the disparity between them kept us no closer than arm's length for much of our childhoods. Peter, who always gave the impression of having somehow sprung fully formed and already brilliant from Borislav's forehead, simply continued a time-honored tradition that did not break down until after Borislav's death in 1970, when our mothers re-established their bond.

Despite the rupture in the family, Borislav was always charming to our faces, always affable. He greeted each of us as though he were thrilled just to be in our presence, and he regaled us with magic tricks, with stories, with his piano virtuosity. Peter inherited his father's talent for charming duplicity, which made it easy to laud him, easy to shower him with love. The return of affection was elaborately flowery, momentarily sincere. It felt good. Because we knew it was only going to last for the few minutes we were in his presence, we never needed to fear his leaving us. The minute he walked away, he would stop thinking

of us, and we would be freed from having to give him another thought.

Ruth died a few months after the wedding, the last of my mother's sisters no longer in my life, the last person who had perhaps known her more intimately than I had. Adriana went back to Bologna and within a year was deathly ill with lymphoma; I never got over there to see her. She was, I realized later, the embodiment of everything good our forebears would have wanted us to be. When I think of Adriana, how close her passing made me feel to the rest of my clan, I realize how very good we all are at navigating the terrain of illness and bereavement. We learned our skills from our parents, whose lives were an epic series of losses, and we learned those skills well. In the midst of life, we never forget about death.

The wedding photo is a critical piece of our history, and it underscores the fragility of memory. I had forgotten that Peter's sister Anna, now my closest friend, a surrogate sister, was at the wedding, as was as my second sibling Helen. So much of the way our minds interpret events is couched in whatever preoccupations dominated our perceptions at the time of the experiences. But there we all are in a picture that shows us as we were then, a polyglot group of ragtag descendants, the remnants of our grandparents' progeny. We were, as we are, what Anna likes to call the Jewish Family Robinson, cast adrift on our Dysfunctional Island, endlessly struggling to justify our survival.

So many of them are gone now. Johnny died a year after Adriana. David and Peter were next. Helen is the only one of my remaining siblings who speaks to me. And while I miss them all, I have aligned myself with those of the next generations who have sought me out as the Family Matriarch.

DADDY'S GIRL

Though I fully embraced Judaism in my adulthood and raised my children in its precepts, I am grateful I was not raised – as, by the Law of Moses, I should have been – a Jew. Unlike my Jewish contemporaries, I never had to endure Christmas Days hiding in movies theaters and subpar Chinese restaurants. I spent my childhood Christmases in the bosom of an eccentric family of church-going Methodists, the first daughter of Charlotte and Alfred Swett, a family whose lives, though enriched by a colorful array of multi-cultural relatives, revolved around belief in the tenets that our Sunday School education presented to us as facts.

Every Sunday, with the consistency of a Swiss train, we arrived at the First United Methodist Church. Unlike that Swiss train, we were never on time; we were wont to arrive ten to fifteen minutes after the minister made his welcoming address. The choir would be putting away hymnals, the congregation rifling through prayer books looking for the Apostles Creed, and we would make a grand entrance. There were nine of us, and we were never inconspicuous.

Each week, the same usher, an elderly man with a large red mole that sat like a laser point on the top of his bald head, would lead us to the nearest empty pew, and each week, Dad

would ignore the designated bench and lead the way to one closer to the altar, parading past the entire congregation. Dad would step deliberately, serenely, looking neither to the right nor to the left, fixing his gaze on the cross and squinting his eyes in what appeared to be pious prayer. His children would follow him like biblical offspring – Carla, David, Helen, Alfred, Elizabeth, and John – the issue of his begetting: I scolding the young ones in harsh whispers, baby John squealing first with delight then with terror as I dragged him away from the columns he sought to shimmy up, hyperactive Alfred climbing onto the back of the pew the moment he was situated between David and me, Sarah whining that someone was picking on her, then Helen and Elizabeth cowering close to Mom, who brought up the rear.

I was perversely proud to be part of the disruption. These people were my posse, an exclusive club to which only a Swett might belong. To be a Swett was to be superior in every way, or so I told myself long after I knew it wasn't true. I held fast to the hope that we were imbued with God's favoritism, and for years, I had no idea my own mother was hidden behind a mask she donned each week for the sole purpose of making my father happy.

I knew that she had been raised in Judaism, an insight she shared whenever she interpreted what I told her I had learned in Sunday School, gave me a sense of what that meant.

"Today we read about how Mary and Joseph took Jesus to the temple when he was seven days old," I reported skeptically. "I wasn't old enough to understand church when I was seven days old. What did he do there?"

"Jewish people take their sons to temple when they are seven days old so they can promise to be good Jewish men. They have a briss."

"A brisket? They eat --?"

"No. It's a ceremony where they promise that their son will obey God."

"Oh." I went to my room to get out of my crinolines, satisfied I understood.

Many of the Bible stories made sense to me after my mother shared her insights.

Further, I knew that the family emigrated from Europe, from Vienna, Austria by way of Zagreb, Yugoslavia, a detail none of my cousins or I could miss. Our families spoke a mishmash of languages derived from the fact that our mothers' marriages had made us a multicultural family. Mom's younger sister Ruth was married to my Genovese uncle, whose non-English-speaking parents lived with them; in their house, we communicated in Italian. Her older sister Herma married a Serbian artist who insisted that they speak the language of his ancestors. In their home, we navigated in Serbo-Croat. I sensed in Mom a disconnect from the Christian rhetoric and recitations, but I knew that like so many things, getting us to church was one just one in an endless series of responsibilities that weighed heavily on her.

I was 11 when I began to understand more. I read *Exodus* by Leon Uris, and suddenly, the hushed German innuendo that had floated around my consciousness all my life began to make sense. Throughout the 1950s and into the early 60s, as my grandfather made his first return voyages to find relatives, as my grandmother reconnected with the six of her nine siblings who had survived, as calls and telegrams came in from Australia, Israel, Brazil, Canada, words like Auschwitz, Bergen-Belsen, Nazis, camps, etc., suddenly had substance, and I forced my mother to share with me what she could, which was never everything. There was so much. She had buried it so deeply inside herself. I'm still uncovering details.

Until I began to question my own sense of Christianity, I had no inkling of what it had meant to her to allow Dad's religion to erase hers from her daily life. She kept that from us, responding to my teenage question by saying simply, "It's only religion. Not important enough to fight over." She was terrified of confrontation in those days. Looking back at it now, I see that she felt like

an interloper in her life, that she was eternally afraid she would be expelled as she and so many of her classmates had been from their school in Europe for not being "like everyone else."

What compounded my mother's fear was her own sense of guilt. Deep, inextricable guilt over the deaths of two of her siblings. When she was ten, mom's eleven-year-old near twin suffered horrifically from tubercular meningitis and died. The sister was beautiful, a dance prodigy, brilliant. Mom was sure that God had made a terrible mistake. The one who should have died was Mom. Her parents would have preferred to have lost her. When she was a senior in college, her little brother John, then 15, died, the freak result of his having being bitten by a dog and administered the anti-rabies vaccine, to which he was deathly allergic. Mom blamed herself that she had been at university finishing her pre-med degree when she might have been home to save the boy. Ironically, until John's birth when my mother was 6, Mom had been treated as her father's surrogate son.

I, who knew little of this at the until much later, was the child who did not fear confrontation.

Shortly after I read Uris's book, much to my father's chagrin, I quit the church. One Sunday morning I awoke, got out of bed, descended to the first landing of the sprawling staircase in the center of the house, and yelled, "I'm not going to church today, Daddy."

It must have taken him a minute to reach me, but in my mind, he magically appeared in front of me, his hand raised, poised to strike.

I could not take my eyes off his ominous knuckles. Bulging, red, striated by the bleeding cracks wrought by repetitive frost-bite. His oversized, gnarled hands, scarred by physical labor, yellowed from cigarettes, trembled under the strain. He wanted to hit me, but he looked as though he might cry. He was not the kind of man who would beat a child for disagreeing with him.

He was the Blueblood son of Yankee prosperity, cultured, genteel. The opposite of his hands.

His April blue eyes stared icily at me for a moment before he murmured, "Do you dare say that again?"

Knowing full well that I was about to declare war, I locked eyes with him and repeated the offending words. "I am never going to church again."

His hand shook, aching to complete its mission. He shoved it into his pocket and stood firm, hunched over, confused by the failure of his hand to bully me into compliance. He seemed to me then a comical, cartoonish image of frustration.

I did not laugh.

"Daddy. . . " My voice broke. How could I make him understand? I wanted him to embrace me, encourage my preteen independence.

The concept was beyond his ken. How could this child, this female child, question his truth? He shook his head.

"This is not an issue to be discussed," he barked. "I am in charge here. You will get dressed, and you will come with us to church. That is that."

"Why?"

"Because I said so. I tell you what to do, not vice-versa."

"I should be allowed to choose. You can't legislate belief, Daddy. I don't believe."

"Nonsense. Of course you believe. What is not to believe? The Lord our God is omnipotent. He is Everywhere. He is love. God is Love. Someday you will see Him, and all will be proven. But for now, you must simply have faith."

Young as I was, I knew argument was pointless. Half a century before, Daddy's grandfather had whispered Dutch Reformed rhetoric into his ear at birth, and his infant brain had embraced the dogma from the start. But our collective church life was a huge lie. It was one thing to be the saintlike family of nine entering the House of God as though we had a personal invita-

tion and still another to put up with the Calvinist surrender to hopeless acceptance of a morose predestination.

Though I was ashamed to admit it, I hated Daddy's joyless God. I would have been more devoted to a god like Dionysus, one who derived joy from man's laughter. Or Apollo, who encouraged mankind to think critically, to mull over nuances of ideas. Not one that required absolute obedience.

Besides, so much of our religious practice seemed hypocritical. We marched as a body into the nave each Sunday, and, once seated, Dad sat upright, his eyes pressed together like a praying monk's. The first time I sat close enough to hear his shallow snore, I knew that that posture was as much for show as the entrance that he insisted we make, that he believed was undeniable. That he needed the approval of his congregation to validate his existence seemed unforgivable. Once I embraced that idea, I was unwilling to be part of his show.

"I'm not Mommy," I whispered. "She'll do whatever you tell her to do just to make you happy. I won't."

" Go get dressed," he whispered back. "We leave in twenty minutes."

The pulsing rhythm of his veins mirrored the pounding of my heart.

"No."

"You will," he thundered.

"I will not."

I took a deep breath. Waited. A great calm had come over me. Nothing would move me. I would not be bullied into seeking his salvation.

Daddy was not calm. His face was bluish as the veins in his temples struggled to carry the oxygen to his brain. For a moment, I feared -- hoped? -- he'd drop dead right there.

I waited for him to fall, to convulse with pain, and then to disintegrate into a crumbled heap.

Instead, he simply sighed. He unclenched his fists and closed

his eyes then opened them a moment later. He smiled his charac-
teristic beatific smile.

"Breakfast is probably waiting," I said. "You know how much
Mommy hates that. We should go eat." One thing I always knew
would stifle his aggression was a reference to disapproval by my
mother. He worshipped her in those days. Or so I thought. I
invoked her name knowing he would back off because he never
allowed even a suggestion that she might now be angry about
anything. He turned on his heel and headed down the stairs
toward her kitchen, humming his favorite hymn, "The Old
Rugged Cross."

So much of my reaction to that moment was based on the
family dynamic. I was the oldest daughter. My job was to set an
example for "the kids." I had not been encouraged or expected to
live a life of my own choosing – I belonged to the fold. For years,
even after I graduated from high school and attempted to strike
out on my own, I returned home when my parents needed me to
be surrogate parent. Until they moved to Arizona the year before I
got married, I made no moves whatsoever without making sure
they did not need me. My rebellion of spirit was just that: the spirit
of rebellion. I never really shook off the oldest daughter mantle.

In any case, I was never sure if I had won or lost the religion
scrimmage. In what I came to accept as typical Daddy fashion,
he shared no feelings about what had passed. I was relieved that
he had eschewed the opportunity to use his dreaded belt on me,
but I wished I knew if he was angry or disappointed. He
betrayed no emotion. Was that because he didn't love me or
because he loved me too much? Would I have to tiptoe around
the topic of religion whenever he was around? I was sure that he
would still expect me to help him teach his Sunday School class.
(He did.) And I was equally sure he would not allow me to miss
the Easter Sunday sunrise pancake breakfast socials. (He didn't.)
But would he forgive me for denouncing his religion? I was
scared, but I was resigned. I had no desire to participate in any

more of the theatrics of this public reverence. If it meant I was giving up my Daddy's love, then so be it.

I was never Daddy's little girl, and at that moment, the fantasy was off the table. One of my sisters became even more religious than he was, and I know that gave him comfort. She willingly surrendered her intellect and will to her Lord and Savior, and she began, even in her earliest childhood, to dedicate her life to Jesus. I did not envy her Christianity, but if I had allowed it of myself, I might have envied her relationship with our father. He revered her.

Another of my sisters insinuated herself into his heart as his emotional favorite. She was good at knowing what to say to him so that he never knew she defied him. My mother expected me to discipline this little sister, and we fought bitterly. She would then wait up for Daddy to come home, no matter how late, and she would assault him with kisses, hugs, declarations of love and then tell him how I had abused her that day. She would massage his anger until he came to my room to yell at me, take away some privilege, hit me. And she would smile ever so innocently, as though she had nothing to do with his actions.

Even so, I was his daughter. I trusted that he loved me. Had I been a son, my resolute independence might have pleased him. I suspect he never knew what to feel about my personality, my defiance. So simply loving me was all he could do.

In the long run, instead of becoming stronger as a result, I developed the inability to ask for help or to seek approval. I expected that men and women alike would tolerate me but would never endorse me. My father's unwillingness to express love or pride or even acceptance helped me to evolve into a woman who could talk tough but was never quite able to assert career or relationship successes. I was not emboldened in the ways women of my era needed to be in order to succeed. I could not railroad my beliefs or my methodologies into a room full of established authority figures. I could not insist on having things my way. I developed a mindset where I would assert myself just

enough to be part of something but never enough to be the voice of insurrection. Still, there was a benefit in my father's not rejecting me. Daddy's tacit acceptance told me I was not evil.

I became a spokesperson for anyone who self-defined as an underdog. I stood up in my sophomore history class and made an impassioned speech denouncing the UN's refusal to accept Red China into the fold. I wrote a treatise on how true Communism was closer to Christianity than any system the US had embraced. When classmates were in danger of failing, I brazenly wrote essays for them. One of my teachers knew and didn't stop me. "Next time," he wrote on top of a paper I had written about *Huckleberry Finn*, "keep the better essay for yourself. The one you wrote for Herman is really superior writing."

While still in high school, though I won writing and speech contests, though I excelled in French and German and was better read than most of my teachers, I allowed my guidance counselor to convince me I could not get into a topflight school. I had harbored a secret desire to perhaps study medicine and write about it or to become a world-traveling journalist. But the counselor had administered an aptitude test that I found boring. I responded to that test the way I responded to my SATs. I stopped reading the questions and simply colored in the boxes with my pencil, making shapes and patterns. Instead of taking my school record into account, my counselor surmised that I was intellectually unfit for college and suggested I concentrate on getting a job selling shoes or greeting customers at the Howard Johnson's in Lake Placid.

Luckily, my father's failure to chastise me fed my belief that I did not need to listen to would-be authority figures. I easily discounted my counselor's advice and successfully applied to college.

DUELING BLOODLINES

Ours was a very simple, inexpensive but traditional wedding. My mother, so grateful to be Richard's mother-in-law, made my dress and my sisters' bridesmaids dresses from fabric I bought in the garment district on the Lower East Side; my matron of honor made her own dress from the same fabric. Mom then took a piece of green velvet I had also found and created matching vests for Richard and his best man, my 11-year-old brother.

For the sake of Richard's beloved grandmother, we went out of our way to find a Roman Catholic priest who was willing to violate the Church's prohibition against marriage between a Catholic and a divorcee, which was no simple task. We started at Regis, believing that an enlightened Jesuit there would be sympathetic when we explained our purpose. We were wrong. Richard's hero, the one priest who might have complied, had already left the Jesuit order and was living too far away to be of service. In desperation, we approached the Catholic chaplain at Columbia University. He had a reputation for being staid, conservative, and unwilling to rock traditions. But when we explained about my unconsummated marriage and our need to preserve the possibility of Catholic grandchildren for Richard's

grandmother, he agreed to perform the ceremony so long as we promised that we would not advertise his compliance.

We had taken an apartment on Riverside Drive, just a few blocks from campus. Richard spent the night before the wedding in the dorm on campus along with his young best man. My sisters, another brother, and my parents stayed with me on Riverside Drive. When it was time to go to the chapel, I donned the wedding dress my mother had sewn – a very plain, lilac-colored sateen underdress with a long-sleeved ivory-colored lace overlay – and a pair of sneakers, put my high heels in a plastic bag along with my hairbrush and some eye makeup, and walked up the hill to Broadway. I could not feel the sidewalk under my feet. I was not sure whether I was awake or dreaming. The sun streaming onto the Columbia campus seemed striated or stippled with bursts of glowing oranges and reds. Nothing felt real – I imagined myself in a Pirandello puzzle play.

At the corner of Broadway and 115th Street, I stopped to look around. It was the middle of the day. To my left, people poured forth from the subway stop beneath me. They moved in a kind of exaggerated rhythm, foot heels and souls marking a beat that shook inside my head. I felt confused. I was about to be married, to enter into a life I had not considered pursuing, and the people around me were unaffected. They simply carried on. The ordinariness of my existence had not until that moment really impressed itself on me. I thought about reasserting my singularity, throwing all expectations to the wind, boarding a downtown subway headed to Port Authority.

The truth is that still today I am not sure what my emotions were. I was intellectually engaged in a questioning process, and for years, I identified my emotions as confused. But that's not an honest expression. Nowadays, I live close to where that part of my life transpired, and I often walk by that corner. Every time I do, I try to feel what it must have been that I felt then. I still can't put my finger on it. Fear? I am sure I was frightened. I know I did not trust myself to be okay without this husband. Was I sad?

Feeling pressured into moving more quickly than I wanted? Or was I so young and careless that I simply ignored my misgivings and forged ahead? I am sure I was emotionally constipated. I still am.

I do remember thinking that I could take a bus to anywhere else. Then, I told myself that I had already been to those places, and I should want to be where I was. For a moment, I wondered if I believed me. I shook the thought off and crossed the street.

At the chapel, as people arrived, I stood and waited for my father. I was in no rush. In fact, I thought if Daddy failed to show, we could just call the whole thing off and blame him. My oldest sister and my second brother were already seated behind the altar, joyfully playing instrumental welcome music. My oldest brother and his first wife were warmly greeting every person who walked through the door. I studied them for a moment. I knew they were fundamentally unhappy in their marriage, that they wished they had avoided their choice to wed. Would I ? Nah. It was way too late to even consider that I might be making a mistake.

My mother, my two youngest sisters, who were in my wedding party, and my matron of honor made small talk while we waited. My sisters were familiar with my father's idiosyncrasies, which included perpetual lateness. Everyone seemed so very happy. I would not upset them.

Richard's parents and sister, his two grandmothers, a few uncles, aunts, and cousins arrived in near unison. They didn't acknowledge me or our wedding party as they entered. I figured it was bad luck or something to greet the bride at the church door. They all sat in the same section on the right side of the chapel. The groom's side, I realized. I am sure there was already a mounting tension on that side of the chapel, but I assured myself that they were just acting out some kind of Polish American tradition I was unfamiliar with. My resolve became ever more fragile as the chapel seats filled up.

Our friends from the Engineering School and a few from

Richard's days at Regis joined his family, and soon there were no more seats on that side of the room. No one on the Groom's side so much as looked at the Bride's side. There was a murmuring tension that became palpable when my cousins arrived.

I grew up with my cousin Johnny. He was 8 months younger than I, and until our life endeavors separated us, we were frequent companions. I adored him. I was the first family member he confided about the pregnancy that precipitated his marriage and the birth of the beautiful two-month-old daughter he and his wife Jill brought with them to the wedding. At the time, Johnny and Jill were living on a commune in Vermont, and they arrived barefoot, wearing peasant garb, baby attached to mother's breast.

Then, my youngest cousin danced into the room just before my dad arrived, and, as she always was, she was immediately captivating. She and her boyfriend were dressed in what was deemed "hippy attire" similar to her brother's, and she bore a loaf of freshly baked bread, our wedding gift, which filled the room with the pleasant aroma of home. The right side of the room bristled audibly. Richard's father winced.

What an irony, I thought. This man who was adamantly opposed to his son's youthful religious fervor sits now in judgment of a family raised by a man with deep and deeply Christian values. We were not good enough. If my mother had married my Italian uncle, a proudly avowed atheist or my very judgmental Serbian Orthodox uncle, would they have overlooked our differences, accepted even our seemingly iconoclastic natures? I realized looking at the assembled group that though my dad seemed to be the most adherent to antiquated mores, his life practices were genuinely liberal.

I looked over at my brother and sister, who were playing their guitars and singing softly, and I had to laugh. What a pair they were. My sister, the ultra-religious woman who was destined to give her life to teaching the disadvantaged and doing mission work on the drug-infested streets of Phoenix, and my

little brother, proudly homosexual. Neither held the other in contempt. Neither judged the other. In the way my parents judged none of us. In fact, my Republican, WASP father's response when his son hesitantly outed himself was, "Is that supposed to make a difference? I love you no less."

My family. Odd, yes. But accepting and generous to a fault. I was overcome with love for them all. It was the only emotion I could conjure. Should I have felt more animosity toward Richard's family? Certainly, I should have felt more outpouring of love for Richard.

The company was sufficiently agitated by the time Dad arrived. The priest, now standing in place, impatient for us to get the ceremony over with because there was another event scheduled right behind us, took note. I signaled my mother to cue my sister and brother, and they launched into "The Wedding Song" while the priest studied the two sides of the room.

I fixed my eyes on Richard, who was standing in front of the altar, eyes boring a hole in the floor. I attempted telepathy. "Look at me," I thought. He didn't. I thought, "Okay, if he's not looking, then maybe. . . . "

Just then he shifted his gaze, and our eyes locked. Now I was stuck. I took his hand.

"Dearly beloved," our priest intoned. "We are gathered here today to join in holy matrimony this man and this woman." Then, I almost burst into laughter when he went on to say, "While some of you may not approve, it is not our place to cast judgment. . . . " Though he stopped for a song by my sister and brother, he quickly got to the end. "I now pronounce you. . ."

I felt like I would faint, which, I told myself, was because I was deliriously happy.

Two of the office administrators with whom I worked commandeered my friends into providing food and drink for our reception at Earl Hall, the center of campus religious life.

The hall was not fancy. It reminded me, in fact, of the basement social hall in the Saranac Lake Methodist Church that

dominated so much of my youth. Concrete walls, small slits of light at ground level, glaring, flickering fluorescent lights. The ceiling was high, the sound of laughing guests and clinking glasses, forks, and spoons bounced from the walls and up into the space above our heads. My friends had decorated minimally, spreading food on a long table adorned with a paper tablecloth strewn with varicolored hearts and flowers and in the center of which was a hand-crafted poster that simply said, "For Richard and Carla. . . because two people fell in love."

Richard and I brought a long reel of music we'd assembled with songs by the Rolling Stones and Marvin Gaye, Diana Ross and Roberta Flack, Paul Simon and Don McClean. There were some 20 or so tables, arranged in small groups around a center designated for dancing. The young people, less interested in the potluck food, gathered on the dancefloor and gyrated or slow-danced, as the music dictated, while my friend Nick, a University of New Mexico classmate, acted as our deejay. After he had allowed sufficient time for food and drink and general conviviality, Nick gathered everyone to do the bunny hop, the cha-cha, and the hora. My cousins and I were ecstatic. We held each other's hands, sang along with the tracks, and to the hora we shouted the words. "*Hava Nagila*. . . " Richard's family stood and stared.

Then came the polka. We paired off in family configurations that symbolized our families' clashing cultural perspectives. It became clear in the middle of the dance that despite the fact that my family was equal parts Italian, WASP, Serbian, and Jewish to Richard's family we were all shtetl "Zydzi," which this group of mostly second-generation Poles called "Zhidi." One of Richard's uncles spontaneously proclaimed as we were dancing that he was amazed that my dancing siblings and cousins were so adept at the polka. "It loses a little something in the translation," he slurred. "But hey, they're doing it!"

"Oh my," I wondered, hoping now that no one could read my mind; "What does this mean for my long-term happiness? "

We rode off to our happily ever after in Nick's borrowed Ferrari.

I assumed – having not yet learned, despite the many lessons my life had already provided, how erroneous assumptions could be – that after we married I would just go on doing what I was doing: I'd finish at Columbia, find a career.

We took residence in an apartment in a Columbia graduate student facility on 112th Street. From the window where I had my desk, I could look across the street at the Tom's Restaurant sign that later became a beacon for Seinfeld fans. I loved watching the movement on the street, even the rats scurrying away from the restaurant. I was sure we could stay right where we were and gradually enter the lives we would eventually inhabit. I never would have anticipated how wrong I could be.

Richard wanted to go to California. I didn't. I had one more year to go in my undergraduate program at Columbia. I had lived in Southern California long enough to know I detested the omnipresent sunshine and the unfailing plasticity. Richard was about to embark on a Master's program and desperately wanted to experience living out west, specifically in California. His National Science Foundation Fellowship enabled him to go anywhere in the world he chose for his graduate work, so he suggested that we pick a California school where I could finish my classes and still receive my degree from Columbia.

I hated that idea and made a deal with him: if he would wait until I graduated, I'd go anywhere he chose. I thought I had won because I believed – but did not stipulate – that after we got California over with, he would see how tarnished the Golden State actually was and would willingly return with me to New York. He would get the West Coast out of his system, and seeing how very much I wanted to be in the East, for my sake he would

I believed absolutely and without doubt at this point, like Nora in A Doll's House, that there would come a time when my making a sacrifice for him, my bending to Richard's will, my demonstrating devotion to his well-being would buy me the

greatest gift a man can offer: an equal sacrifice of his own. Some-day, when I needed it the most, Richard would, without hesita-tion, lay his will at my feet, and the most wonderful thing of all would spring into being. I could return to New York City.

The devil, however, was in the detail. I did not specify.

Richard liked the plan. Unlike most schools, where a master's required two years' worth of work and a research thesis, Columbia's Master of Engineering was a single year of intensive classes without any burdensome investigation and writing. He especially liked the part where he got to choose where we went next, and – I didn't realize this until later – he was especially grateful that there was nothing in our agreement that bound him to return east.

During that first married summer, I actually got excited about heading back to the Left Coast. Thanks to a Columbia fellowship grant, I was immersed then in what was still called Serbo-Croa-tian literature. It was glorious. As a Comparative Literature major, I found I enjoyed both the translation and the compar-isons to Italian, Irish, French, and German literature. I began to envision a career as a theater analyst and critic, specializing in modern Eastern European drama. Berkeley had a fantastic program, and I was eligible for a coveted National Defense Foreign Language fellowship for the study of Eastern European languages. A blessing of the Cold War.

During the mid-year break of his first graduate and my last undergraduate year, we went to visit my family, who had relo-cated to Arizona, and there we rented a car and drove out to the coast. Our goal was to explore the possible schools and settle on a choice. We both expected we would wind up at Berkeley, Stan-ford, or UCLA, all of which were recruiting him relentlessly and offered me access to graduate Slavic Language departments and the promise of a Ph.D. in Comparative Literature.

Our exploratory trip proved to be a disaster. Richard hated Berkeley because it rained every minute of every day we were there. At Berkeley, we stayed with Terry, a first-year grad student

who had been Richard's undergraduate classmate, in a tiny apartment he shared with three roommates. Fortunately for us, all the roommates but one were away, but we still felt cramped.

The friend took us around the engineering school and then, when we went to look at other facilities, he followed Richard relentlessly, chirping, "Aren't you going to declare your intention to come here?" He wore a perpetual expression of deep stress that glowered from his red-rimmed eyes and terrified Richard.

The day we went to the Foreign Language department for my interview with the department chair, the hills were slick and slippery from so many days of rain. My interview was delightful. The department chair was a hip, young-seeming professor with beautiful green eyes, and we connected immediately. His expertise was in Slavic literature, and he said there were never enough people interested in any of the literature from Yugoslavia. He assured me that I would definitely earn the fellowship I needed to study there, and he encouraged me to apply. As we left the building, I was soaring on my own excitement.

Which is why, I suppose, as I fairly skipped down the long hill toward Terry's apartment, I slipped and landed flat on my buttocks in a huge puddle. No one stopped to gape at me; campus activity simply went on, and I was amused. I looked up at Richard, who looked horrified. I howled with laughter. "OMIGOD, I love this place!" I shouted. Richard extended his hand to help me stand and said nothing. He remained quiet the rest of the afternoon, and we never revisited that moment. Clearly, we had issues.

For some reason, the rain stopped the day we went to Stanford. The sun shone far too hot, and the air was dusty dry. "If we're going to be where it's this arid, we might as well stay in Phoenix, where living is cheaper," Richard grunted soon after we arrived. "Why would we come to a place where we'll need roommates just to pay our rent?" We turned around and

returned to Terry's to pack up. We were leaving early the next morning to visit the schools down south. Based on my interview at Berkeley, I was especially excited to see what I might find for myself at UCLA.

We never got to Los Angeles. Or to San Diego for that matter.

We had intended to travel down the Pacific Coast Highway, an adventure to which we were both looking forward. Richard expected the rain to stop, but on the day we left Berkeley before the sun had fully risen, the skies darkened once again. I turned on the radio. Just then, as we heard the 900th reiteration of the popular song "It Never Rains in Southern California," the car was suddenly engulfed in a deluge. Grapefruit-sized water droplets pelted the windshield, and the tires hydroplaned. Richard yelped. "Why won't it stop? I can't stand it anymore."

"So just let me drive. You can close your eyes and . . . "

"I can't close my eyes. The road is slick, and I need to watch because. . . "

"You don't need to do any such thing. I took my driver's test in a blizzard for Christ's sake. This rain is just beautiful. Listen to the rhythm of the drops hitting the roof. It's like being on a boat in the middle of the lake, washed on all sides by cool, refreshing. . . "

Richard sneezed loudly. "I'm getting sick. Just drive and stop talking."

"Okay." I was quiet for a few minutes. Then, before I could stop myself, I was effusing, "Singin' in the rain. Just singin' in the rain. What a glorious feeling, I'm happy again." Richard groaned but did not ask to re-take the wheel.

All the way south to San Luis Obispo, the rain was torrential, and by then, Richard was in tears. "I hate that you love the rain," he chided. "Do you have to be so gleeful?"

He was right, of course. One more disconnect.

Somewhere around the exit to Solvang, Richard began to cough and sneeze. Violently. "I'm running a fever," he insisted

when I told him he was just overreacting to the rain. "You've got to find a place for us to stop. I need to sleep."

I pulled into a motel right outside Santa Barbara, rented a room, and went out to find food and juice. There was nothing nearby except for a great expanse of vineyards or farms or secluded mansions. "How does anyone live around here?" I asked myself. When I finally found a store that called itself a delicatessen and ordered a sandwich on rye bread, the clerk looked at me with pity in his eye and said, "We don't ever carry that."

Oh, I thought. I would perish if I had to live here.

The next day, Richard's fever was gone, the sun came out, and the sparkling Pacific Ocean beckoned. We had a breakfast picnic by the water, and Richard remarked that he had seen a sign on the highway pointing to the University of California at Santa Barbara. "I looked at the map," he said positively. "The university is on the beach. Let's go take a look!"

I thought a university in this wilderness was something of an oxymoron, but it was so nice to see Richard smiling and speaking pleasantly, I took him seriously.

We walked around the area, and it was gorgeous. We both relaxed enough to enjoy the feel of the warm sand under our toes as we walked on the beach. We held hands for the first time in days. We hadn't had time to process what we'd taken in up north, had not even talked much about what we'd experienced. Strolling in the sun made it easy for Richard to finally share his thoughts.

"You know," he sighed. "I'm tired of the pressure cooker atmosphere of Columbia. I think I need a program that allows me to breathe. I mean, I am not sure I even want a Ph.D. Just because they all say I should get one? What for? I can't think of a good reason. But let's say I do decide I want the degree. I sure don't want to be like Terry, red-faced and tired all the time. So I wouldn't want to be in a place that was even more intense than Columbia. You gotta admit . . . Berkeley's way worse."

We came to an unoccupied beachside bench, and he sat down and pulled me down next to him. I didn't know if he was finished talking. He just stared at our intertwined hands. He took a deep breath and then continued.

"If I really don't want the degree at all, then no place anywhere is gonna work. If I do, this could be the place. It sure is the opposite of Berkeley down here!"

What he said put everything in a new perspective for me. He was only twenty-one, after all. Still a boy with California dreamin' in his veins. He loved that the campus was on the beach, that the Engineering School faced the water, that there were students coming and going with surfboards on their bicycles. He loved that the student housing in Goleta, where we would live, overlooked the ocean. He loved that it never rained – well, seldom rained – in Southern California and that Santa Barbara is not a city. By the time we left two days later, he had visited with people in the Mechanical Engineering Department and had felt welcomed. He was sure now. He would enroll at UCSB the following fall.

I knew this was a choice I would never have made. I disliked the beach. While Goleta, where all student housing was, was everything he believed he loved, it was everything I knew I abhorred. But I had given my word, so I kept my mouth shut, and I joined him in his enthusiasm.

"In a world not made for women criticism and ridicule follow us all the days of our lives. Usually they are indications that we are doing something right."

Erica Jong **Fear of Flying**

ABIDING BY THE RULES

Feminism was a kind of dirty word in the 1970s. Letty Cottin Pogrebin, a pioneer in the movement, worried that feminism seemed narrow to too many women, that it was a "negative fringe." In those days, Feminism connoted bras being burned, women spurning men who tried to hold their doors, lack of respect for societal norms. I didn't care about any of that.

I was anti-ism. When asked if I were a feminist, I would reply that I subscribed to no movement. Individuality was my only cult. Nothing could sway me. Even writing by women I admired intensely.

Toward the end of the decade, as I neared my thirtieth birthday, my friend Marilyn began sending me weekly clippings from the *New York Times* weekly *Hers* columns, essays by women about daily life in a man's world.

Reading them today, I am struck by how current many of the essays remain, how well they encapsulate the vagaries of womanhood. Faye Moskowitz and Norma Rosen wrote often about the loneliness of child raising that made me feel less alone, especially as my children were growing up and away from me. One of Moskowitz's explored the notion of "empty nest syndrome" and posited that women actually long for that empty

nest. What they miss is the presence of the companionship of the people who have been raised to be most like her, to share the most interests. Susan Jacoby's essay on the meaning of Feminism resonated then as I began to picture my own independence, and it remains profoundly relevant. She wrote that feminism was "a word with a shady reputation" and that "To a woman who is proud to call herself a feminist, the most disturbing aspect of this phenomenon is not its naivete but its adoption of the age-old patriarchal assumption that a woman who wants the same intellectual, economic, and professional opportunities as a man is rejecting her sex rather than the disabilities imposed on her because of her sex" (April 14, 1983). Patricia O'Toole, with whom I had the honor to study later at Columbia, wrote an essay that reinforced my fear of leaving home and years later reminded me that I had options. "Just as women begin to shed their economic dependence and to savor the luxuries of having their own money, the world makes independence too expensive." And then "College tuition and rent are now so high that a woman who wants to go to school either has to drag things out, a course at a time, or incur a staggering debt" (June 18, 1981). And Carolyn G. Heilbrun, who had been a professor in my under-graduate program, validated my sense that if I held on to my beliefs long enough, my own sense of feminism would prevail. "As every feminist knows, those women who bide their time, and are silent, often live to reap the benefits won for them by others who spoke out and were called strident" (March 12, 1981). The contributors, all established or nearly-established writers, brought a wide variety of perspectives to the columns, and, in less than a thousand words, each column wrestled with one or another of the issues that confronted us daily.

Marilyn and I have lost touch. Those clippings, however, lie in my filing cabinet, inside a decayed envelope addressed in Marilyn's hand to my Phoenix home. They constitute my awak-ening. Not to the condition of being female. But to the need for community.

I was born just six years after my mother lost her only brother. He had been the light of the family, a devoutly wished-for addition, born in her sixth year of life. When I was very young, I thought the loss of the brother John was her greatest tragedy. It was the one she freely spoke about.

John was nearly fifteen, about to become the youngest Eagle Scout in New York State. On the day before Mom's 20th birthday, my grandparents went to a film. John did not want to go and stayed home to care for the family's small dog. When a strange dog came menacingly into the yard, John attempted to shield his pet and was fiercely bitten. A neighbor rushed the boy to the hospital, where, bleeding profusely, he required stitches. The offending dog's origins were unknown, so the doctors automatically administered the first in the anti-rabies series. Before my grandparents could reach the hospital, John was dead of anaphylactic shock.

I understood that my mother missed her brother terribly. One of the few things she shared with me as a child was that she had great guilt where John was concerned. Oddly, though I don't remember it precisely, she must have equated his death with that of her favorite uncle, who died in a concentration camp, because for many years I imagined my Uncle John dying in a shower of gas. I am guessing the connection came from his having been far removed from her. She was away at the University of Vermont, and he was in Kingston. There was no opportunity to say goodbye. With every passing year that he was gone, my mother, her sisters, and their alcoholic mother painted John as ever more brilliant, handsome, musically talented. My cousin Johnny, born 8 months after I was, looked like his namesake. The women doted on him. He was loved. I was another girl.

If the family had a predilection for male offspring, I reasoned, it was understandable. My grandmother often told the story of the

long, agonizing wait for the boy to carry the family name. In fact, when my mother was born, my grandparents' third daughter, her father left home. Dejected and disappointed that he had not achieved a male offspring, he packed himself off to Paris and stayed there for six months.

His unfathomable insensitivity became clearer to me with every telling of the tale. That he was narcissistic enough to believe he had the right to do that was bad enough. Worse, though, was that the family made a great joke of it. As soon as she could understand what they were saying, Mom knew the story and understood that she was the butt of that joke. "Daddy didn't want you so he left us for six months to punish us all." What a riot.

Even after his return, my grandfather pined for a son. In an effort to curry his affection, my mother took to dressing and acting like a boy. She said she was relieved when John released her from the burden. I know better. On the day he arrived, she was cast aside, and she never forgave herself for not being a real boy. That was the lesson she taught me. It was her fault she could not please him.

Of course, my family was only following established cultural norms. Boys were far more worthwhile to most of their contemporaries. Their preference for boys, their hyper-protectiveness of their sons may have been exacerbated by the death of the golden child, but girls would have been of limited value in any case.

My fourth grade teacher Miss Smith called me out on this. I had written an essay about how my brother David was nearly deaf and required special care. He was in Kindergarten in the same school I attended. My mother expected me to watch over him when we were at school. If he were in any kind of danger, I was to drop whatever I was doing and run to him. Miss Smith had seen me in action on the playground on the first day of school.

David and I were waiting for the first bell so we could go inside. He was bored with standing around and went to play on

a jungle gym. The bell rang. He didn't hear it. Miss Smith, whom I only knew as the school principal, came out and called us inside. "Kindergarten boys and girls, that bell means it is time to come into your classroom," she barked. David ignored her and kept on playing. She repeated her statement, raising her voice several decibels. Still, he ignored her.

Standing in line, I tried to get his attention. I was afraid to move. Miss Smith's fury had a reputation for being frightfully mean. In the end, I had no choice.

She called him a third time and walked over to where David was playing, where she grabbed him by the ear. In a flash, I was at his side.

"You let go of my brother's ear," I demanded. She did. We stared at each other. I was terrified. She dismissed us all to our respective classrooms. I was shocked to learn that the classroom to which I had been assigned was Miss Smith's.

I feared retribution. Instead, I became her favorite.

Miss Smith looked like a storybook witch. She was wrinkled, and her mouth was frozen in a wizened snarl. She was said to be merciless, unforgiving. To me, she was protective, encouraging. When I was clearly bored with the busywork of social studies workbook activities, she sent me to the library to find information and write a report on the Mayflower. When I seemed irritated by our spelling exercises, she asked me to use the word list to create a poem. I adored her.

The day after I turned in my essay about my brother's right to special treatment, Miss Smith called on me to read the paper to the class. Afterward, she asked me to remain after school for a few minutes.

"Carla," she scolded me. "You must learn to value yourself more than you value your brother. Do you think he deserves better than you?

"I don't know," I stammered. "My mother says . . . "

"Your mother needs to know this too, my dear. You are an individual. You are smart, you are strong, you are important. No

one should force you into a shadow. You must stand in your own light."

I put her advice to action. But I never took it to heart. I was good at creating my own light, at being different, at standing up to authority. But I was terrible at respecting myself. It took me 60 years to really understand what Miss Smith was trying to tell me.

Feminism didn't help either. Even at age 27, reading an essay by Letty Cottin Pogrebin, who wrote that objectivity was impossible for a true believer in women's rights, I wanted to remain objective, secure in my individualism.

DREAMS DEFERRED

Richard and I celebrated our graduations in 1973 by making a trip to Europe. Our belongings were already in boxes stored in his parents' garage in Clifton when we walked out onto Broadway one early rainy morning at the end of May to hail a cab to take us to the airport for our flight to Luxembourg. I stood on the corner of 112th Street and Broadway, reciting to myself, "*Il pleut dans mon coeur comme il pleut dans la ville. . .*" melodramatically weeping while Richard uncharacteristically ignored the storm and found a cab. This man, who usually melted at the hint of a single raindrop, was exuberant. He was thrilled to be leaving the city I loved.

From the moment we got to the plane, however, the tables turned. The trip itself was difficult with delays and baggage mix-ups, and Richard's inner crank emerged. He complained incessantly about everything we encountered. The food, the people, the smells, the heat, the cold, the water.

In Italy, he never stopped grinding his teeth. "How does anyone live here?" he screamed over the traffic noise in Rome's Piazza della Repubblica.

"What do you mean?" I laughed, determined that my pleasure would not be derailed. "It's just like home."

"Exactly," he screamed back. "Why travel thousands of miles just to land back in the middle of a deafening cesspool?"

We stayed in inexpensive pensions wherever we traveled, which sometimes meant the beds were uncomfortable. In Venice, where we stayed in a convent, we had single beds, and he was too tall to lie flat on his. "Catholic revenge," I joked, thinking he would laugh as he usually did at my humor. "The apostate's feet must dangle painfully such that intercourse may not occur."

He did not laugh. "Are you crazy," he raged. "You honestly think. . . ."

I buried my head under a pillow so I wouldn't have to hear whatever his rant turned out to be.

In Austria, my mother's cousin and his wife treated us like visiting royalty, and Richard drank it in with gusto. We stayed in their spacious apartment in a Baroque building whose outside was an array of complex, dramatic forms – opulently decorated columns, a dramatic entranceway, and a circular lobby. A spiral staircase wound its way to the top of the 6th floor, at the center of which was a huge skylight that shone sun or moonlight onto a tiny, self-operated, cage elevator that took us to their 5th story apartment with its high ceilings and sprawling views of the city below. Inside the apartment, every room had a grand fireplace, none of which was lit but all of which gave a sensual charm to the place. Our room had an art-deco bedroom set–a 3/4 -size bed with a diagonally banded rosewood, teak, and mahogany frame that was polished until it fairly gleamed and a matching dressing table, mirror, and chest of drawers. I lay there each night imagining my mother in just such a bed when she was a teenager before she had to leave the country she thought was her home.

We drank local wine, ate Wienerschnitzel, and sang with the natives in the Grinzing. We took a drive to the top of the Kahlenberg, and we walked around St. Joseph's, the Polish Catholic church where the Viennese still celebrate their defeat of the Turks in the 17th Century, a defeat they never would have accomplished without their Polish allies. My cousin and his wife spoke

good Polish, and Richard was able to employ the bits he had picked up over his lifetime to communicate with them.

It was a happy reunion.

He had an equally great time in Samobor, a quaint village outside Zagreb, with the people who had been the house staff when my mother's family lived in the city. Although the day did begin with a fight.

I had no directions as to how to find the family we were seeking. I only knew they were a small family, the head of which was a man named Milivoij, and they lived in Samobor. I knew enough Croatian to find us a bus and get us to the town, and I trusted that I had enough words to ask directions once we got there. Having grown up in a small town, I was unintimidated by the prospect of conducting a search. Richard, on the other hand, was a wreck.

We had spent the night on the train from Vienna, sitting in second class, dozing as best we could. I bounded off the train, thrilled at the idea of new adventure.

I held out my hand to Richard and was startled to see terror in his eyes. "Oh, sweetie!" I tried to be conciliatory. "You look like you're about to face a firing squad. Cheer up. I bet this'll be fun."

He groaned. "You don't even have an address!"

He was right. I didn't. I believed, however, that we'd figure it out.

At the bus depot, I went to the ticket window and asked the agent if he knew where I might find Milivoj. He laughed.

"Over there. Across the street. You see that little house with a fence in front of it? That is Milivoij's house. That woman feeding the chickens? That's his sister.

"See?" I crowed at Richard, "It's a miracle."

He shrugged, lifted our suitcase, and followed me across the street.

In front of the house, I froze for a moment. I had seen photos of this woman as she looked in 1939, when the family left

Zagreb. I had heard stories, knew she and her sisters, originally from Slovenia, had come to Samobor when the oldest sister married Milivoj. The family had saved my mother's family in multiple ways over the years. For me, this was like meeting Wonder Woman and Batman and Mary Poppins in the flesh. I didn't know what to say.

"*Um, ja sam. . .* " I could not find any words in Croat. ". . . *obitelji Robinson. . .* " They stared at me. I thought perhaps I had the wrong house. Then, I blurted, " *uhh, kći Lotte. . .* " And suddenly, at the mention of my mother's nickname, the woman threw down her chickenfeed, ran toward me screaming, "Lotte, Lotte. . ." and calling to the others inside. I was engulfed in a group bear hug, all of us weeping with joy as they now whispered over and over, "Lotte has come home."

When they relaxed the hug, Milivoij said in perfect German, "We never expected to see a child of Lotte's. She was our favorite. We still miss her as though she were our own little girl. Thank you for coming."

Then, he clapped Richard on the back and said in very halting English, "You we welcome too. You are husband?"

I made the introductions, and Milivoj said something to Richard that Richard deciphered, thanks to his Polish background. I watched a grin crawl across my husband's face, a grin I had not seen since we left New York. Suddenly he relaxed and so began a few glorious days in the Croatian countryside.

The family wanted us to see every vestige they could conjure of what had been my mother's family's life. They drove us to Zagreb, where they pointed out the street where the Robinsons had lived. "I can't go there," said Milivoj. "It makes me too sad." Instead, he veered from the center of the city to another outskirt. There, he parked in front of a huge industrial building.

"*To je,*" Milivoj said proudly, pointing to the front steps, "*djedova tvornica,*" and before I could conjure the translation for Richard, he said, "Your grandfather's factory!" We went inside, and Milivoj pointed out the space where he had his office. He

stood there a long time, gazing wistfully. *"Dobar čovjek,"* he whispered, nodding. "A good man."

He and his sisters took us to a restaurant my grandparents favored all those years before. It was on a gentle, grassy green hill by a bubbling, gurgling stream, a local spot where the working folks of Samobor and its environs congregated for leisurely meals. We sat, and Milivoj went to a spigot, where he filled a carafe with wine. He poured each of us a glass, and we toasted the family. *"Robinzoni, pozdravljam vas!* Robinsons, I salute you." The wine was perhaps the best white wine I have ever had. A nearly sweet local wine with no mustiness, only clear, fresh, grapey flavor. We drank a lot of it that night. Along with the wine, we had trout that Milivoj selected and the owner of the restaurant captured with his net for his wife to sauté in olive oil and wine. I never liked trout, and I have never liked it since. But that night, I could not imagine any food as desirably delicious.

Milivoj and his sisters treated us both like prodigal children, showering us with love and regaling us with stories about my mother and her sisters as children. "Did you know that Lotte played the cello?" Milivoj asked. I nodded. "I drove your grandfather to Vienna to buy her cello. Never have I seen such joy as hers when he brought it to her." "Ah, Richard, you are an engineer. You and Lotte's father would have much in common." They wept with us over the sad stories, laughed with us at the antics of the rambunctious Robinson children, and waxed nostalgically deferent as they spoke of my grandmother. "You have chosen a special family," Milivoj told Richard.

Richard responded to the family, to their stories, to their hospitality with warmth and grace and as many words in Polish as he could muster. In that moment, Richard was the delightfully bright, engaging young man I'd fallen in love with. If this was where he resided, I wanted to stay.

We had to leave.

My friend Janet, with whom I had studied Serbo-Croat the

summer before, was meeting us in Dubrovnik, and we had promised to go with her to Belgrade. As soon as we were on the train, waving goodbye to Samobor, the air became gloomy once again.

We traveled by bus to Mostar first, a lovely little city on the Neretva River in Bosnia-Herzegovina. Richard walked with us one day and admitted that the Stari Most, or the old bridge, a living relic from the Middle Ages, was beautiful. I was captivated by that bridge. That it had survived over years of wars among the South Slavs, invasions by the Ottomans and the Austrians, floods, and earthquakes seemed impossibly miraculous, and I was transfixed. Richard was hungry. We went to a local store for food.

In the little market, we chose our items, food we could eat in our little rented room in order to avoid restaurant costs. I felt playful. Knowing that in Bosnia-Herzegovina, there are three national languages – Serbian, Bosnian, and Croatian – I asked aloud whether I should ask for "*Hleb*" or "*Hljeb*," or "*Kruh*." The vendors and the customers then began a lighthearted competition, calling out the three words and laughing at the sound of them echoing about the store. Janet and I reveled in the moment until we looked at Richard and realized he was mortified. We erased our laughter and slinked back to our room to eat our *Hleb/hljeb/kruh* and *sir/sira/sir* (cheese).

In Belgrade, Janet and I were assailed or ignored because our language pronunciation was clearly taught by a Croat. We wandered the streets, explored the garbage-polluted ruins of Kalemegdan Park, quoted Janet's husband who delighted in the fact that the word for restaurant looked in its Cyrillic form like *Pectopah*, and battled bed bugs in the little hotel we'd chosen. We could not wait to move onward. We traveled by train to Germany, where we said goodbye to Janet, who was flying home from Munich, and continued on to Amsterdam.

In those days, Americans could buy an unlimited rail pass to travel in what is now the EU for $50. The pass was not good

in Yugoslavia, but train travel there was cheaper than New York City buses. We rode as second-class passengers, which meant no sleeping cars or reserved seats, and sometimes we had to take overflow spots outside the seating areas. When I had traveled in Europe by myself in 1969, I had loved the trains, especially the overflow area conviviality. I had great conversations in multiple languages, ate food proffered by generous strangers, and shared my American idiosyncrasies with inquisitive acquaintances. Glorious. But traveling with Richard on the same trains was excruciating. He scowled and treated all overtures as impositions. He snapped at me if I spoke to him. He complained about the seats when we had them and the train floor when we didn't. Consequently, I spoke to few people, shared no food with anyone, kept as far from interaction as I possibly could until we got to Amsterdam.

Where Richard finally emerged from his sulk. Until then, we just went through the motions of visiting Europe.

Though we had put aside plenty of money to splurge occasionally, his penny hording limited where and how we ate or slept. For the most part, I was fine with all of it. Fancy hotels repelled me, and I found it romantic and artsy to rely on fresh bread loaves and local cheese, sardines, tomatoes. But sometimes I would watch diners in outdoor cafes savoring local specialties and find myself drooling involuntarily. In Paris, eating the cafeteria meal that came with our room, I got my first and only case of raging dysentery. The city I had expected to love most on our journey made me sick. I've been back a number of times, and the smell of the city still makes my bowels creak.

In Holland, however, he relaxed; everything there was much more "American" seeming. "Finally," he sighed when we awoke beneath the cozy featherbed in our Amsterdam pension. "Western civilization." The lighting was brighter; the museums were larger and smelled less like mildew. We found supermarkets with multiple choices of bread and cheese. We could even

opt for tuna instead of sardines. Moreover, he said, the people stared less.

Yet even in Amsterdam, or perhaps especially in Amsterdam, he clung to his Bible: our copy of Arthur Frommer's *Europe on Five Dollars a Day*. We had found our pension, a stellar discovery, in the guidebook. The room came with a sumptuous breakfast, portions of which we were able to wrap and carry with us to savor for lunch and dinner, which meant Richard never had to lay out food money. On our third day, he was so sated and relaxed he suggested that after we visited the Van Gogh Museum we should treat ourselves to *Rijsttafel* at the Indonesian restaurant that "Uncle Arthur" recommended. That was a night to remember.

Rijsttafel, which in English means "Rice Table," is a uniquely Dutch way to experience Indonesian food. Forty separate dishes, served in side-dish portions, comprise the main meal, which is served with an accompaniment of rice made in several styles. The focus is food prepared with a flair for multiple tastes and widely varied colors – it's most popular dishes include egg rolls, sambals satay, an assortment of fish dishes, fruit, vegetables, pickles of all sorts, and nuts. It is a food experience that resulted from colonialism but can be found wherever Indonesian restaurants abide. For us that night, *rijsttafel* made for a sensual date, the first truly satisfying meal we had bought abroad, and a reason to celebrate. When we got back to our room, we were so enchanted that we actually enjoyed sex for the first time since we had landed in Luxembourg. That night, unlike too many of the nights we had spent in Europe, we both desired to keep the pleasure going just as long as we could.

Frommer stood us in good stead as we proceeded north. "It's good to be back in familiar territory," he exclaimed in Frankfurt or Hamburg or whichever German city we coursed through en route to Norway. For me, however, Germany remained terrifying.

In my early childhood, when my family was in the process of

finding their lost relatives and friends, even before I had any real knowledge of what they had escaped, the images their German-language shock and dismay conjured bored into my conscious-ness in vividly ferocious colors and shapes. I cannot identify how or where I heard the sound of European sirens and deduced their intimidation, but by the time I got to Germany in 1973, I had seen plenty of movies and had read plenty of books to augment what my brain had called forth. I was not entirely surprised when I could not sleep in Germany. I understood what kept me awake.

I lay there next to Richard troubled by the siren sounds outside our windows. I'd close my eyes, and the omnipresent movie versions of WWII would play relentlessly under my lids. I'd feel the earth shake, hear jackboots in the hallway and dark, male voices shouting, "*Juden heraus!*" I wanted to wake Richard, ask him to protect me from the demons I was imagining, but I knew he could not deal with any reference to the so-called Holo-caust. I had learned that back in New York.

Soon after we were married, I was wakened by a recurring dream that had terrified me since childhood. I woke Richard.

"What's wrong?" he asked.

"Nazis. The old dream. They've come back to finish with us. We can't get away this time, and . . .

"Go to sleep. It's just a dream."

"I'm scared. Please let me tell you the rest."

"I can't. Father O'Brien made us watch *Night and Fog* at Regis. It's too depressing."

There was no use arguing. Alain Renais' 1956 film, which documented abduction and torture of Jewish prisoners in Auschwitz and Majdanek, two of the Third Reich's most noto-rious concentration camps, was torturous. I had by then seen the film at the Elgin, the NY art house cinema I often frequented. Richard was right to feel violated. The movie is relentless, harrowing, a harsh lesson to expect privileged youngsters with no prior background to take in. Like everything else I devoured

on the subject, this one only fueled my desire to see more, read more, know more. Richard's sensibility was virginal, raw. He shied away from tales of horror. He refused to watch the evening news because the images were too brutal. I understood and left him alone whenever the nightmare returned.

Nor did I complain about the pigeons pooping on me in Oslo though I devoutly wished to be back in Italy. Or Yugoslavia. Richard loved Scandinavia. While I loved the cool air, I found the cold people and omnipresent pigeons intolerable.

Richard was more buoyant, more upbeat during this part of the trip. It was, by then, mid-summer, and the sun was nearly omnipresent. The language on signs and shop windows was decipherable because of the plethora of English cognates. In Copenhagen, he was delighted that we found a room with a family whose grown daughter offered to guide us around the area. She narrated the tour, and her 5-year-old daughter translated visitor information into perfect English. They fed us breakfast and dinner and treated us like old friends of the family. We visited the Frederiksstadden harbor area and the two royal palaces, feasted on international dairy products, and waved to the Little Mermaid. In Norway, we took the spectacular train ride from Oslo to Bergen. Richard was thrilled with the Grieg Peer Gynt Suite and the sight of glaciers and fjords. I was fascinated but grew weary of the midnight sun and the endlessly looping Grieg.

Then, the money issues kicked back in. Richard began to complain about the price of bread and cheese. After Copenhagen, we were no longer able to augment the sandwiches with tomatoes, which were too expensive. Instead of cheese, he insisted on cheap sausages, which were, I was sure, pure pork meat. Repulsive. I loved the bread and was happy to eat it without adornment. That made him angry. "You want to guilt me into overspending?" I did not.

By then, the trip was nearly over. We wended our way back to Luxembourg, where, because our flight was delayed, Icelandic

Airlines treated us to a buffet luncheon at the local Holiday Inn. I watched Richard gleefully navigating his way through mountains of meats and cheeses, salads and side dishes, desserts and fruits, gorging himself on culinary delights he would never buy there or at home. The delay was of no consequence to him, and his mood lightened.

Back in the US, we stayed at his parents' home for a few days while we readied ourselves for the move to Santa Barbara. I worked hard to keep busy enough to have little or no interaction with the family. His mom spent all her time cleaning and cooking—she ritually began prepping dinner in the early afternoon and resolutely overcooked every morsel of food. Richard's father was still a few years from retirement, so he left before dawn to reach his office in downtown Manhattan before 8:00 AM, and he rarely returned home before 8:00 PM. He was kind enough to hire a bargain basement moving company to load our bigger belongings into a van, which they promised would find us in California within the month. Smaller stuff fit into a U-Haul trailer that we would pull across the country. Richard was endlessly agitated about our move, but all the while he regaled his family with reports of our fabulous sojourn in Europe.

Something was suddenly clear to me – something I came to disdain later on. Richard was thoroughly able to enjoy travel retrospectively. Though a finicky, easily-panicked, whiney traveler, when a trip was over, he would wax joyously about what a great time we'd had. Moreover, I irritated him endlessly. I love – have always loved – everything about traveling, including the discomforts.

The night I was so sick in Paris, after I finally fell asleep, Richard nudged me awake.

"You see why I hate going anywhere? It's inevitably gonna make someone sick."

" A little sick in Paris is worth the trouble," I said without hesitation. "I'm in Paris! I'd rather get sick trying the food in a new city than be home in a suburb watering the lawn."

"Nothing wrong with lawn watering," Richard muttered, turning over and shutting his eyes. Clearly, my answer only exacerbated his misery.

Another schism between us, which should have been obvious. It remained unconfronted.

Santa Barbara was immediately a disaster.

In the years I had been living in New York before I moved in with Richard, I often felt held back by my unfinished education, by my lack of self-confidence, by a shortage of skills. But I had never felt the sting of misogyny. In fact, I was more likely to feel rejected by women my own age. I was a guys' gal, whose friends tended to be men, and, for the most part, I felt I got fair and equal treatment. California was a wakeup call. The reality of antifeminism slapped me in the face the moment we entered the Golden State.

But first, we had to contend with the fleas.

Until our boxes and furniture arrived from New Jersey, we slept on the floor on foam pads my mother had covered with upholstery fabric for us. We both awoke abruptly in the middle of our first night, itching miserably. I called the local animal control center, and the man there laughed at me. "Sorry, little lady, but you prob'ly have fleas. Or – and don't take this the wrong way – crabs." There was no wrong way to take that. It was a flagrant insult.

After about a week, we figured out that we had sand fleas. Whoever lived in the apartment before we did had had a dog, apparently, and the dog had brought companions home from the beach. The place was infested. So much for the Richard's fantasy about being Moondoggie, chilling near the waves, letting his hair grow long until his inhibitions disappeared. Those were washed away in the industrial spray cleaning we had to give the place after its fumigation.

That crisis had abated by the time our furniture – our bed!! – arrived.

A good night's sleep did not soften the blow of my first encounter with job discrimination.

I had applied for admission to UC Santa Barbara, where Richard was enrolled. They had no program for me. The regents suggested in my rejection letter that I look instead to UCLA or Berkeley. Undaunted and fortified by the fact that I had just worked my butt off to obtain a bachelor's degree from one of the best schools in the country, I went looking for a job. There weren't a lot of those for someone with my skills . . . or lack thereof. We were in Santa Barbara. It was humbling to learn that no one cared that I was a Columbia grad.

Finally, the perfect job for me presented itself at UCSB, a job writing press releases about notable members of the university faculty, the same job I had done for three years in the Dean's Office of Columbia's Engineering School. I made it through three rounds of interviews, but in the end the director of the program told me – people could get away with such things in 1973 – that while they thought I was a great candidate, they preferred to hire a man.

A week later, I took a job as a circuitry tester at an electronics company. I sat at a counter in a warehouse all day, touching probes to metal parts, watching for the light to activate so that I could throw away the parts that failed to elicit that light.

There were mice in the building. Though a dedicated rodent-phobe, I was grateful. My abject fear mitigated the head-cracking boredom. It was a job, I reminded myself, and we needed an income.

The California Department of Motor Vehicles wielded the next sharp blow, and it, too, smelled of misogyny. In order to transfer my driver's license from New York State, I had to take a driving test. That in itself was demeaning. I had learned to drive in an Adirondack winter. I took the test for my operator's license in a full-blowing blizzard and had, thereafter, commandeered my father's vehicles all around the North Country through ice and snow, driving the length and breadth of New York, New

England, and New Jersey since I was 16. Driving was something I knew I did well. The officer administering my test took one look at my license and sneered, "Well, young lady, your address here says 251 West 18th Street, New York, New York. That's New York City, isn't it? "

I hated being referred to by the word "lady," especially when it dripped of condescension as it did then. Still, I mustered all my pride and put it in my voice as I answered affirmatively.

"Well," he said, shaking his head in disgust. I felt the word *lady* emerging from his lips again. I was right.

"How is any lady driver gonna make her way on the freeways we got out here? You don't have much 'sperience drivin' on superhighways."

I was aware of the California anti-NY bias, but I was feeling an especially vibrant misogyny vibe. I should have said something self-deprecating, even apologetic. I was never good at being demur, at letting things go. I realize now my whole life could have been a different trajectory if I had been more socially conscious. However, instead of doing the right thing or what might have been the right thing at that moment, I defiantly replied, "Well, I wouldn't call the New Jersey Turnpike or the Long Island Expressway country roads!"

I failed the test. The report said I used no turn signal, which was a lie. I was supposed to surrender the license, wait some weeks, then re-take the test. Instead, I tucked the precious New York State affidavit into my pocket, got back in my car, and drove home. I'm not sure what would have happened if I had ever been stopped for a violation after that, but I wasn't.

Meanwhile, Richard didn't want to admit it, but he was as much out of place in his program as I was in the community. He had never had anything less than an A at Columbia in the five years he studied there. At UCSB, he had a hard time cracking a B-. He was oriented toward analytical thinking; at UCSB, they concentrated on nuts and bolts.

Still, we were young and married, and we worked everything

out in bed, which unfailingly revived our commitment to each other. We were absolutely compatible there. So long as we were horizontal, our relationship was perfection. We had proven that to ourselves in Europe. When the going was toughest, the sex was the ointment that soothed the marriage's cracked and bleeding skin. Again in California, no matter how awful the day was, we could count on the fabulous high of orgasm to reconstitute our faith in our union. The more out of sync we were, the more fervent the love-making.

At the end of the day, having shot multiple barbs at one another over dinner, Richard would retire early. I would stay up to clean the kitchen and sit at the table to write one of the myriad letters I wrote in that period, letters to my parents, my siblings, my friends who were now reduced to pen-pals. Eventually, I'd crawl into bed and lie inert, clearing my throat, sighing heavily until Richard paid attention to me. At which point, I would challenge him.

"You were going to go to sleep like this?"

"You never said good night."

"I wasn't ready to go to bed yet."

"I was."

"Okay, but you could have said something. Could have tried to make up with me."

"What? You want me to say I'm sorry? For what?"

"That's not what I said. I just think you could have. . . . "

We would spar for another ten minutes or so, and then one of us would initiate a kiss, and then . . . well, I don't want to embarrass my children, grown though they are, but that is when our marriage came alive. And I suspect that is where our resolve to remain married always resided. It could never be this good with anyone else!

But the light of day brought with it the inevitable anti-climax. There was more and more to contend with in our vertical lives. Richard was nearly as unhappy as I was, and we fought terribly. One afternoon, I dropped a sandwich I was eating, and he yelled

at me that I was a careless idiot, that I was wasteful. Thence followed a screaming match that ended in his throwing a coffee mug at me; it missed my head and shattered at my feet. I retaliated by pushing over our flimsy bookcase, and its over-loaded contents crashed dangerously all around the room, hitting knick-knacks, drinking glasses, dishes, anything in their path, breaking several. We were definitely on track for disaster.

So we decided to have a baby.

IN EXILE

I didn't expect to become pregnant the minute I had the IUD removed, but that's exactly what happened. We needed to make adjustments.

Richard had decided by then that he was through with the Ph.D. altogether, and I begged him to consider moving us back East. He agreed. East it was. To Phoenix, Arizona.

"Phoenix?" I moaned when he suggested it. "But it's in the desert."

"So?" He cajoled. "Your whole family is there."

Richard loved my family. My mother treated him like royalty. My father never tried to run his life, and my siblings adopted him as their big brother and savior from failure in math.

I loved my family, but I longed to be back in the land of distinct seasons. And I wanted to be a writer. Having lost my bid for the sanctuary of an academic position, I wanted to explore the possibilities of a career in freelance writing. Or journalism. Even when I was applying to graduate schools, I had made it clear that at least part of my motivation was to be in a profession where I had to publish or perish. Richard was aware. We had discussed my ambitions and desires *ad infinitum* over the nearly

three years we had been together by this time. Richard abso-
lutely knew that therein lay the key to my capitulation.

"I'll get a job," Richard promised. "So you can write. Trust
me. As soon as we are settled, you can spend all your free time
writing."

At that moment, the prospect made sense. I'd have my
mother and siblings to help me. My aunts and cousins would be
near enough that my child might have the same sense of family
protection I'd had in my early childhood. And I would most
assuredly have the time and the freedom to spend some hours of
every day writing to my heart's content. I was in.

We stayed with my parents while we looked for jobs and a
place of our own. More accurately, we stayed with my parents
and the four of my siblings, who were still teenagers, living with
them. During my third month of a difficult pregnancy.

I was so seriously ill with morning sickness that my doctor
put me on medication that made me want to sleep all the time.
Sleeping was not an option. I had to substitute teach to generate
income while Richard hunted for a job.

He too tried subbing, which would have allowed him to earn
and keep searching. Subbing was not for him.

After one day of working in a high school math classroom,
Richard came home in tears, actual, heart-wrenching, full-blown
tears. Seeing a man cry was usually a turn-on for me, as I was
definitely a sucker for men with poets' souls. At that moment,
feeling heavy with child and exhausted at the end of a gut-
wrenching day of my own, being asked to vow never ever to ask
anything like that of him ever again invoked my contempt. I was
no happier with subbing, and I had had no fewer nightmare
moments. Since I did not have a master's degree in engineering,
I had few options. In any case, I knew that we had to have an
income, so I shrugged and said nothing more.

I persevered and eventually developed a certain facility for
teaching, even subbing. In those early months, working made
me even more sick and more tired, and I was almost perpetually

in a foul mood, which took its worst toll on my mother and siblings. Miserable and in a constant state of agitation, I took any bait proffered, rose to any challenge to be defensively aggressive.

One of my sisters was so enraged that I wasn't being nicer to her that she stole our belongings from our room and hid them, taunting us when we could not find them. My father took out his frustration at having us there on my mother, yelling at her, making unreasonable demands. Mom stayed away from home as much as she could, remaining at her sister's house for days at a time. When she did return, we all engaged in yell fests, picking fights just for the sake of expiating our mutual irritations. I stopped bothering to keep a journal. Writing was the last thing I felt capable of.

Even with a Master's in Engineering from an Ivy League school, Richard did not find a job for nearly two months. Every day, he would don his skinny pencil-bottomed, too-short black slacks and his plaid cotton sports coat, whose sleeves barely reached his wrist bone, and he would go to whichever companies might be looking for a mechanical engineer with a specialty in heat transfer. Every evening, he would return to my parents' home sullen, worried, and confused. He could not understand why no one simply took him on the spot. When he was finally hired by a large aerodynamics firm, there was little relief at first.

The time had come to find a house of our own.

We had no money. None. The job Richard found was a good one, but in those days, without collateral, there was no mortgage to be had. We needed very little, as houses in Phoenix were pretty cheap. Great houses were going for under $30K, and a down payment of $1,000 would have qualified us immediately. We looked at houses all over the Valley of the Sun, but, without that down payment, there was none that would have us.

I badgered Richard to ask his father. I hadn't told him about the $25,000 offer to walk away, but I figured if he had that kind of money, then maybe he'd help us now. After a week or so of fighting with me about it, Richard finally picked up the phone

and dialed the long distance call. His mother answered and grilled him for a few minutes before finally relinquishing the receiver to her husband. I sat next to him, eavesdropping, and it was all I could do to not scream into the phone at the despicable bastard.

"Dad!" Richard stammered. "Hi. No, nothing's wrong. Yup. Everything's fine. Nope. Job's great. I'm doing some good --- What? No, I don't need you to call them. It's – What? Okay. No. What I called about is I was hoping I could borrow some money. No. Not much. See, if we could borrow $1,000, I could pay you back within the year, and we could. No, I didn't. You're right. Okay. Bye."

"What'd he say?" I asked, knowing full well we'd been turned down.

"He said he won't jeopardize his retirement or my sister's wedding.

"Shit," I fumed.

"He said you should get a job if we need money so badly."

He was so sanguine about the experience that I wanted to punch him. Later, I realized he was repressing emotions – Disappointment? Jealousy? Anger? I could not be sure. What I did know was that his rages, which had been intermittent at worst, began to unleash themselves daily. Whenever we were alone, he found a way to belittle or hurt me. He blamed me viciously for the disconnect with my sister, for any mistake I made as a substitute teacher, for the mud caked on the body of our car.

"Why can't you go to a car wash? Are you deliberately trying to wreck the car's exterior?" The insults and the berating sound feckless in retrospect, but I was fragile. I slept little and worked much, and he knew it. I admit I overreacted. At the time, I was spent and had no tolerance for his displacement.

Finally, my grandmother solved our dilemma. My grandfather had died the year before, and their house in north Phoenix was too big for her to live in alone. My oldest cousin had built

her a little cottage on his mother's property, and another cousin was occupying the vacated house, abusing it.

Since the cousin living there was about to move to Tucson to attend the university, Grandma was loathe to spend money repairing the myriad damages. She asked us if we would take the house on as it was in return for which she would loan us the down payment and would provide the mortgage on a price that would have been a good price in 1955.

Thus, we ended up on Yucca Street, in a house that was subsumed in the 1990s by the Phoenix Freeway frenzy. It was a cute little place in a typical middleclass Phoenix neighborhood not far from my mother's younger sister. It was a single story, flat-roofed house with three bedrooms, a large living room with a vaulted ceiling and cathedral windows that minimized sunlight, two full baths, and an open western style kitchen/family room/dining area that looked out on a quarter-acre plot of land. Eventually, we reasoned, we could add a pool, and in the meantime, there was ample room for a dog and a child to romp and frolic around the clock.

My parents and siblings expressed joy. They were delighted to have us near to celebrate holidays and attend events with them. But Mom made it clear to me that she was not to be counted on for child care assistance. "I raised my seven, Carla. It is my turn to pursue a career, and I will not sacrifice my teaching to be at your beck and call."

I laughed. Of course not. It was preposterous to expect that of my mother.

My grandmother was pleased. The move and her assistance cemented a new era in our relationship. We were adult women who could talk openly to one another. She was never going to be the nurturing, adoring grandmother I might have wished for, but she would help where she could, and all she asked was that I visit her regularly.

My siblings all thought they loved the idea of having a niece

or nephew or both to play with. But they were busy being teenagers. In school.

From the day we moved into Yucca Street, it was clear that I was on my own. A serious writing career would remain back-burnered for at least the foreseeable future.

And so, we awaited the birth of our first child as our so-called "wedded bliss" began in earnest in a culmination of compromises.

HAVING BABIES

Growing up with seven siblings meant I was never alone. There was no such thing as privacy. For my mother, it was even worse. She was constantly on call, forever demanded, incessantly accompanied by some needy personage. *Damn procreation*, I thought. It robs you of yourself. By the time I was thirteen, I was absolutely sure I never wanted to be a mother. My resolve seemed firm.

When I was 26, however, the cervical dysplasia I'd had for a few years showed readiness to burst into a full-bodied carcinoma. It had been a non-threat until then – cervical warts that I'd had removed, slightly elevated numbers on pap smears. But at my annual gynecological visit that year, my doctor told me my cervix and uterus would, in the not too distant future, have to be removed. Therefore, if I planned to have kids, I should get to it. It was unlikely I would keep my reproductive capability past my thirtieth birthday. Suddenly, the idea of children became less abstract than it had ever been before, and I surprised myself by falling backward into basic instinct. Despite my passionate decision to eschew motherhood, I realized for the first time that I actually wanted children.

What had changed me?

Roe v Wade was passed into law a month before I conceived for the first time. I was aware even then that the journey to legalized choice had weighed heavily on my consciousness. That I suddenly wanted children had everything to do with the exercise of choice, which had become especially precious to me when I was a very young woman. I had learned then from my friend Julie, a coworker in my last dead-end job, with whom I had formed a deep friendship, how extraordinarily important it was for women to have dominion over their own bodies. That I might be robbed of mine was unthinkable.

Julie lived in Bay Ridge, Brooklyn, with her little daughter Addy, who was just 4 when I met them. Julie and I were both 20, but Julie was years older in many ways. She was far more mature and responsible. She had to be. Addy was entirely dependent on Julie for everything.

Julie had a volatile relationship with Addy's father. The two were in a perpetual dance of abuse-your-partner, forgive him twice, shuffle off to beddy-bie, and do-si-do again. It confused me endlessly. Why Julie didn't just tell Rocco to get lost was incomprehensible. Then, she met Josh, and I was sure Rocco was gone for good.

Josh made Julie happy. Julie made Josh happy. He was a musician, a stoner like she was. He was gentle, supportive, kind. He adored Addy. Their names sounded so cute together. Julie was delighted when she became pregnant with Josh's child. She was sure her happy-ever-after had finally begun.

One morning shortly after she shared the news of the impending event, Josh kissed Julie and Addy goodbye, patted the miniscule baby bump on Julie's middle, said "See ya soon," and left to tour the South as the opening act for a well-known ensemble. He never returned. There were no explanations, no final farewells. He simply stopped contacting her, left her, Addy, and her fertilized egg on their own.

Late one night after Julie realized she was alone again, I got a frantic call from her. She was babbling almost incoherently, but I

inferred that the gist was that she had decided she could not have another child unless she went back to Rocco. She conjectured that if she could seduce her ex-husband and convince him the kid was his, he would have two holds on her, and maybe he'd reform. She ranted for a while then hung up on me. I learned later that after a long night of crying and soul searching, she decided to abort.

Abortion was not legal. Julie began a search that spread dangerously into the following weeks. She risked her freedom and her custody of Addy every time she asked another friend or colleague or physician or anyone else to recommend an affordable doctor she could trust to help her. Someone in our office, where Julie worked as a typist, suggested a kindly doctor with a clean, reputable clinic, but the cash required for the service was out of Julie's reach. In desperation, she finally turned to a " gypsy" in her neighborhood.

The woman Julie engaged had no kind of training. She knew some old wives' tales, possessed recipes handed down through centuries of necessity, and one of these she offered to sell to Judy – at a reduced rate – to take on her own. The concoction contained turpentine, bleach, and herbs pressed into a juice Julie forced herself to drink. The cost was considerable – over $300, equivalent to nearly $2500 in today's currency. By selling a television and stalling her rent payment, Julie came up with it.

"She promised me this'd be easy," Julie told me afterward. "I had to trust her."

Julie told none of her friends or family what she planned to do. She parked Addy with her mother one afternoon, stopped by the gypsy's place to get her concoction, and went home to drink it down. When she found herself feeling woozy, she called her mother and asked her to keep Addy overnight. Two hours later, she called me.

By the time I got to Bay Ridge, she was hemorrhaging. Despite doctors' dire prognoses, she lived. Miraculously. The abortion was successful.

I called Julie's mother and exchanged places with her. She stayed with Julie, and I stayed with Addy until Julie was released from the hospital. Weeks afterward, assuming Julie had had time to be introspective, I asked her why she would do such a thing to herself. "I can't be robbed of my choice," she told me. "I'm not in any shape to care for two kids. I'm barely holding on with one. If I had another kid, Addy's life would be ruined."

At the time – late 1968 – Julie's experience strengthened my resolve. I was not going to ruin another person's life, would not add to an over-populated world. I would finish school, become a working writer, write about the Right to Choose, and be an advocate for all the Julies of the country, for whom the government had no right to make choices.

From 1972, though we could see women's rights eroding in certain sectors of the country, we thought we had at least secured women's dominion over reproductivity. We saw conservative Catholic countries like Ireland legalize choice. We warned young women not to take their freedom for granted, but we never thought. . . .

When Roe was overturned in 2022, returning control over our bodies to state governments, many of us wept. As further rights erode, it seems clear to me that women's rights are the canaries in the mines; all the advances we have made in ensuring rights and protections for the LGBTQ community are dangerously vulnerable. I hope our youthful sisters and their minority cohorts appreciate the import of their responsibility to continue fighting for their right to make choices.

MOTHERHOOD

In 1973, I deferred to Richard's future, and in so doing, I lost my resolve. Ironically, I found I wanted children to preserve my own limited range of choices.

At twenty-six, just beginning my second year of a marriage I expected to last a lifetime, I had to admit to myself that I was intimidated by my dearth of options. I never thought I'd want to be a mother, but I had already taken so many detours that my intended life course had changed entirely.

How could I predict what I would regret when I got to age thirty and a necessary hysterectomy? In 1973, when the vast majority of women defined themselves by the number and quality of their offspring, I was suddenly afraid to not have a child. It was not a badge of honor but rather a mark of shame to eschew motherhood. Young women today would not relate to the mindset I had in those days. Remember, until 1972, reproduction was considered an obligation, not a choice. In 1973, we still labored under the oppression of societal expectation that we marry and procreate before we reached 30.

There was a pervasive stereotype in those days of the childless old lady, and I certainly did not want to be one. They were characterized as angry, bitter, vindictive females. Unloved, unap-

preciated, they lacked the attributes of the maternal life and so were incapable of giving affection. They remained unresponsive to the efforts of those who sought their approval. I knew only one childless woman who had crossed the threshold into middle age. Her name was Miss Bliss, an old friend of my dad's, who knew his sisters and seemed to adore him. She visited us when I was 6 or 7 and stayed with us for a few days during which time she had me enchanted. She laughed at my jokes, played charades, and acted out scenes from books with me, and she promised to come back the following month to take me to the theater. "We'll spend a lovely girls' weekend together," she vowed.

I never heard from her again. I relentlessly hounded Dad to remind her of our plans, but she never returned. Dad did not know why, and I certainly did not. My surmise was that a woman without children makes no binding commitment. Later, she became my image of the kind of thoughtless spinster who comprised the stereotype.

In truth, I knew no more than three women who were childless at 35 – one was embroiled in a long-term affair with a married man, one was a lesbian, and one was a pure and simple solipsist. Of the three, my lesbian friend alone was the one who seemed to have retained gentility. I had no reason to doubt my intuition that I would be a better person with children.

Further, my mother had made her expectations plain when I told her I was marrying Richard. She wanted brilliant, beautiful grandchildren, and I had a duty to produce them. As ever, her demands were my directives.

I was sick throughout my first pregnancy. Lost 35 pounds before giving birth to an 8.5-pound child, at which point the all-day morning sickness finally lifted. And lo and behold. . . I found that I was happy!

Perhaps the simple relief contributed to my contentedness, or maybe I was actually cut out to be a mommy. Whatever the root cause of my happiness, I was amazed that I loved motherhood.

The nine months of nausea and the long, difficult labor and delivery vanished from memory the moment that beautiful child catapulted forth. I was ready to do it again almost immediately.

Admittedly, our first child was a golden child who rarely cried, rarely complained. I firmly believed that a second child would be an easy addition. And I was right. The second pregnancy was infinitely easier, and the adjustment was simply organic. With two children, I easily negotiated the terrain I needed to cover, had no trouble keeping up with all the things I had to do, and even managed to keep writing.

Shortly after the birth of Number Two, we decided to find a good preschool for Number One. We had talked about raising the children Jewish, to give them a foundation, a set of tenets they could reject once they had absorbed the knowledge if they so chose. It seemed like a natural progression to choose for a Jewish Day School for their early enlightenment. The choice was satisfying on a number of fronts. For me, it meant confederates, many displaced New York women with educations similar to my own. My mother kvelled, as they say in Yiddish, over the idea that her grandchildren would help to put Jewish traditions and rituals back into her life, and we promised to share them all with her. My father was as accepting as always, and my grandmother was overjoyed. We knew that Richard's family would not be pleased, but they lived far away in New Jersey and made very little effort to see or interact with us. They had no say. We settled happily into the new schedule with all its rites and obligations. I took on the task of selling Tupperware to pay for the school, and we decided life couldn't be any more difficult with three kids.

I was the oldest of seven children. Three children seemed like a small family. Certainly not unwieldy. Plus, having grown up in a world where parents were inevitably outnumbered in every situation, I firmly believed that stopping at two children put the kids at a decided disadvantage. I saw myself as a force that could easily overwhelm – I almost always felt that I over-whelmed Richard in critical ways – and I wanted them to have

the edge. I wanted them to be invincible, impervious to the smothering presence of a big-voiced, opinionated mother.

Nearly 45 years later, I am not sure we made the right choice. I love my three children. Every one of them. Individually and collectively. None has any more or less of my affection than the others. Even so, there was not enough of us parents to go around.

To be fair, our youth was a factor. Richard was far too young at 23 to be thrust into a role for which his only training had come from a drunken egoist. I would not have been capable of recognizing that then. After all, I was the grandchild of an alcoholic, and as far as I knew then, my mother's and her sisters' parenting skills were not impaired. Besides, in our day it was commonplace for young married couples to begin procreating as soon as the ink was dry on the wedding certificate. Certainly, our parents had done so.

In any case, I had a biological clock whose battery was expiring, and I was selfishly impelled to procreate.

Choosing to have children is a supremely selfish act. No child asks to be brought into the world we inhabit. No child seeks to be born knowing that death is inevitable, that suffering is probable, that cruelty is just beyond the protective arms of their parents. I knew this even as I rubbed my abdomen lovingly as my third child fidgeted inside. I realized that I had chosen parenthood because it gave my life the meaning I had forfeited to my marriage to Richard. So long as I was running around in constant pursuit of "family priorities," I had an excuse for not writing, an excuse for not investing in myself.

I loved being my children's mother, but I was probably not as good as it as I wanted to be or imagined I was. I relinquished too much of myself, which made me a terrible role model. I was so ashamed of my body, I could not hide my disdain, and I acquiesced to Richard too easily, which weakened my marriage. I did not adequately convey the depth of my love for them. I operated too often out of guilt and obligation, without joy, which must

have confused them too. Overall, I was the damaged child of a damaged set of parents, and I am sure that in turn I damaged my children immeasurably.

I had no help. There were the occasional carpool collaborators, who took some of the burden of endless schlepping after school. Yet sports, culture, and socializing provided us all with breaks from one another. Richard and I made it a point to spend some one-on-one time with each child and found there were never enough days in the week to give any of them what they needed in terms of attention, affection, and reassurance that no matter what they were loved, appreciated, valued above all else.

I struggle with my guilt. I was not a terribly affectionate person. Did I hug them enough? Did I listen well enough? I doubt it. Were they secure in the knowledge that I loved them unconditionally? I don't think so – somehow my demeanor belied my constant reiteration that I would always be there for them. I pushed them for victories in their competitive sports. I let them believe I cared if they went to an Ivy League School. . . though I did not. I pushed myself endlessly and set a standard that was unrealistic for every one of them. Each projected onto me a vast array of expectations that they mistook for milestones they must reach in order to retain my love.

And Richard yelled. Constantly. At every little thing. I yelled back. We said cruel things to each other. His intermittent abuses increased. His deprecating language escalated, especially with me, and I did not curtail it. He called me "fucking stupid," and he called his children "assholes." He belittled my efforts and bemoaned his responsibilities. When we needed money, he never looked to improve his earning capabilities by finishing his Ph.D. or taking on consulting work. He put the pressure on me, playing into my guilt to manipulate me ever further away from what I wanted to do in the first place.

Over the years, my burden increased exponentially, and his never altered. He went to work, he stayed for eight hours, he came home; he collected a Mechanical Engineer's salary. I

became a teacher then added drama directing and working with the state drama association. Still not enough. I took on multiple class adviserships and union advocacy positions. Kids needed braces, and we needed vacations. No problem – I spent every June, July, and the first week in August coaching drama and directing at theater camps. I took on as many duties as I could in order to accrue the stipends attached. Over the years, the demands grew, and my availability for my children dwindled. By the time the kids were approaching their teens, Richard and I had well-established corners in our boxing ring of a home. No one was happy. No one was secure.

I see now how my behavior engendered a natural flood of doubt in my children's nascent cores. How could they trust that I loved them and was proud of them beyond measure when I was incapable of loving and being proud of me.

Perhaps they will forgive – have forgiven – me soon enough to liberate themselves from their own fears of failure, their own useless guilt. I want all three of my beautiful children to know that they made every compromise more than worthwhile, despite my being exiled in Arizona. In the end, all I ever really wanted was for them to find happiness, fulfillment of their own devising. What I really want for them is inner peace, satisfaction with the world they have created for themselves.

My release from the bowels of hell did not come until 1987. Until then, I managed to retain my illusion of contentment.

My compromises lulled Richard into the complete confidence that I would never leave him. I failed to specify my boundaries, to articulate my needs. Instead, I acquiesced to his will in most things all our married life. When he did not want to buy me an engagement ring, I believed it was because he was non-material-istic. When he wanted to spend $10 on our wedding bands, I applauded his ingenuity – we found lovely bands in Greenwich

Village that had little turquoise chips, and I loved them. On our tenth anniversary, when the chips began falling out one by one, and I begged him to go with me to choose newer, more durable rings, he said point blank that he would not spend money on such a frivolous nothing. We had bands that had symbolic meaning, and what did it matter that the chips were falling out? I simply nodded and made no fuss though I truly wanted something beautiful to wear on my finger.

During the first four years we lived in Phoenix, I endured three pregnancies without benefit of an air-conditioned car. Of course I wanted one. I believed we could not afford one. I was that naïve. I believed in Richard and in the notion that he simply wanted to protect us. So when I drove my small children around in our 1968 Chevy Nova with black vinyl interior, I carried spray bottles filled with water so I could wet and cool their car seat buckles lest they be burned. At home, we ran a swamp cooler, a device that basically worked like a fan blowing over a tub of ice, and it was heavenly when the heat was actually the dry heat of Arizona mythology. In July and August, often into September and October, the monsoons hit and lingered. Then, our house became soggy, and we were only enlivened when we went to the malls or into the pool. At times, I wished I could simply turn to dust like the old cacti dying at the side of the road. I complained. Richard simply dismissed me or belittled my complaints.

"You're from the Adirondacks. Of course you hate the heat. It'll cool off in a few months."

When I was pregnant with my third child and running myself ragged braving the summer heat with a nearly four- and two-year-old, I suddenly gained a lot of weight and developed high blood pressure. We knew the baby was large – my previous children had both been in the nine-pound range pound range – but this was worse than anything I had experienced before. I felt horrible.

Richard took me to the doctor for a mid-month exam. I was pre-eclamptic, a condition, the doctor said, exacerbated by the

unusually hot and humid summer we were having. He wrote me a prescription and told me to keep calm and stay out of the heat. I laughed and told him about my car. Suddenly, the doctor's face turned an ominous shade of reddish gray. He turned to Richard.

"Are you insane?" He scolded. "You want to be a single father? This is Phoenix. Air-conditioning is not a luxury item. If you want a live wife, get a new car. Immediately. And turn off the swamps; activate the aircon."

To his credit, Richard bought a new car within the week. The swamp coolers persisted. I spent most of the remaining time of my pregnancy in the pool or driving in my new car. My condition stabilized enough so that the baby could be induced near the due date. On October 6, 1978, on the way to the hospital to give birth, I noted that the temperature was 106; humidity was 78%.

At least, I assured myself, I was writing. At first, I worked with my mother's older sister, whose late husband was a Serbian painter of some renown. I wrote program notes for a posthumous exhibit of his work in Zurich then a short biography for my aunt's future use. Later, I began working on short stories, accumulating rejection notices. When my children became involved in US Swimming, I wrote articles about and for swim clubs. I began a collaborative investigative project with a friend, a veteran, about drugs, the military, and the American prison system.

As the kids got older, I wrote less and less because I was increasingly pushed into the workforce outside of home in order to keep up with our ever-rising bills. Richard was impatient. Waiting for an article or a story to sell did not put immediate money in the bank. I briefly sold Tupperware, which led to my meeting a woman who ran substance abuse prevention classes, she recruited me to take her training then teach classes. The organization was government-funded and paid us fairly well to go into Phoenix area schools and run weekly sessions aimed at teaching students the dangers and pitfalls of drug use. At the

end of my first year, the director who had hired me resigned and asked me to take over. I did.

For another year, I ran the program, and we thrived. I recruited teachers from a variety of professions and sought to ensure that they reflected the cultural diversity of the community. I continued to teach, of course, and it was my final assignment that convinced me the time had come for me to find another source of employment.

In 1981, I was asked by the Phoenix Union School District to do a series of empowerment sessions with the sophomores and juniors of the beleaguered North High School in downtown Phoenix, which was closing its doors because of declining enrollment, gang warfare, and white flight. The students who were still attending North felt abandoned. To go to any other school in the city, they would have to use public transportation and cross gang boundaries. They were largely Native and Hispanic kids who wanted an education, and at that moment, they especially wanted to be heard.

Together, the students and I prepared a program that we rehearsed for eight weeks and which culminated in their presenting their stories and concerns to invited guests, who included their parents and friends, state legislators, the school board, City Council members, and Mayor Hance. The mayor failed to attend, but her assistant came and took notes. The preparation was grueling, and I was pulled in multiple directions so forcefully that I felt compelled to pass the leadership of the group to a trusted associate as soon as the North High project was completed. I should note here that North High School, a necessary component of inner city life, reopened in 1983. I like to imagine that our program had some minor effect on the city's decision to revisit the closure.

In the meantime, our personal life was disrupted by the deaths of Richard's uncle, his favorite grandmother, and my grandmother, all within a few months. I then had a health scare – a mass appeared on my breast that required three biopsies. In the

end, it was a benign lump that was removed along with a third of my breast after a fraught few months of repeated, inconclusive tests.

Eventually, needing to be gainfully employed, I drifted back into substitute teaching.

I took it all in my stride. I still believed that in the end I would regain my momentum, that I would return to a life of writing. I trusted Richard's promise.

Besides, I was certain that eventually, the most wonderful thing would happen. Richard would sacrifice himself for my redemption. I need only endure a temporal crucible.

DADDY AND DADDY

Richard was often my adversary, but I depended on him. He was a responsible breadwinner, a mostly gentle father whose worst offense was his angry raving. If he was too seldom available to relieve me from the stresses of parenting, he was always there. Most evenings we managed to have dinner together, and as a group, we laughed, told stories of the day's events, argued over minutiae. The kids loved watching TV with him after dinner. They sparred with one another for the honor of scratching his head, sitting close to him on the couch. During vacation time, when we prepared for one of our many camping trips, he could be terrifying to be around. But once we reached our destination, he was jovial, delighted to be in nature with his children, free of the burdens he carried daily. Burdens he never grew accustomed to.

I wanted to lift the weights from him and so returned to substitute teaching for a more reliable income stream, but my efforts were inadequate at best. Then, in 1984, he suffered a trauma that continues to haunt me. It was he who found my father's body when Daddy died; it was he who held us together in the aftermath of the shock.

My parents, who had lived in a big farmhouse on a large

Scarsdale property when we settled in Arizona, had moved to a smaller house on a tiny lot only a few blocks from ours. Dad hated living in a small space, saw himself as a gentleman farmer, and resented having to relinquish his property. But he was getting old, if not chronologically then in his health and demeanor. We could all see that he was not well though he refused to see a physician and, therefore, gave us no diagnoses on which to hang our suspicions. He had always been a gifted salesman and had managed to support his family well enough, but we could see that clients no longer responded to him, and he took less and less care to attire and clean himself properly. More and more we questioned if perhaps he was descending into senility or dementia or worse.

My kids and I often saw Daddy in absurd circumstances, and we would laugh. They loved the old man, but he was, even in his best of times, a raving eccentric, who never let others' expectations limit his behaviors. As he declined, he became downright bizarre.

One day, driving on the freeway toward a swim meet in Glendale, we found ourselves behind a car swerving dangerously about the road. Determined to get past the menace, I merged into the left lane, and as I passed the offending car, my kids shrieked, "It's Papa." Sure enough, it was my father, who was holding, instead of the steering wheel, a pen and notebook into which he was scribbling. I never told him I saw him that day, and my children never forgot that we did.

Then, on a splendid Thursday afternoon in May, we were leaving the parking lot of Basha's Supermarket with snacks for after swimming when my son said, "Look at that bum diving into the dumpster. Maybe we should stop and give him some food."

Before I could reply, the man stood up and faced us.

"Papa!!"

I don't know if he recognized us. We drove away.

The next morning, right after the school bus carried my kids

off for the day, I was in the shower and heard a knock at the front door then the doorbell and another knock. I got to the door and opened it just in time to watch my father drive out of our driveway. I looked down at my feet and saw that he had left me a gift: a box of wilted lettuce, limp carrots, yellowing broccoli, and yogurt containers with bulging tops. The bounty from the dumpster dive. I screamed at him. "Dammit, old man. I don't need your f'n'g garbage!" He didn't look back or respond. I don't know if he heard me. It was the last thing I ever said to him. He was on his way to see my mother.

Mom was in the hospital. The catastrophic car accident she'd had in 1963 had left her with a severely impaired left leg, and a new young doctor had offered to rebuild it. The surgery was difficult, and her recovery required ten days in the hospital before she could begin therapy. Dad went religiously to see her every day as soon as visiting hours commenced.

Two days after he deposited the compost at my door, Richard was home for some reason, and we were at the table having a calm discussion over breakfast when the phone rang. We ignored it. It stopped then started anew. We ignored it again, but this time it went on and on. Reluctantly, I finally picked up. It was my mother.

"Carla, have you seen Daddy today?"

"Not since Sunday, Mom. What's up?"

"He's not here. He's never not here by now. It's 11 o'clock. He never gets here later than 8 or even earlier, before they'll let him in. . . . "

"Maybe he had errands to run or. . . "

"No. He would have been on his way to work and would have come here first. Something is not right. I know it."

Richard was standing by my side now. He could see that I was alarmed, and his eyes asked what was wrong. Mom was still talking, so I whispered to him, "Dad didn't show up at the hospital, and. . . "

Before I could finish my sentence, Richard had his shoes on and was out the door. "I'll call you from over there," he said.

I told Mom that Richard was on his way to their house.

"Richard? Already? That's not like him," she mused.

"No," I concurred. "He is as worried as you are."

Not long afterward, Richard did call.

"You should come over," he said. His voice was morose.

"What's going on?"

"He's in the shower. Paramedics are on their way. They'll have to cut him out."

Daddy was dead. It took the better part of the day for the fire department to do what they had to do and get Dad to a mortuary. As soon as they had, I went to the hospital to tell Mom, and Richard went home to wait for the children. He had to tell them. Everyone was shattered. I returned home and assembled the children and Richard in my arms, and together we wept. My middle child, who was then age 8, remembers that that was the first time she remembers seeing me cry.

Poor Richard would awaken from a deep sleep in the middle of the night saying, "I can't get him out. He's stuck."

When Richard found him, Dad's body was already in rigor. The only way to get him out of the shower stall was to cut it down. I hadn't seen Richard's nightmare, but I, too, was haunted.

"Eight children he's raised and nurtured, and not one of us was there to hear him cry for help," I moaned.

"No reason to think that way," the cardiologist told us after the autopsy. "It's likely he never knew what hit him. His death was instantaneous. The source of Dad's seeming dementia was suddenly clear. He'd died of an arterial sclerotic attack of the heart, precipitated by severely blocked arteries.

If the pronouncement was reassuring in that Dad did not suffer, it did nothing to block Richard's recurring image of my father's lifeless, stiff, distorted, and putrid-smelling body cramped in the box where he died. My dad was more than just a

dad to Richard. He was a stalwart, loving support, a man Richard could trust to be there when he was needed. The model of the father his own father was not.

I wonder if I have ever sufficiently expressed to Richard how grateful I still am for his swift actions that day, for the love he bore for my father, Richard's hero and for the comfort he gave my mother by taking care of the myriad details associated with the way my dad died. Waiting for the paramedics, reiterating the explanation for how he came to find dad as he did to the various official entities who needed to know, making reports for weeks afterward were life-saving to all of us, and I cherish the memory that he was able to be so caring.

Hale: I cannot say he is an honest man; I know him little. But in all justice, sir, a claim so weighty cannot be argued by a farmer. In God's name, sir, stop here; send him home and let him come again with a lawyer—

Danforth (patiently): Now look you, Mr. Hale—

Hale: Excellency, I have signed seventy-two death warrants; I am a minister of the Lord, and I dare not take a life without there be a proof so immaculate no slightest qualm of conscience may doubt it.

Danforth: Mr. Hale, you surely do not doubt my justice.

Hale: I have this morning signed away the soul of Rebecca Nurse, Your Honor. I'll not conceal it, my hand shakes yet as with a wound! I pray you, sir, this argument let lawyers present to you.

Danforth: Mr. Hale, believe me; for a man of such terrible learning you are most bewildered—I hope you will forgive me. I have been thirty-two year at the bar, sir, and I should be confounded were I called upon to defend these people. Let you consider, now—
(to Proctor and the others)
And I bid you all do likewise. In an ordinary crime, how does one defend the accused? One calls up witnesses to prove his innocence. But witchcraft is ipso facto, on its face and by its nature, an invisible crime, is it not? Therefore, who may possibly be witness to it? The witch and the victim. None other. Now we cannot hope the witch will accuse herself; granted? Therefore, we must rely upon her victims—and they do testify, the children certainly do testify. As for the witches, none will deny that we

are most eager for all their confessions. Therefore, what is left for a lawyer to bring out? I think I have made my point. Have I not?

The Crucible by Arthur Miller

THE WITCH IN ME

I have always identified with witches but neither the Halloween cartoons that children become once a year nor the broom-riding caricatures on over-priced cards. Real witches, the kind who were burned or hanged or at very least excommunicated from the protection of their villages from the earliest days of Christianity into the 18th Century. They have been a preoccupation for much of my life, largely because of the literature I consumed and also because in my early youth, before the number of my siblings made it impossible for him to hold their attention, Chaucer and Shakespeare comprised my father's lullabies. Stories about witches terrified me because their crimes were merely the miscomprehended actions of human iconoclasts. Misfits, like myself. At the same time, the stories were comforting as they reminded me that being different was a blessing as well as a curse.

Over time, I came to understand that witches are merely outliers, mostly women and mostly women who don't fit the accepted norms of femininity. They are most often bold, dissident women, quarrelsome, aggressive, sharp-tongued and noncooperative females who scoffed at societal mores and refuse

to know their place. Historically, they were women who fright-
ened community leaders, posed what was perceived as a threat
to the general well-being. King James I, the first Protestant King
of England, wrote a book entitled *Daemonologie*, a book that
defines witches as necromancers, messengers of the dead. What
is most interesting about the King's opus, and about the several
books about witches and witchcraft that followed, is that the
word *witch* is often nothing more or less than a synonym for the
word *woman*, which suggests that any woman who was not
weak and emotionally fragile was in danger of being called a
witch. The punishments for witchcraft were designed to terrify
women into submission.

European notions of witchcraft emanate from the classics.
Aristotle defined women as imperfect humans, failures of the
process of conception. Women, he averred, are more intrinsically
and innately prone to malice, sensuality, and evil, and they must
be contained. The worst kind of woman was one who was sexu-
ally active, untethered by the prohibition of adultery. In one of
the many 5th Century tracts he wrote that became adopted as
Roman Catholic doctrine, St. Augustine claimed that sexual plea-
sure was antithetical to God's will, and all women must be cured
of any tendency toward pride in sensuality.

It took very little substantive proof to convict a woman of
witchcraft. Spectral evidence—the mere assertion by a person
perceived to be reputable that the accused had appeared to them
in a dream or a vision and brought or wished or suggested them
harm—was enough to hang a woman that few liked to begin
with.

Witchcraft trials were officially outlawed in the 18th Century,
but society has found ever new ways to chastise and punish
those nonconformists who refuse even to conform to nonconfor-
mity. The true outsiders are punished in subtle but no less deci-
sive and decisively unjust ways. Whether by being outed as
homosexual or ousted from positions in government or by being

shunned by a community, society never tires of finding ways to "hang" those they do not like.

I felt the sting of spectral evidence twice in my life. The first time it very nearly destroyed my family and me. The second time it merely made me strong enough to let it go.

SPECTRAL EVIDENCE

It was my mother who encouraged us to move to Phoenix in 1974. She should have worked for the Chamber of Commerce.

"I just love it here," she often said. "Remember, if I had my way, I would have gone to Israel in 1939. My father wouldn't let me. Now, I'm here. This is my Holy Land of milk and honey."

I never saw it her way. We were there from 1974-1987, and I was incessantly uncomfortable.

I suffer from summer seasonal affective disorder, which makes me prone to terrible anxiety when subjected to warm temperatures and long days. Since summer is very nearly a perpetual state in Phoenix, I was never able to completely relax in that environment. I found myself praying for rain, anything to relieve the relentless sunshine that glared the color out of everything but the sky and turned Arizonans so blonde they all looked like clones of the same Aryan grandparent.

The social atmosphere in those days was insouciant. Midwesterners and Easterners who had emigrated from their winter tortures reveled in the predictable weather, and they embraced the lower cost of living that afforded them a standard they could never achieve where they came from. Easy credit made accumulating possessions easier than collecting cheap

Garbage Pail Kids cards in bubblegum. The newcomers relied on installment plans to furnish their brand-new, fully mortgaged homes and settled into a life of plastic luxury. The illusion of well-being was emblazoned in glorious yellows and blues across the desert sky that hovered over the irredeemably beige land-scape. My surreal surroundings exacerbated my deep-seated anxieties. I lived with a queasy sense of perpetual guilt whose origin I could not discern.

One day in early Fall 1985, my malaise found disquieting fact to settle into.

Morning was still breaking. The heat was just beginning to seep in under the heavy drapes on the glass patio doors, and the kids' trusty little bus had carried them off to school when a knock at the front door made my stomach cramp.

I reasoned the pang away, reassuring myself that it was prob-ably a pair of Jehovah's Witnesses, who, failing to understand the significance of the salient mezuzah on the doorframe, had come to explain God's plan to me. I ignored the knocking.

But it persisted. Ever louder. Ever more insistent.

I had to pay attention.

A voice bellowed. "Police, Mrs. Stockton. Open up."

I was befuddled and confused. The last time I had broken any law was years before when, on a whim, my fellow adoles-cent husband and I stole a $2 padlock from a suburban Two Guys Department Store. The company detective had followed us out and escorted us back inside the store, where we paid for the lock. Had all not been forgiven?

Timidly, I opened the door. The hot desert air blasted in at me as though I'd just opened a preheated oven.

"Mornin', Ma'am," drawled a glowering man wearing a blue business suit and flashing a badge.

I smiled. "How can I help you?"

He didn't return the smile. "Mrs. Richard Stockton?"

I continued smiling and nodded. "Carla.

He looked at me quizzically. "My name is Carla."

He asked, "May we come in?"

Clearly, I had no choice.

The officer, two brown-shirted henchmen, and a dowdy social worker stomped into my living room.

The woman spoke first. "Mrs. Stockton, we would like to look around your house if you . . ."

"I'm sorry," I said, trying to find a voice that reflected no disrespect. "Who are you?"

"Oh, yes. Of course. You deserve to know that." Her saccharine tone irritated my throat with an impulse to guffaw, but I caught myself as she gestured toward the men. "Officer Decker, Officer Jones, and Detective Bauer. I am Mrs. Anthony Fiedler, MSW, with Arizona Child Protective Services."

The bile of fear rose to my mouth. This was serious. What horrible thing had befallen one of my children?

But wait, I thought. She's a social worker. What?

The detective was impatient. "Mrs. Stockton," he said officiously. "Do you know Jessica Moran?" I tried to look at him instead of at the patrolmen wandering about my house, looking at the pictures on the wall, examining my books, etc.

"Uh, yes, of course I do. She and her brother were my children's teammates at the –"

I stopped. The question perplexed me. Of all the names on earth, this was among the last I would expect to hear. The named child was one of a gaggle of siblings who had swum with mine at a summer club before we moved on to a year-round team. The three oldest came to my house often; each of them was the same age as one of my children, and the trio would have come home with us every day after practice if I let them. Their mother was a sweet, mousy immigrant, subjugated to the needs of her five children and her overbearing husband; she seemed grateful to have these three out of the house for an afternoon.

They were a simple lot, a fundamentalist Christian family to whom my Jewishness was a continual affront though they never said as much in so many words. Jessica, who was 6 or 7 at the

time, frequently offered to pray for my children, and she never tired of telling me that I would be a perfect mother if only I would encourage my children to love Jesus. She followed me around like a puppy dog, "helping" me with chores, reminding me of God's commandments.

I could not fathom why her name was being spoken at that moment.

I heard something drop in the other room. My bedroom. They were poking around my marriage bed. What could they possibly want?

"What I am asking you, Mrs. Stockton, is what did you do with her?"

"I don't know. Like I said, it's been at least a year, and I imagine I made lunches, supervised pool time, kept the p –"

"Aha! She swam in your pool?"

"Why wouldn't she? This is Phoenix. It was summertime. The kids were swim teammates. What else –" It was stupid question.

"Just answer the questions simply, Mrs. Stockton. We don't need any attitude. When Jessica went swimming with your children, did you dress her?"

"I rather doubt that. My kids are very self-sufficient, and I don't tend to –"

"Did you help Jessica with her bathing suit?"

"The last time I saw the child was over a year ago. How do I know if –"

"Simple answer, Mrs. Stockton. Simple. Please. Did you help her with her bathing suit?"

"I might have helped her get dry after she swam, but – "

"Ah. So you attended to her when she was naked."

"HUNH?"

"Did you touch her?"

I couldn't do this anymore. The room was reverberating with the aftershock of his voice, rendering me weak.

"Mrs. Stockton. You must answer my questions. If you

helped her dry off, isn't it likely that you might have touched her in her private parts?"

I could not possibly be hearing this, could not be standing here. Could I? I had no reply.

I was keenly aware that I should say no more. I had the presence of mind to remember an episode of *LA Law*, which I watched religiously, and I told him I was not answering any more of his questions.

I couldn't have spoken further anyway. The screaming in my head had become so loud it overpowered my voice.

The detective was visibly riled. "Know this, Missssssusss Stockton. We have been to the school, and we have interviewed your children's teachers, their principal, and any other adults who know them."

Now I was speaking involuntarily, perhaps even screaming. "You did what? Behind my back, you –"

Now the prissy social worker with no interest in working socially, put her hands on me and explained in her most bureaucratic tone that the state had every right, where child molestation was suspected, to take children from their homes without informing the parents. They needed no permission, and I need know nothing about their ongoing investigation.

The detective added that he was ready and willing, that day, to take my children into his custody for their protection. Furthermore, he made it clear that I should know that even if the children were not seized today, the State reserved the right to do so on any day in the future unless and until I could prove my innocence.

Mrs. Fiedler was recharged; she straightened to her full height of 5'4", came over to me, and stood on her tiptoes to get her eyes parallel to mine.

"I am serving you notice," she said, "that if they deem you unfit, the Arizona Department of Child Safety can and will take your children into foster care. In order to get them back –"

I managed to hold my tongue and listen. They left, and I fell into a chair.

All my life, I had been possessed of a great agility in emotional disengagement, a trait that at times impeded my ability to bond with people, but at that moment, it would have served me well. Unfortunately, I was feeling uncharacteristically vulnerable. It had been a horrible year. One of those difficult years we all have periodically. I had teetered for months on the edges of calamity – a health scare of my own, catastrophic illness of loved ones, death of a grandparent – and felt as though I were incapable of sustaining anymore. I was fragile.

When I was able to breathe again, it hit me. Damn! Jessica. That poor little girl was being molested. That was clear. But NOT by me.

My first impulse was to call Richard. I decided against it. His way of dealing with things inevitably cast blame on me. I knew he would chide me for being too available, for being too hospitable to "those Moran kids." "Sure," he'd say, "I know you're innocent, but you brought this down on yourself." I didn't have the fortitude to face him now. I had a better idea.

By this time, I had lived in Arizona's Valley of the Sun for eleven years. Luckily for me, I had managed to make a place for myself in the still small, growing, but tightly-knit Jewish community.

When my children had attended Valley Jewish Day School for preschool and Kindergarten, from day one, I had dived into the thick of school operations. By the end of our first Parent Teacher Organization meeting, I was the Vice President and had the reputation for being tireless and fearless, an intrepid spokesperson and a very good writer. I practically gave birth to my youngest child at a fundraiser we were running at Dillard's Department Store.

When the children were older and the school had evolved, I needed a job. It was not difficult to talk a fellow Valley parent into referring me for the directorship of a substance abuse

prevention program, and my reputation grew. I became known for putting out fires, for providing teenagers with platforms for expression, for writing letters to state and federal officials. I was an advocate.

By the time I was accosted by the absurdity of Jessica's accusation, the school had folded, and we had moved our children on to the public school for which our house was zoned. But my history had provided me with a wonderful array of connections in the city hierarchy.

One of my favorite parents was a close friend of the governor's wife and served as an advisor to state education programs for state governor himself. My friend's husband was an Assistant Attorney General with specific responsibilities in the areas of child abuse and neglect. I dialed their home, and my friend answered on the first ring.

As I blurted my story, she listened attentively, assured me that this was as ludicrous as I perceived it to be, and promised to phone her husband. Ten minutes later, she called me back. "He can't talk to you directly. But he did say, Carla, that you'll need a good attorney."

Then, she shared his recommendation that I call another VJDS dad, a crackerjack trial lawyer.

"This is crazy," my new attorney said as I finished the tale. He assured me that the officials were clearly rattling sabers and had nothing to go on. He did confirm, however, that no evidence was needed in a case like this. "You're okay for now," he added. "If they had any real evidence, they would have taken the children already. But it's enough that this kid says it was you. A case like this can be tried on spectral evidence."

Well, that answered my question as to why I was not innocent until proven guilty.

He promised to contact his private investigator, a man with strong connections in the State's Attorney's Office. "I keep him on retainer so I can always send him to find out what's going on." He said the PI would keep him apprised of anything new

that might turn up. For now, I was to talk to no one but him . . . and to the forensic psychiatrist he was going to insist we see as soon as we could get an appointment.

The day just seemed to evaporate into the heat of corroborations: I must be wary. My kids came home one by one, and one by one, they exhaled their anger then their abject fear. My oldest, the kind of child who would rather cut out their tongue than utter profanity, steamed and fumed and finally screamed, "Who the fuck do they think they are? Goddam them. What the fuck." My second and third, less than two years apart in age, egged each other into a fistfight and wound up lying on the floor crying, pleading with me not to send them back to school. They had all been interrogated, had all been told that Jessica made wild allegations. They felt betrayed. Jessica was, after all, their friend.

At precisely 5:30, just as it did every day at the same time, Richard's car pulled into the carport. I left the kids and went outside to meet him, planning to tell him what was going on before he saw how wounded his children were. But he asked if I could wait to talk to him. He'd had a long day, he said. He wanted to change into his after-work attire – a sleeveless undershirt and Bermuda shorts – and have a beer. We could talk over dinner. Which we did.

"I told you not to let those kids over here all the time." Richard said to me. "I told you it'd come to no good."

After all three children were asleep at last, I told Richard we were going to see a psychiatrist the next day and that he should come with us. He never cottoned to psychiatry. We had gone once when one of the children was having some behavioral problems, and when the doctor could not give us a timeline, a projected end-of-therapy date, Richard refused to go again and insisted I cease seeing the doctor as well. I told him this time he had no choice.

Richard nodded. Then, as he usually did when something unpleasant needed to be discussed, he changed the subject. He

talked on for a while about something that had happened at work, but I didn't hear him. I had buried myself in an episode of *The Love Boat*.

For months afterward, life was a flurry of phone calls between the attorney and me. My friends–even the ones in high places–and my family checked in on me every day, expecting the worst, relieved by the endlessness of nothing happening.

For a while, the social worker called periodically to remind me to be careful, to say they were watching us, but she never visited again, and the cops never came back. They just left us with the dirty threat hovering over us, a shard-filled piñata poised to spray destruction on our existence. Nothing mitigated our terror, nothing dispelled the tension. We endured.

The kids and I went to a psychiatrist, the best part of the ordeal. He was the perfect therapist, and I suspected that he was someone my DA friend had recommended because he was adept at ferreting out the emotions—all of them—lurking in every crevice of our beings in order to identify what was true and what was fabrication, a practice served us well and undoubtedly served the state's purpose too. If there had been any basis to the allegations, this doctor would have identified it. At the doctor's insistence, Richard went with us a few times, and when our allotted sessions ended, I could see that we had all benefitted from the hours of sharing. Even Richard agreed. He huddled closer to us, and we drew him into our circle, needing his strength.

One thing I didn't tell my therapist or Richard, didn't share with anyone, was that I was having a terrible time functioning. Early mornings had lost their allure. I wouldn't have left my house at all except that I was unable to let the kids get on the school bus so I drove them every morning, in my pajamas, which were the most constrictive clothing I was willing to wear. I couldn't sleep. If the television wasn't on and sometimes even when it was, I heard jackboots on the narrow sidewalk outside the bedroom window, guns in my backyard, shouts of *"Juden*

heraus" on the street. When I did sleep, the old dream recurred, the dream I have had since childhood, since I learned of my mother's escape.

I am in my grandmother's attic, and my family is scattered about our small town, running errands, tending the garden, etc. All of a sudden, a large man on a bicycle with spiked wheels is ringing his bell and blowing a whistle. "Carla," he calls. "You cannot hide anymore. We have found you." He comes to the door, and I look out the window to see he is carrying an enormous butterfly net. "We missed you in Europe, when your family fled, Jew, but we won't miss you here. Here we burn witches. We have you now."

I run, terrified, past him out the front door and up my grandmother's street. He's following close behind me, his boots making a terrible noise on the pavement, the net waving perilously close to my head, and he's shouting, "You'll burn, witch. You will."

Then I wake. I'm fine. I am no stranger to this dream. I inherited it from one of my forebears in my DNA. It has been visiting me since long before I knew any details of my family history. I shake it off easily now.

So it was with my living, breathing nightmare. Eventually, it simply evaporated.

One unusually blustery, sunless day the following April, the phone rang, and I answered after a moment's dread hesitation. It was my attorney. "I have some news," he said. "It's over."

Just like that. Done. He managed to find out that the witch hunt had started with a school assembly, one of those revival meeting-style convocations where kids were encouraged to "tell, tell, tell" by grownups playing various roles in a dramatized version of a child's being "touched where there should be no touching." It was easy to understand how Jessica must have been swept into it. I had been to those assemblies, had hated the way they offered all manner of positive reinforcement for kids' denunciations of family members, friends, teachers. I understood the real value in finding perpetrators but was skeptical of this methodology.

In any case, it was over. For me at least. It couldn't possibly be over for Jessica. Poor little Jessica. She must have needed to tell. Only she couldn't possibly tell who the devil was who touched her, and it had to be far easier to identify a devil her parents had already pointed out to her many times before. My attorney confirmed that apparently her court-appointed therapist had finally figured it all out and had called the authorities. I asked if his source had told him who did it, and he paused. I prodded him – surely, I had the right to know for whom I had been the stand-in villain.

It was her father. Jessica, her two sisters and two brothers were in foster care. Her mother was in a mental hospital. The father was in jail. He had been molesting all the girls.

I sighed. So the physical presence was behind us. We were free to re-assemble the remains of what we were and find a new way to go on. But that didn't happen easily. I was emotionally fractured. I dissolved easily into tears over nothing, flew into rages with little provocation. I was in the process of seeking a teaching certificate so that I could live up to Richard's demands that I have a steady income and so buoy the family finances. But after the experience with little Jessica, I was terrified of the idea of going into an arena where kids ruled.

That the law enforcement establishment was so eager, so willing to assume my guilt even without a modicum of reasonable substantiation horrified me. John Proctor became my soul; I could not read or see *The Crucible* without being reduced to emotional rubble. Like the judges who tried John Proctor, my accusers made lunatic sense of the ravings of a distraught little girl. I felt singled out as a witch, and I developed a paranoid sense that I would never be safe again.

It was a year before I could open the drapes and curtains, to let in the desert nights I had always found so soothing. I heard spies in my rose bushes, imagined ghouls in the carport. Sleep didn't come without a battle until two years later, after we had moved East, and I had begun to teach fulltime. The nightmare

persists. It's a nightmare I recognize now as one that comes from my omnipresent knowledge that I am my mother's daughter.

I am, as I have always been, a Jew in a world that doesn't really want us. Wherever we are, whatever we have, whatever we may pretend to be in our assimilated world, we never really belong.

Richard, who was raised Catholic, is a third generation Polish American and doesn't carry the genetically stamped fear in his gut. He has forgotten all about the incident.

REPATRIATION

In 1987, much to the chagrin and detriment of my children, we moved to Connecticut. I was thrilled, relieved, and entirely oblivious to the fact that all three of my kids were miserable.

My insensitivity astounds me today. We moved less than a year after the Jessica floodwaters abated. The damage, the extent of which I doubt I'll ever know, had only begun for my children. The move created greater problems for them and put them in an alien world for which they were unprepared. We don't talk about what happened to us in Phoenix, and if it manages to come up at all, they simply become agitated, try to shrug it off, refuse to let it live in our presence. It happened to us. It was no fault of our own. Not even mine. Moving, however, is a trauma for which I may never be forgiven. I did it to them, and I did it purposefully.

I admit it. I was thinking selfishly. After thirteen years of exile, I was thinking only of escaping the desert. Actually and figuratively. It pains me to realize that, despite the fact that my parents moved me many times during my school years, I was remarkably, unusually unempathetic to my children, who were aged 12, 10, and 9. I should interject here that it was neither the first nor the last time I did something so monumentally selfish,

but most are forgotten or released. For the move, there will always be repercussions. I will never make full amends. I do keep trying. Perhaps overmuch.

In any case, at the time, we were oblivious to all but our own adult given circumstances. Richard, threatened with being laid off as his company was downsizing, had had a scare with his eyes. Doctors identified floaters and told him he must reduce his stress. The eyes convinced him to look east for work, and he began actively seeking, a process that lasted for nearly three years before he finally found a job in Stratford, CT, one that restored his self-esteem at least for the time being. It was supremely selfish on both our parts to barrel forward, but apparently each of us had an inner motivator that was stronger than parental protectiveness.

Connecticut was the last place I wanted to be. Having been born in Bridgeport, I had managed to steer clear of the state since then. Except for visits to my aunt and uncle's summer retreat in New London and visits to Hartford with my dad when he worked in Springfield, I had little connection. But it was east. It was green, not beige, and autumn colors could be counted on. Best of all for all of us was that it was close enough to the Adirondacks that we could visit periodically.

Finding a house was not so easy. We had chosen to move during one of many housing bubbles when property prices in Connecticut spiked and we could only afford what we had received from the sale of our Phoenix home, where such a spike was still years in the future. In the end, we found a dilapidated little cape in a suburb of New Haven, and we hunkered down and enrolled the kids in schools and swim teams so that I could concentrate on finding a teaching job.

Richard made it clear that we could not afford to live in Connecticut if I did not have a fulltime job. Fear and loathing notwithstanding, teaching was an expedient solution. With luck, I would find a job in a district where the calendar coincided with my children's. I had my Bachelor's in Comparative Literature

from Columbia, and in anticipation of needing to have such a job, I had pursued a Master's of English and English education at Arizona State University. It took three years, including a summer camped on my mother's Scottsdale, Arizona, floor with two of my kids consigned to sleep-away camp and the oldest to driving themselves to and from sports practices, to finish, but I did it. I was certifiable. Pun intended.

As I luxuriated in the gentle leafy greenness of New England, I found a job teaching English and drama at a school whose playing fields abutted my back yard. Through drama, I finally had a creative outlet. My oldest brother David, his wife Lisa, and son Michael lived close by, and they provided us with family grounding. They were raising Michael in the Jewish tradition so we even had that in common. They helped fix up the house, were our frequent companions on trips to the farmhouse in Deerfield that had been home for a year or camping on the shores of Osgood Pond near Saranac Lake, and they celebrated holidays with us.

If you had asked me then, I would have said I was supremely content. I loved my husband. I adored my kids. I was a happy woman because it was clear that sometime in the not-so-distant future that most wonderful thing was going to happen. Richard would recognize that I had earned my right to be the writer I wanted to be, and in the meantime, I had my beautiful kids, a tightly knitted family, a job directing student actors, and a bright future. Life was pure joy.

Except when it wasn't.

Like any mid-marriage couple, we had our share of difficulties though the move had rejuvenated us.

Richard was relieved to see my optimism return, and he loved having grass to mow and trees whose leaves donned colors and fell away as the seasons changed. He often said he had not realized how much he missed the seasons, how oppressive he had come to find the persistent beige of the desert. That I was gainfully employed reassured him that we would not be

easily bankrupt, and we allowed ourselves occasional luxuries he had never allowed before – we remodeled our kitchen, went out to eat, got take-out meals on busy evenings. After twelve years of spending all our vacations in our cars, we even took a winter trip cross-country trip on an airplane. He still exploded over surprise expenditures, but my secure, persistent income gave him a sense of security that allowed him occasional though infrequent indulgences.

My family, however, as it had in years past, brought with them heavy doses of tension. That tension was exacerbated by my youngest siblings' unbreakable belief that Richard was a hoarding, miserly man who refused to care for them. My mother loved Richard. She did not subscribe to the family trope that he was holding out, but she was too afraid of confrontation and too frightened of her children to stand up for him. For us. I, the siblings insisted, was his protector, who had abandoned all concern for her original family. For my youngest brother, I became evil incarnate that winter, and I am sure that my decision to be Jewish weighs heavily to the detriment of his respect for me. In fact, he later became a conservative charismatic Christian when he married an Italian Catholic woman. I doubt he feels any connection to our Jewish roots.

We arrived in Connecticut in June of 1987. Later that year, my brother David, a lifelong diabetic, accepted our sister Elizabeth's gift of her kidney. My mother needed to be near, but they had no room and no patience for her, so she stayed at our place. Despite the fact that she had by then forged a very successful career as a biology and special ed teacher, my mother did not know how to be my mother. She needed me to make her choices, to tell her what to say to my sister, to mediate between my sister-in-law and her. We argued constantly about everything, and I was relieved when she returned to Arizona. But then she came back for Christmas, just in time to be with us when our youngest brother John was shot.

It was Christmas Eve. Lisa, David, and Mom were at our

house, digesting our traditional apostate Catholic vegetarian Christmas Eve dinner. We were all, for the nine hundredth time, complaining about John, who had been living with David and Lisa for over a year. Mom, whose accident had left her with guilt and remorse about what her youngest child had had to endure, defended him entirely, insisting that he was a good man who just needed encouragement to live up to his potential.

" Bullshit," David said. "The little shit wrecked my truck, and he never even said he's sorry."

John had tumbled into crack cocaine use, had totaled their pickup truck just days after they bought it, and had refused to take responsibility. He swore, however, that he was done with drugs. He was getting married soon, and he was on the wagon that would lead to a new lease on life.

He lied.

When he was shot on Christmas Eve, police said he had multiple drugs in his system. He denied that he had taken any, insisted that he had been kidnapped by some goons who tied him up and forced him to inhale their burning crack. We coerced him into a residential rehab program in New London, but just a few weeks later, he was back, claiming he didn't need what they were selling. He was fine. Many mornings then I would wake to see his car parked in my driveway, where he would be sleeping off whatever he had the night before. My kids were frightened and for good reason. He parked there because he thought our suburban home would be a good place to hide from the loan sharks who were after him. I told him he had to stop parking there, that I'd call the cops if he insisted. He asked to borrow money, and Richard made him sign a contract promising to pay us back on specific dates. He never paid a dime. Instead, he denounced us for having rejected him. He has not spoken to me, has not introduced me to his children, has not forgiven me for my transgression. At the time, the money and his disdain were a source of enormous strife between Richard and me. Richard thought of John as his own little brother. He was deeply hurt.

CAREER

Over the course of my early years of motherhood, I had subsidized our family income in a number of ways. I sold Tupperware, taught, did telemarketing. To my greatest joy, I even managed to write and sell a fair number of freelance articles.

After our move to Connecticut, I published a few letters to editors and some unpaid op/ed pieces, and very quickly, the *New Haven Advocate* and the *Hartford Courant* were willing to buy my theater and film reviews. At the same time, I began teaching full time.

I was never one of those fortunate, gifted people called to teaching. My mother was. She was the perfect role model for an aspiring teacher, having begun her career at age 50 after raising her seven children. Though she had originally wanted to be a physician, she fell in love with teaching, a profession through which she was able to channel all the intelligence and creativity she had repressed from her wedding day. She was in every way the consummate teacher, equally at home in her special ed and advanced biology classrooms. Not me. Though I eventually learned to love teaching, I had to warm to it. At the start, teaching was no more than an expediency.

I had prepared to teach before we left Arizona, when we would need an additional steady income to support our lifestyle and our children's growing necessities. Richard categorically refused to take on consulting work or any additional responsibilities in order to bring in money. My intermittent freelance and counseling work provided insufficient remuneration. I was obliged to find a "real" job.

I knew myself well enough to know I would not settle for anything that I could not feel good about doing. If I were to be in the workforce, I had to do something that had a positive impact on my world. Further, I needed to find work that would allow me to be off when my children were off, to continue managing the details of their sports and cultural pursuits. At first, I sought a job that used my writing skills, a daunting task. I had not accrued the necessary credits to compete with women who had fought their way into journalism, and I had not time, money, or freedom to pursue the kind of stories that might put me on the map. Journalism, like everything else, was dominated by men who measured women's worth with coffee spoons. I did not have what it took to muscle into the fold. Teaching, then, was a logical choice.

I was well-educated and genuinely loved literature and writing. I viewed the great books—books I would require my charges to read—as the keys to understanding the universe we inhabit. I was an example of the strength to be derived from reading, and my skills and acumen were valuable as gifts I could pass on to youngsters. I believed firmly in the precept that if I respected my students, they would respect me. If I modeled responsible critical thinking, they would seek to emulate the same. If I encouraged their creativity in every possible way, they would reward me by taking the reins of their own lives and setting examples for others. In return, I would receive the gift of their affection, and through them, I would learn to love teaching and the students who showed me the way.

I ended up teaching high school for fifteen years. I would not have survived as long as I did had it not been for Stuart Elliot.

My plan when we moved to Connecticut was to get us settled into our new home then apply for substitute teaching at a few of the various school districts near wherever we wound up. That way, I reasoned, I could choose a district that was most in sync with my philosophy of education.

The house that became our home in a quiet suburb of New Haven abutted the local high school. The day we toured the house and surveyed the property, as we walked through the woods that completed the house's acreage, I pointed to the high school and commented to Richard, mostly in jest, "Wouldn't it be amazing if the owner of this house accepted our offer, and I got a job teaching over there?"

When we did get the house, I went to the high school, and they informed me they weren't hiring; in fact, they weren't taking on any substitutes. So I joined the rolls of subs at a few nearby schools.

Then a new friend, my daughter's best friend's mother, who taught English at one of the highest ranked high schools in the state, found out I was available to sub. She got very excited, explaining that good subs were hard to come by. She put in a word with the head principal, who immediately placed me on the roll. Because my friend told her friends, who told their friends, to ask for me, I soon became a regular in that school, a delightful school with a warm, supportive collegial atmosphere.

My helpful friend was among the few women in suburbia with whom I could feel truly comfortable. She and I had common interests – we both loved Shakespeare and good litera-ture, and we both valued critical thinking as the most important skill we should impart to our students. Like me, she was not shy about sharing her opinion, and I found her company reassuring. Being with women was never easy for me, and I was grateful to have a female friend.

I spent countless hours with the mothers of my children's

various teammates and classmates in public and religious school, and I inevitably felt enormously out of place. I was not thin. I did not know or care about fashion. I read books that were not considered pop fiction. And I did not drink. A misfit in every way. Worst of all, I had a mouth. If I perceived an injustice of any kind, I spoke up. If I saw a teacher mistreated, a student overlooked, or a team member slighted, I refused to let it pass. I wrote letters to the editors of local papers to insist that the community fund programs I thought were necessary, advocated for some programs—like drama instruction or swim teams or additional teachers for special ed—that were deemed frivolous or outlandish. My perceived brashness made the people around me uncomfortable. I perpetually felt like the 9th Grade girl in Saranac Lake High School who couldn't keep her mouth shut when the UN refused to accept Red China. "They constitute a huge portion of the world population. How can you accept Taiwan and reject China?"

On one of my subbing days, when I was having lunch with my friend in the school cafeteria, she pointed to a tall man who was deeply engrossed in a conversation with a group of seniors. "That's Stu Elliot," she whispered. "Assistant Principal. The best we've ever had. He's going places. I bet he'll have his own school soon, and every new principal likes to bring in a few of his own hires. Let me introduce you."

Stu and I liked each other immediately. He had graduated from high school the same year I did, and like me, he had taken some time to get his degree. When he did, he got it at Dartmouth. We had both been older students in Ivy League environments, and he had a theater background as well. Within minutes of meeting him, I began to fantasize about how sweet life would be if he were hired as a head principal soon and then called me to be one of his chosen people. I wanted to work for a male principal but not all men found me tolerable. I would never be able to work for a woman, I thought, because women found me irritating. Stu was a godsend.

I lucked out. The very next year, Stu was hired to helm the high school next door to my house. At his invitation, I applied for a job, and I was hired. At first, being low on the seniority pole, I had to accept a part-time position teaching two classes at the middle school and two classes at the high school. But the following year, I signed a new contract, and I was officially a full-time high school teacher.

Stu requested that I choose an extra-curricular activity to coordinate. He said the school desperately needed a drama program. "There hasn't been a drama club or anything like it here in over 10 years," he said. "We could change the whole culture of this school just by adding one."

He continued, "We also don't have a literary magazine, and I could ask you to get one started, but I have a feeling you'll be happier doing drama."

He was, of course, dead right. He intuited my long-repressed desire.

I loved theater. As soon as my sisters and brothers could talk, I had begun writing little plays for them to act in for our parents and grandparents. When I was twelve, I adapted *Puss in Boots* and stole music from all the songs in my *Big Broadway Songbook* to turn it into a musical that I produced and directed on the stage of my father's church.

When I was a high school senior, I had planned to be an actor. Having starred in all my high school's low-budget, lame productions and having won speech contests and debates by acting like I knew what I was talking about, I proved to myself that I had what it would take to "make it" in show business.

I briefly studied acting with Stella Adler after completing a year and change as a drama major at the University of New Mexico. I quit dreaming of theater when I realized Stella only accepted me because she liked my cousin, who was her prodigy. Seeking to escape the ignominy of my failures, I headed to California, thinking perhaps to make a career in film. I lived in LA for 8 horrible months.

Sometime during my Left Coast time, my cousin, who was by then well on his way to being the boy wonder Peter Bogdanovich, and his wife told me I should go back to New York and concentrate on writing. "You'll never make it out here," they assured me.

They were right, and I knew it. I was not thin and feminine, didn't have even a modicum of any "it" factor, and I was not bold about promoting myself. My writing was far stronger than my acting abilities, but I had no clue how to peddle my talent. When I left LA, I pretended I was never there. But I never lost my love or affinity for the theater. When I returned to college at Columbia, my Comparative Literature major had a concentration in modern drama.

Stu also knew that as an English teacher I would be reading papers ad nauseum. A theater group would be a nice reprieve.

"I accept," I said.

"Listen," he told me, locking eyes so I could not look away. "You know you are gonna rub people the wrong way. I know who you are. You will want to do things your own way, and you'll break rules. I'm all for that. Just be aware. CYA. Everything you do, you need to write a rationale for. Keep those rationales in a file drawer, and bring me a copy of every single one. That way whenever someone reports you as a renegade, I'll have proof I gave you the go-ahead."

I opened my mouth to offer a rejoinder, but he cut me off.

"Rationale, Carla," Stu chuckled. "Even for your drama choices. Cover your ass."

The man was brilliant.

Had things worked out differently, had I been able to work with Stu until we both reached retirement age, I might still be teaching high school. Then, I might have reached the thirty-seven years I needed to claim my pension.

IN MEMORIAM - STUART ELLIOT, 1947-1992

Stu put me in charge of creating a course I called "English for the Undefined," a course for at-risk kids whose difficulties with the work were actually difficulties with the system. They were iconoclasts. Some were rebellious and prone to acting out, and some were angry that they were required to sit in desks that were far too small for them, pinching their brains into boxes that felt claustrophobic.

I took them out to have long discussions in the sunshine, and I looked the other way when they ducked behind a bush to have a smoke. We watched soap operas to enable understanding of *Othello*, we went to the auditorium and acted out song lyrics to understand poetry, we built sentence models in wood shop. Everything was geared toward affecting a non-traditional engagement with the work they needed to do, and they thrived. When we read Hal Borland's classic novel *When the Legends Die*, about a Native man and his struggle for self-acceptance, they created their own film adaptation. The rodeo star of the book turned into a hacky sack champion in our film; he went searching for his Native roots on the peak of Sleeping Giant, a mountaintop park on top of Mount Carmel near Hamden, Connecticut, on the coldest day of the year, 1989.

The rationale I wrote for that project proved Stu's prediction.

While many of the people I worked with were collaborative and congenial, many sought to undermine me. My female colleagues were especially virulent. I was used to their tongues wagging about the way I conducted my classes, their pronouncements that I had no discipline, their insistence that students could walk around the classroom and that they covertly wandered the halls when we were on our way to the auditorium to act out scenes from Shakespeare. Teachers criticized the way kids talked to me, claiming (without proof) that in class I was called by my first name, spoken to as a familiar. No one understood why I insisted on protecting the most undisciplined students in the school. They claimed that it was a disgrace the way I disregarded the rules as they interpreted them. The teachers' room was a living, breathing Facebook page, and the teachers spent their free time there pontificating judgmentally.

I could not blame them. I had been like this my whole life. Annoyed by rules and picayune requirements. Whether hellbent to get out of college with my tuition payment in my pocket or simply annoyed that the medical form that insisted on knowing my specific marital status as though it made the damnedest difference, I have balked at rules and regulations my whole life. I was already that way in Kindergarten, when the principal insisted that my mother take me out of the school because I refused to take a nap at the appointed time. How could I expect understanding from anyone, especially from women in my own age group who only knew how to survive by complying with rules and living up to expectations, how to keep their dignity by acquiescing to every demand the society makes of them? In their shoes, I daresay I would resent me too.

Stuart's protection surely exacerbated their displeasure.

The hackey sack/rodeo replacement was the students' idea, and it was perfect. Everyone had one of the little footbags that year, and all the boys were itching for an excuse to play with them at school, which was, of course, prohibited. To practice for

our film, I took them out to the grassy slope next to my class-room window, and as soon as I did, I could see teachers on that wing staring at us out of their windows. When next class arrived, students told me that teachers were complaining.

"Ms. Stockton, they're really angry."

"Why's that?"

"You're letting those boys do whatever they want. Against the rules!"

"To be fair, the girls –"

"Ms. S – you know they think you're letting them smoke. . . . They reported you to Mr. Elliot."

Of course, Stu was already aware and made it abundantly clear to the staff that I had his permission. I found myself prefer-ring the school environment to my home. I felt understood, supported. Stu stood up for me, took my side, advocated for my iconoclasm. So different from Richard, who was embarrassed by it.

Richard would shrink away whenever he sensed a contro-versy I might have had a hand in starting. If I complained about the treatment I received from my colleagues, he told me to adjust my behavior. If we were out among people and my opinion differed from the consensus of the others, he would shush me. If I wanted to explore possibilities in anything the least bit contro-versial, he disassociated himself from me. He belittled any idea I suggested regarding saving or spending money in any way, and he would not even discuss politics or the world situation with me for fear I might have an idea that could force him to deal with any of it. He would tell people he admired me, but I hardly felt respected.

Despite the fact that I was hurt by Richard's failure to back me up, I should have tried harder to understand. It's easy now. I have more insight than I did then, and I'm no longer so close to it that it burns me. His mother, who spent her day cooking vegetables until they were void of life or nutrients, who polished the polish on her furniture, who never moved without her

husband's permission, had raised him to be a priest, to accept the expectations of all figures of authority without question. He had defied them by marrying me. But perhaps he lost his nerve in the fray of his responsibilities. Perhaps he was afraid that if he let me get away with what he considered my craziness, we would lose our livelihood. I did try to keep reminding myself that Richard was entirely cowed by his fear of financial ruin.

But then so was I. I knew by then that I did not want to be hobbled by my marriage. I knew that I needed to escape. But I did not trust my ability to fend for my three children. And I did not believe that I could trust Richard to take care of us if we left.

Stu gave me a sense of power I had forgotten I could feel. And he increased my power by continually letting me know he had my back. Stu gave me incentive to keep on being myself but only in the context of my teaching in that school. It felt as if I could not step away from where I was without risking my children's well-being. And mine.

"Watch yourself," Stu said to me one day when I looked particularly glum. "Promise me you'll make nice with those teachers who are scrutinizing you. Go into the teachers' lounge at lunch time, be cordial, talk about the stuff they're interested in. Promise me."

He knew I avoided the teachers' room religiously. But I promised, and I took my lunch there as often as I could.

It wasn't easy. I would enter the teachers' lounge and hope that everyone would stop talking. I could not stand hearing the reprehensible gossip they spread about students. On the other hand, there were teachers in my school who had much to teach me, and I gratefully listened to them. A history teacher with a Ph.D. The chair of the math department and the expert geometry teacher. Senora Spanish Teacher. Most, however, sublimated their frustrations by denigrating the kids, whispering half-truths about them, slurring the reputations of fellow teachers. I sympathized. Teachers are the untouchables of society. Well-educated but hampered by laws and parental interference. Overworked,

spending far more hours embroiled in their professional duties than any of the more respected professions, and severely underpaid. I wanted to commiserate, but so much vitriol was spewed at me that I lost any interest in camaraderie.

They got especially voracious when they learned that my students and I spent at a day filming our novel adaptation on Sleeping Giant.

I was impervious. I had Stu Elliot rooting for me.

When the Legends Die took months to film and edit, our production activities replaced essay assignments and exams. An abundance of criticisms coursed through the school.

When we finished, we invited Stu to the film's premier, and he eagerly accepted. The next day he summoned me to his office.

"What an achievement," he said. "I am impressed. Those kids pulled something spectacular off this semester."

We submitted the film to a student film festival that had entries from around the state, and it won first prize. The project turned out to be a deeply empowering experience for us all.

I loved my job, as I loved Stuart. I would walk to school each morning singing, absolutely flabbergasted at my great good fortune. The town was actually paying me to work at this school doing this job.

However, the success of the film only stoked the furnace of the teachers' indignance. As Stu predicted, many teachers increasingly questioned my choices and complained to him about me, but he had my rationales, and I felt eminently safe.

He wrote me lovingly grateful thank-you notes after every drama production, and he went out of his way to show his appreciation for the extra work I did. He would stop in at my classroom just to share a laugh or to sit in on a lesson, and he was generous with his praise and appreciation. I often stopped by his office to find him sitting, staring into space. Those occasions engendered the best visits. We would talk about whatever was on one of our minds, and often we were contemplating the same things. Bush hypocrisy, immigrant exploitation, child

abuse, macaroni and cheese versus Spaghetti-os. He knew my kids, so he would tell me about his daughter. He could make me laugh, and he could tolerate my tears. There was nothing I could not tell him.

The students loved him too. He was always welcome. He was especially loved by the drama kids, and he dropped in often. He would come to our rehearsals and engage in improvisational games or take a script and jump in for an absent actor. And sometimes we would simply stop doing whatever we were doing to just play. He was great.

Stu Elliot made me happy to go home to Richard. I had what I needed in school, and it ceased to matter that Richard could not discuss topics of interest. It did not matter that Richard blamed me for my own misfittedness. It did not hurt that Richard wanted to watch sitcoms, which I deplored. I was sated. I did not need emotional or intellectual stimulation from Richard. We had our very satisfying bedroom routines, and they were enough.

The real difference between Richard and Stuart, I thought then and still believe, was that Stu was a truly liberated man. He treated all people with the respect they deserved. He knew that in order for true liberation to happen for women, men had to be liberated as well. They had to be equal. He honored the differences, exalted them when appropriate, but different did not obviate equal. And he understood that. Richard thought he did, but he lacked the necessary depth of introspection to internalize the essence of it.

My love for Stu was neither unique nor universal. Most of my colleagues felt much as I did, but he had his detractors. And those haters hated me even more. One of them started a rumor that I was having sex with my students. Another that I smoked pot in the costume closet with them. Anyone who knew me – especially anyone who knew my ridiculously squeaky-clean personal children – knew how absurd the suggestion was. But that only made things worse.

Stu knew that protecting me made him reprehensible to

them. He was too liberal. He was too soft, didn't punish with a heavy enough hand, was too quick to reverse a suspension even when students should not be allowed back to school. They suggested that he must have something illicit going on – I never knew what they were implying – because he was too good. Not even a superman like Stu Elliot could possibly please all the people all the time.

Because of the incessant rumors and aspersions, when the word began to circulate that Stu was leaving, I ignored it until he corroborated the gossip.

One day he came into my classroom after school and sat down, silently watching me read essays. He often did that. I imagined my room was a safe hiding place where he could be just Stu and not Mr. Elliot for a few minutes.

He cleared his throat. "I don't know if you've heard what's being said. . . "

"Sure, I've heard. But I don't pay attention."

"Well, there's some truth. I'm looking. . . ."

"You're unhappy here?"

"Not that exactly. I'm ready to move up. I'm applying for a superintendency."

He handed me a letter of application he had written to a district in Massachusetts. "I'd be grateful if you would write a letter to them. You're both a teacher working with me and a parent of students in the system. Your word would carry weight."

I was honored, pleased, excited to be helpful, and I was crushed at the idea Stuart Elliot would consider leaving me. I said so. He laughed.

"I know. But you must make me one more promise. Support Ann for the principal position. Promise me you will." He was talking about our First Assistant Principal, a former P.E. Teacher.

"She hates me."

"I'm not sure that's true," Stu laughed. "But I do know she would NEVER have hired you. Never. She's a by-the-book kind

of leader. But she'll be good for the school, a real contrast after me. That's good for a system. Just be in her corner."

I nodded. "Only because you asked me to."

As it happened, just a few weeks later, Ann had to take on the role of Acting Principal. But not because Stu got a new job.

Before he had time to file the application for which I wrote the recommendation, Stuart suffered a ruptured colon as the result of diverticulitis and nearly died in surgery. Ann ascended to the post of interim principal, and while I was breathless for his return, I lived up to my promise to support her efforts. I hated everything about the way she ruled the school, but I reminded myself that soon everything would be back to normal, at least for long enough for us to prepare for his exit. In the meantime, I sucked in my disgust, smiled, and nodded at her. I was the very model of a model employee. And I was hopeful. Stuart recovered slowly, and though we did not get him back for the entire school year, by the end of it, he was making brief appearances in his office and at those times stopped in to greet my classes.

We had coffee together after all the students left on the last day before summer hiatus.

"You probably guessed that I could not take the new position. I'll probably need a new letter in the Fall."

"But you're coming back. . . "

He laughed. "Yes. I'll be all better and back fulltime," he promised. "I've got some changes in mind."

What a relief. The school year was nearly over. Summer respite from the classroom meant I need not worry. I'd return to find Stuart in his office, the world would be back to normal, and, I fantasized, perhaps his illness would even deter his further search for promotions. Maybe he'd even decide it was too stressful to keep looking.

Two weeks before summer vacation ended, on a dewy August morning that was rich with the promise of Fall, I returned from my morning jog to find our Second Assistant Prin-

cipal, who was also my neighbor, in my driveway along with the local Chief of Police.

"You look like shit, Prez," I teased. I was perplexed by the chief's presence but had no time to consider it before my friend said, "Listen. Carla. Stu. He's. He. Stu. . . ."

Chief finished the sentence, "He died this morning."

I would not process it. "He did not. I talked to him just yesterday. He's completely recovered."

The chief nodded somberly. Then, I heard words that may or may not be what he said. I was incapable of taking them in.

"Yeah. Recovered. So he went out for a run. Damned fool jogging. . . . on the road early this morning. Drunk hit him. Killed him instantly. Never saw it coming."

Stuart! Gone? Never returning? The shock refused to let me feel it, and then I could not shake it. School started up again, and I forcibly dragged myself back to my classroom, dreading a world without Stu in it but looking for him walking in the hallway, poking his head into the teachers' room, emerging from the counselors' office. How could he not be there?

I pledged myself to making the most of the way things were. The kids were hurting as much as I was. We would help each other learn to live with this. There was no question of how to proceed. I had made a promise to Stu. I would support his successor.

Of course, his successor had made no such promise.

When we all – students, teachers, townspeople – gathered for Stuart's memorial service, I sat with my drama club and Senior English students, two groups who revered Mr. Elliot beyond measure, and I held them – boys and girls – as they wept. We all wept. Even the teachers who disliked Stu sobbed inconsolably. I looked around the church and caught my breath in a panic. How were we going to carry on without Stuart Elliot to guide us?

I looked over at our presumed new principal and saw that she was staring coldly into space. It's okay, I thought. We'll be

fine. She knows how much we depended on Stuart, and she'll live up to his legacy.

I hoped.

For a few days, maybe even for a few weeks, my hope remained steadfast. We had a schoolwide memorial and invited the community. Our 1500-seat auditorium was full to capacity with mourners standing in the aisles. Ann asked me to speak, and, sitting on the stage with the other chosen few, I thought that maybe I had been wrong. Maybe she didn't hate me.

The school year slogged along. Not having Stuart in the principal's office was painful, and I had to fight the urge not to knock on the door, take refuge in the big recliner facing his desk, and pour out my funny, poignant, illuminating moments of teaching and directing the drama club. Several of my students were acting out, in need of his calming influences, and I begrudgingly sent them to the social worker, for whom I had little respect. I'd be in the middle of something terrific or something despicable in the classroom, and I'd think, *I gotta go get Stu – he needs to see this!* Then, I'd remember.

Like any amputation, Stuart's abrupt excision became a fact we learned to live with. I was lonely. I no longer had my pal to argue with about whether Weinberger should be indicted for the Iran Contra affair or why Othello had to kill Desdemona, so I busied myself with the class of '95, to which Stuart had appointed me class advisor, and I prepared the Drama Club for our first competitions and the senior class for a production of *Li'l Abner*. I was often frightened that someone would stir up trouble I would not know how to assuage without Stuart, but perhaps because we were all chastened by our loss, things were stable, and Ann seemed to have no beef with me.

In fact, thanks to her recommendation, I even received the gift of a lifetime.

Sonnet 8

William Shakespeare

Music to hear, why hear'st thou music sadly?
Sweets with sweets war not, joy delights in joy:
Why lov'st thou that which thou receiv'st not gladly,
Or else receiv'st with pleasure thine annoy.
If the true concord of well-tuned sound,
By unions married, do offend thine ear,
They do but sweetly chide thee, who confounds
In singleness the parts that thou shouldst bear
Mark how one string, sweet husband to another,
Strikes each in each by mutual ordering;
Resembling sire and child and happy mother,
Who, all in one, one pleasing note do sing:
Whose speechless song being many, seeming one,
Sings this to thee: 'Thou single wilt prove none.'

1995 – RECALLED TO LIFE

Fortunately for me, before I descended into the cataclysmic climate change of my classroom, I received a rare opportunity.

In the Fall of 1994, the English-Speaking Union invited me – and a select group of English teachers from around the state -- to apply for a summer fellowship grant to study any topic at the university of our choice, anywhere in the English speaking world. I knew immediately what I wanted to study and where: Shakespeare and his world, in Stratford-Upon-Avon, UK.

I won the grant!

I first fell in love with Shakespearean drama when I discovered a set of volumes entitled *Shakespeares Werke* in my grandparents' basement bookshelves. The compilation was translated and edited by August Wilhelm Schlegel, and I mistook Schlegel for the author. When I was nearly 12, babysitting at a neighbor's home, I watched a late-night presentation of the 1936 film version of *Romeo and Juliet* starring Laurence Olivier and Vivien Leigh. How beautifully the words had been translated into English, I thought. Far better than the original. My infatuation only deepened when I learned the truth. As an English and drama teacher, I found that working with the words satisfied my longing for expression. I took great pleasure from watching

students' minds bristle with excitement as they recognized the magic.

And I got the grant!

The timing was perfect. My oldest child had stayed at college to train with the swim team, the middle one had a job wrangling five-year-olds at a local summer camp, and the youngest was enrolled in summer classes. My sister-in-law was nearby and promised to keep an ear open; she and my brother vowed to invite Richard and the kids to occasional dinners. I cooked and froze multiple meals so that Richard would have what he needed even if the kids ordered out or ate with friends. Everyone was well engaged. No one needed me.

The fellowship took me back to my theater roots and re-anchored me in my original interests. The English Speaking Union bought me an airplane ticket to Birmingham then a train pass to Stratford-Upon-Avon; there, they billeted me in a quaint Victorian townhouse that belonged to a wonderful local woman, and they sent me to school for six weeks of study, through Roehampton University, with the Royal Shakespeare Company. It was heaven.

Every Monday through Friday, from 9 until 5, I sat with a small group of cohorts discussing the bard in a classroom where Will himself (might have) studied. Two or three evenings a week, we attended performances of selected plays at the three RSC venues after which we gathered at the Dirty Duck Pub to share unlimited pints of pleasure with the casts and crews.

On weekends, we were free to explore the amusing environs of Stratford-upon-Avon. The house where I was staying was situated outside the fray of tourist attractions and American franchises that made the town seem somewhat more like Epcot Center in America's 51st state than the 12th Century market town where Shakespeare's family originated.

The town sits squarely in the center of Warwickshire at the hub of the West Midlands. People there speak an English that has evolved little since its origin. They muddle tees and dees,

and they use "arr" rather than "yes" or variants of "thou" rather than "you." They abbreviate their words, clipping and shortcutting, much the way Puerto Rican and Cuban dialects do in Spanish. Living there, especially hanging out with my landlady Vikki who was a Midlands native, enabled me to learn a whole new English, and I loved it.

Born in Coventry, Vikki knew every pub in every market town, every cow path with the best views of the countryside, every little shop with the best deals in the Cotswolds. She loved to show them off. She talked about English history as though every event had happened just the other day. Hiking down Edgehill one morning, she said to me, "This is where King Charley faced off against old Essex," and it took me a minute before I realized she was talking about the first battle of the English Civil War in the 1640s.

"You talk about your Civil War like it happened yesterday," I told her with wonder. "That was three centuries ago. We talk about our Civil War like it happened when dinosaurs roamed the earth, and it just happened a hundred years ago."

She smiled at me. "Americans have such adorable notions."

The best surprise of the summer happened at the end of the first week. I made friends with a man exactly my own age named Tony, and with Tony and the two more friends we added to our tiny clique, I spent a great deal of time cavorting and discovering my inner teenager who had never really gotten to play.

Tony was American by marriage and profession, but he grew up in Cheshire and trained as an actor and director one of Britain's tony academies. Despite being the chairman of the drama department at a small, prestigious college in the South, Tony was an exquisite playmate. His wife and kids were in London for the summer, and he would disappear on weekends to be with them, but during the week, Peter Pan himself could not have thought up better hookey games, better pranks, better spots for picnics. Tony's company was especially satisfying

because since his wife and kids were nearby, we could cavort with no guilt whatsoever, a situation which facilitated my easing into a relationship with John as well.

John was the second surprise. He and I were also the same age, and like me, John was a theater teacher. Unlike me, he taught theater in one of New York City's rare public private schools, schools where students make their bids for acceptance into the middle school before they start Kindergarten. John didn't direct plays, but he coached his students so they could shine in them. John's wife and children had stayed in Brooklyn, and though he spoke with them every day, though he promised them that he was busy being a stellar scholar, the truth is that he, too, was feeling the oats of liberation and came up with great ways for us to circumvent work and enjoy the playtime. All together and along with our very young classmate Sarah, we maintained the safety of platonic engagement.

But while I was in no way forming any kind of extra-marital relationship, I was being intellectually and emotionally unfaithful. John and I talked all the time. We sought each other out to take long walks along the Avon, to visit Shakespeare landmarks like Trinity Church and the birthplace, to eat bad Chinese takeout from a storefront in the High Street, to drink with our classmates at the Dirty Duck after evening performances. We never ran out of things to talk about, things our spouses might have lost interest in hearing us discuss. He had actually pursued the acting dream that I abandoned at 18, and he trod the boards before and after settling down to raise his twins. In Stratford, he spoke often of missing "the business," and together we imagined forming a company back in the States. We could see our lives rising out of the stagnancy we perceived as having usurped our vim.

Tony, John, and I were committed to our spouses, and all three of us wanted our marriages to go on forever, but we missed the freedom to talk about things that had nothing to do with the daily maintenance issues couples never escape.

I did speak every week to my family in Connecticut, and I found that surprisingly confusing. No one was really interested in what I was doing; they wanted me to know what they were up to. That seemed right at the time. It's how kids are, and that was a big summer for all of them. I actively missed all of them, worried about them. But we talked, and they shared their goings on as far as the telephone and Richard's obsessive concern about the cost would allow. I was intrigued with how much they experienced in a month. I loved listening and didn't even try to interject a report of my activities, which seemed in that context to be meaningless. But oh how my conversations with Richard disappointed me.

I had not taken the time to analyze the state of our marriage until then. I was too engrossed in living it, I guess, too encaved in the everyday to be objective. I began to realize then how the standard idea of living happily ever after leads us astray, obfuscates the truth of what we have chosen.

In our youth, as we envision a future with a new spouse, few of us know enough to consider the nuts and bolts of a marriage. We expect the co-mingling of emotion and passion, the sharing of pursuits, the collaborating on a dream. But the day-to-day business of being a couple is elusive at that point. We can't begin to imagine the things that will preoccupy us ten years after our walk down the aisle. How long it takes to get a child to stop a tantrum. How much money it takes to cover gas and lunch and all the myriad responsibilities attached to getting a child to swim practice. Which carpool mothers will be able to cover a run if your car needs to be serviced. Which sink needs snaking. What bills must be paid on payday and which can float until the next one. Then there are the endless tribulations in the workplace that create agita you can't shake before you get home. The copy machine that slows production of a critical project. The coworker who can't get to a meeting on time. The support staff who seem lazy or unfit to do the work. Details and obligations of balancing a family's business are boringly exhausting, and they too easily

cause a shutdown. If talking is going to be this excruciatingly tedious but inescapably necessary, then we just don't want to talk once we're on the other side of it. After a day of work and juggling responsibilities, it's easier to watch a mindless TV show than to have a meaningful conversation or even to think.

In Stratford that summer, we married shadows found a way to tether ourselves to stimulating conversations, and we reanimated.

I strained to miss Richard. I wanted to want to talk to my husband, but I was too happily engrossed in my summer fun. At my core, I didn't want to deal with the mundane reality of home. But I did call. Once a week.

Every time I picked up the phone to call him, I would imagine the conversation we had had about Mahler in our youth, and I would plan the things I would offer up for discussion. Then he would get on the phone, always very nervous about the minutes ticking away and adding dimes to Ma Belle's coffers.

"We went up to Chipping Camden today where they hold the annual Cotswold Olimpicks."

"Yeah? That's nice."

"It was fun. Did you know they have an event called shin-kicking? They. . . "

"I took all the magazines and newspapers to the recycling station this morning. We sure had a lot of paper. I hope I didn't throw away anything you need."

"I'm sure it's fine. You should have seen the production of *Romeo and Juliet* we saw last night. I think the kids I directed were more. . . ."

"I burned my dinner tonight. Had to throw it away. I wish I could cook."

What I know now that I did not know then was that our inability to talk was more than just a sign that we were ill-suited for one another. By then, neither one of us had any real motiva-

tion to pursue what might have been. Lost in our many dangling conversations was any innate desire to court one another. Maybe neither of us had the stamina. Or perhaps we were people who never knew how to build a relationship. Perhaps a good psychiatrist could clear that up for me. Any doctor I have consulted has been unable to give me any believable clue. I will never have the answer.

I gave up and engaged in the conversation he initiated, which was mostly informational, keeping him abreast of what he needed to know to keep the house running for the summer. All the while, I continued to romanticize my life with him. A protective mechanism, I see now.

Connecticut was far away, and from the moment I arrived in Stratford, I was vaguely aware that I was idealizing my New England home. The first night in Vikki's narrow guest room, lying on my single bed, staring up into the peaked rafters, I found my mind drifting back a few weeks to the Senior Prom I had chaperoned with my handsome husband.

I wore a white dress, fitted at the bottom, bloused on the top, and my coarse wavy blonde hair was tightly permed into corkscrew curls. I felt beautiful, and we danced all night. I took off my shoes and wore holes in my pantyhose, and during every slow dance, I melted into Richard's body, feeling us move as a single entity, wanting to stay attached forever. It was a glorious night. Our oldest offspring was home from a prestigious college, our middle child had been accepted into another, and our youngest was a stellar student at an elite private high school. Cozy in my Stratford idyll, I fondly remembered us dancing, me singing the lyrics from "I Love You, I Honestly Love You" along with Olivia into his ear, feeling drunk with love and happiness.

The Stratford reverie edited out the hours after the prom, the angry screaming that came on out of nowhere as a reaction to something that seemed entirely insignificant –a glass of spilled water or mud on the clean kitchen floor or a missing button – then exploded in a torrent of verbal assaults, which dominated

that Sunday as it dominated so many Sundays. Sleep blocked out the discomforts, and I fell asleep before my dream ever reached the prom's last dance.

So it was that our marriage, like so many marriages, remained intact long after it stopped being healthy.

Winnie: Was I lovable once, Willie? (Pause.) Was I ever lovable? (Pause.) Do not misunderstand my question, I am not asking you if you loved me, we know all about that, I am asking you if you found me lovable - at one stage. (Pause.) No? (Pause.) You can't? (Pause.) Well I admit it is a teaser. And you have done more than your bit already, for the time being, just lie back now and relax, I shall not trouble you again unless I am compelled to, just to know you are there within hearing and I conceivably on the semi-alert is ... er ... paradise enow.

Happy Days by Samuel Beckett

HER MARRIAGE NEARLY KILLED HER

Violence was never discussed in our home. Mom had escaped Europe without personal confrontations, and though the postwar years were a constant barrage of horrifying news that inspired dark nightmares, she could not bring herself to speak of the horrors she left behind until years later when I finally figured it all out and confronted her. Both my parents were appalled by America's military action in Korea and brought me up in a cotton wool home, where, because they would not buy him toy guns, my little brother regularly used his fingers and sticks as weapons when he played war games with his friends. All I knew of barbarity were the images I got from my family's reactions to telegrams and phone calls and what I read in books, which were disruptive enough and the source of unbearable nightmares.

I first confronted real-life murder on a small black and white screen late one March night in 1962.

We lived in a protective enclave in those days, a small, closely-knit and gossipy town. Everyone knew my family and knew that I was capably providing nanny services for my mother. By the time I was fourteen, I was among the most sought-after baby-sitter in town. I never had to set a rate. Mothers offered me at least twice what I would have thought to

ask for to watch their offspring for a night or a weekend. My schoolwork and home responsibilities kept me pretty busy, but I made time for one or two select regular customers.

The Barkleys were an easy choice. They lived in the house adjacent to mine and had a single child. They also had a television with multiple channels.

My father didn't believe we needed television. But had we owned one, we would have had access to a single channel. WPTZ, out of Plattsburgh, an NBC affiliate with a few ABC offerings as well. Programming was limited, so I never felt deprived for not being plugged in.

The Barkleys had a cable connection of some sort, and they received channels from Burlington, Albany, even Montreal. It was a miraculous source of entertainment for the long hours awaiting their return from their periodic outings. On week-nights, I would hold my breath, willing the parents to stay out late enough for me to watch *The Tonight Show*. Jack Paar amazed me. He had guests like Oscar Levant and Totie Fields and Hans Conried, and they talked about issues I would never have considered otherwise. Levant talked about his drugs and ticks, Fields about her weight and diabetes, and Conried shared sala-cious Hollywood stories. Paar himself was often hilarious.

Weekend stints were even better. I'd move in and take full custody of the Barklays' polite little boy. Once he was in bed, I'd overdose on the veritable cornucopia of flickering options. I watched *Romeo and Juliet* for the first time, saw my first televised ballet, listened to classical music concerts, and watched *Bonanza*, *Playhouse 90*, Ed Sullivan.

My love affair with their television ended on March 24, 1962, the night Emil Griffith killed Benny "Kid" Paret.

Mr. and Mrs. Barkley were at a banquet, a very late-night affair. I put Brucie to bed, did my homework, watched all the prime-time stuff and then sat mesmerized by the sign-off signal on the channel I was watching. On a whim, I flipped the dial to see if any station was still broadcasting, and I happened on the

infamous match, live from Madison Square Garden. The bout was well into round 12 or 13. I was horrified but could not look away. How could such a thing be called "sport?" Why did the "players" punch with such fury? Why didn't anyone stop Griffith from pummeling the Cuban guy? How could he have so much hatred in his fists?

None of it made sense.

I panicked. I wanted to turn the set off. I could not move.

Paret was going to die. Griffith was going to murder him. No one was going to intervene. Griffith was relentless, long after Paret was visibly conquered. When the officials finally pulled the aggressor off Paret, the smaller man lay motionless, where Griffith left him. His bleeding face was contorted in frozen misery.

I blamed television for subjecting me to the gruesome spectacle. In truth, however, I suspect that the brutality of it evoked the scenes I imagined my family endured, conjured the dark fury I felt in my childhood nightmare. In any case, I vowed two things – never would I watch television of any kind after the broadcast day ended and never would I ever watch boxing in any kind of way ever again.

Yet, nothing in that experience prepared me for my first first-hand encounter with real-life violence.

Soon after my evening of horror, the Barklays moved away, and a childless neighbor took their place. I was relieved that I would not be tempted to watch late night television but saddened that I had lost my best source of personal income. As it turned out, I soon had a new one.

In what seemed like a serendipitous moment, my mother returned home from a College Club meeting one night and said, "Judy Zakaryan asked me today if you could come babysit for her. You know Judy. She mostly needs someone who can spend weekends."

I was delighted. Overnight work paid overtime wages. I did know her. She was my guitar teacher. I liked her a lot.

Despite her many accomplishments, which included

advanced degrees from a prestigious university, a book about guitar instruction, and a host of concert appearances and recordings, Judy was known in our town as Mrs. Dr. Zakaryan.

Dr. Z was the newly-arrived pathologist for Tupper Lake, Lake Placid, and Saranac Lake. A specialist in forensic medicine, he had graduated from a small liberal arts college and studied medicine at the same university where Judy was enrolled. My mother's reverence for the doctor was abject. Her upbringing, her own diverted dream of being a doctor, her inescapably low self-esteem conspired to render her incapable of criticizing anyone with as much erudition as she ascribed to Dr. Z. I realized later that I, too, was influenced by her estimation. I, too, succumbed to an inflated view of his intellect and expertise. I see now that had my mother been able to look at the couple with an open mind, a mind with which she admitted to her own disappointments, she might have recognized Judy as a kindred spirit. I was too young to understand the depths of Judy's predicament, but I was nearly sycophantic about her.

Judy had tabled her career as a classical guitarist to be a stay-at-home mom who gave occasional lessons. A wannabe folk singer and her guitar student, I was in her thrall. She had asked me about babysitting, and I had told her I was not sure my mother could spare me. So she went straight to the source. My mother would never have turned down an opportunity for me to endear her to so respected a townsperson as Dr. Zakaryan. I was delighted.

But from the start, the job was a challenge. I was used to the sweet little Barkley boy, who went beyond expectations to please me. The Zakaryan boys were anything but sweet. The oldest was sullen, moody, even secretive. He would close himself into his room at the top of their cavernous house, refusing to come out even for meals. There was no television in the Zakaryan house, which I found personally consoling but vocationally disturbing since it was up to me to keep the other two boys from killing themselves or each other.

I would arrive on Friday afternoons, and sometimes both parents would be there. They might be preparing to go to a fancy fundraiser or a weekend conference, or they might be preparing to go their individual ways. No matter what, from the moment I entered the house, they both abrogated responsibility. I was in charge of the brood. Their sons took this in their stride and only vaguely acknowledged my arrival. No real change in their activities happened until the parents were gone.

As soon as both parents were safely removed, the oldest would slam his bedroom door and lock it. The two younger boys, less than two years apart in age, would begin bickering. By the time we had been alone for fifteen or twenty minutes, all-out war erupted. Fires were lit in backyard attempts to create missiles, hoses were dispatched to soak whole portions of the house, especially where open windows allowed the water to flood the room they shared. Mrs. Zakaryan told me each time she left that my job was to oversee but under no circumstance was I to endanger my own life trying to come between the combative duo. I found the best tack was to find something we could all do together – we made cookies, went for hikes, made plays in the basement, etc. Being busy successfully distracted them from their rivalry. For a time. Then it would rise again, and I would fumble for another solution. Each Sunday that I dragged myself home from an interminable weekend, I collapsed into my bed, grateful that all three kids and I were still alive with no visible scars.

As a parent, I am incredulous that my parents did not see the toll the weekends took on me; I am more incredulous at the couples' overt neglect of their young sons. At the time, though I understood how unruly the kids' behavior was, I said nothing to my parents. I would not have wanted them to know anything that might move them to forbid my returning to the crazy house.

The boys' penchant for fighting derived, I became convinced, from behaviors they observed in their parents. Each Friday, while Judy and the doctor prepared themselves for their exits, I

was often aware of a brawling enmity between them. They would shout mercilessly at one another. He screamed obscenities at her, and she would volley curses of her own. After a while, quiet would ensue, and I would hear whispering something like., "Please, we don't need the whole town to know. . . "

His simple reply was inevitably, "Who the fuck cares."

Once I began working for the couple on weekends, I gradually understood the bruises I often saw on Judy's arms and torso as she leaned in close to correct my hand positions on the guitar. Sometimes she would return on Saturday and ask me to stay so she could rest, and he would come home late in the night. I would hear then the sound of agitated voices and heavy objects hitting the walls. I was convinced that one of those heavy objects was Judy herself.

I talked to my mother about the situation. "Shouldn't I tell someone what I think is going on?"

She was adamant that I say nothing. "You don't want to cause trouble for the family just because you have your suspicions. He is, after all, an important man in this community."

My participation in multiple extracurricular activities gradually diminished my availability, but I continued to spend occasional weekends at the Zakaryans'. Those weekends became steadily longer and increasingly stressful, and I found myself wanting to pull away. I stopped taking guitar lessons too. It was too painful to observe the growing signs of abuse that marked Judy's appearance and behaviors.

She often had one or more black eyes. More than once, she could hardly play the guitar because of broken fingers.

I reached my limit when I arrived one day for a lesson to find her in a huge cast that encased her upper body, suspending left arm out in front of her, immobilized by a bar. The back of her head was shaved, and I could see stitches there. When she talked, her words slurred together, as though she had swallowed a ball of cotton that absorbed the sound.

Again, I asked my mother for advice. Yet again, she urged me

to withhold judgment. "You never know what the truth is in another person's life," she counseled.

Conflicted and confused, I decided I had to end my relationship with the family.

I still marvel at my mother's silence. She must have known there were rumors. Judy was best friends with another prominent physician's wife. The two sang duets at major fundraising events, often socialized together. Both were seen on the arms of men not their husbands. In those days, a woman thought to be philandering was simply assumed guilty. Women were not to be trusted.

Whenever the rumors spread that a man was having an affair, his wife was blamed. She was disrespectful.. Didn't meet his needs. If she were friends with men or if she had lunch with male colleagues, she was flirting, inviting disaster. A woman was a natural gossip, who told tales to her girlfriends or ran home to Mommy when things got rough. The entire marriage, just like birth control, was the woman's burden. It was 1975 before women were allowed to get credit cards, have bank accounts without co-signatures, explore careers that entailed anything less "feminine" than teaching or secretarial work. Those women who did follow the non-traditional female path were the object of derision in a community like ours. They were deemed evil, simply a promulgation of an age-old human tradition of caging women. Women who walk a less diminutive path threaten the patriarchy. It is clear by the way the male establishment and its female support groups insist on clamping down on reproductive rights, the way they vilify those of us who resist their dominance, the way they extinct women over fifty who can no longer be relegated to child bearing. A woman with time and a following can do a lot of damage to the comfortable status quo of the traditional American chain of command.

It is no accident that the women who were hanged or burned as witches were societal "rebels."

My mother was no different from most women of her genera-

tion – and mine. She had no sympathy for Judy because she revered the doctor. Besides, in those days, long before the Me Too Movement, women were more likely to throw stones at women who claimed to be abused. Women were complicit facilitators of men's crimes. I never understood exactly why they were so unwilling to decry the men's behaviors. Perhaps they were afraid they would suffer repercussions. Perhaps they had simply bought into the system, had accepted their place and, like enslaved persons who protected the enslavers, like hostages suffereing from Stockholm Syndrome, they were simply unwilling to be critical of their own predicament.

Further, because Judy made no secret of her having a life apart from her philandering husband, he was credited for having rightfully punished her.

I knew that the doctor had at least two girlfriends. I had seen him with one that winter sitting on a bench at the town beach. I almost didn't see him because he was entirely enveloped in her arms and upper body, passionately displaying all kinds of desire. I saw him holding hands with the other one at a store in Lake Placid.

Judy had one boyfriend for the entire time I was in her employ. He came to pick her up a few times, took me and the boys out to dinner at least once. He was artsy, handsome, seemingly gentle. It made no sense to me that Judy would remain with the doctor and not run away with this guy. She insisted they were just friends, and later I learned that he had a wife and children in a suburb near Albany.

When I could not take it anymore, I quit.

In 1963, the doctor's star rose in the firmament for a moment. Two young divers discovered a thirty-year-old corpse in a cave near the bottom of an 80-foot drop in frigid Lake Placid. The divers thought at first the body was a mannequin. Then, as they dragged it to the surface, the body began to decompose. It was Dr. Z who identified the body and dealt with the press.

The remains belonged to the first female dean of a prestigious

college, who had disappeared thirty years before. Reported missing by her family at the end of an annual camping week, she had disappeared without a trace.

The case made the doctor famous. Not just for his skill as a pathologist. But also for his drinking, which had escalated since I knew him. He was a pathetic drunk most of the time. It was a miracle he was able to make any determination about the woman, but he did. And to the press, he was a kind of a hero. To the local folk, he was just another poor excuse of a man.

I did not discover the details until years later.

Judy finally left him and eventually married a second time. Her husband may or may not have been the lover with whom I was acquainted. I had long since been gone from the scene.

The addendum to the doctor's story is a matter of public record. He moved to a small city in the Finger Lakes region of New York State and took a job there, which he executed with more or less competence. He did not distinguish himself in any way. Until he murdered wife Number Two.

A notice in a nearby city's newspaper reported on November 20, 1969, that, "The strangled body of (the second Mrs. Dr. Zakarayan) was removed to the Monroe County Medical Examiner's office, Rochester." Zakaryan was tried, found guilty, and sentenced to life in prison. I am pretty sure he is dead by now.

I am sorry I failed to be more empathetic toward Judy. That I was of no help. I regret that I accepted my mother's pronouncements about meddling. Though I don't remember it that way, I probably blamed Judy just like the rest of the town.

Conventional wisdom always blamed the woman. Not just in those days but through most of history. It is clear to me why Me Too causes men to get short shrift, encourages women to be overly quick to believe every allegation of abuse, to conflate uninvited flirtation and physical assault. The root of the rush to judgment lies, I believe, in the long-standing tradition of discounting women's claims, or overlooking all abuse, of society's age-old reluctance to punish crimes against women. Me

Too is a great idea. But it has carried itself to an extreme that I find harmful. Allegations are made that are unprovable, and people's careers and reputations are ruined. It has become another excuse for the supremacy of spectral evidence. Even so, Me Too might have saved my friend and teacher Judy.

The decision to exit my marriage helped me to understand how I failed Judy in those days. At the time, however, I hardly understood the way in which Judy's troubles were buried by societal insistence that the woman assume all responsibility for the health of her marriage. I only became sensitive to all that I could have done for Judy after I slogged through the messy proceedings that led to my divorce.

Women are their own worst enemies. And guilt is the main weapon of self-torture . . . Show me a woman who doesn't feel guilty and I'll show you a man.

— Erica Jong, Fear of Flying

Winnie: There is so little one can speak of. (Pause.) One speaks of it all. (Pause.) All one can. (Pause.) I used to think ... (pause) ... I say I used to think that I would learn to talk alone. (Pause.) By that I mean to myself, the wilderness. (Smile.) But no. (Smile broader.) No no. (Smile off.) Ergo you are there. (Pause.) Oh no doubt you are dead, like the others, no doubt you have died, or gone away and left me, like the others, it doesn't matter, you are there. (Pause. Eyes left.) The bag too is there, the same as ever, I can see it. (Pause. Eyes right. Louder.) The bag is there, Willie, as good as ever, the one you gave me that day ... to go to market. (Pause. Eyes front.) That day. (Pause.) What day? (Pause.) I used to pray. (Pause.) I say I used to pray. (Pause.) Yes, I must confess I did. (Smile.) Not now. (Smile broader.) No no. (Smile off. Pause.) Then ... now . . . what difficulties here, for the mind. (Pause.) To have been always what I am - and so changed from what I was. (Pause.) I am the one, I say the one, then the other. (Pause.) Now the one, then the other. (Pause.) There is so little one can say, one says it all. (Pause.) All one can.

Happy Days by Samuel Beckett

STRATFORD EPIPHANY

Even if I had admitted to myself how very unhappy I had become, I never would have had the courage to leave Richard in those days. He controlled all the money, handled all the important decisions like car care and insurance and long-term planning. I knew no women living on their own, and I was fairly certain that I would never be adequate to the task, especially with children. I thought all women living alone were pathetic. I subscribed to the notion that a husband and children defined a woman; without them, she was nothing.

Then, in the second week of my classes in Stratford-Upon-Avon, I got a glimpse of life as I might like to live it.

One day, out of the blue, Tony said to me, "I have a friend, a dear friend named Brenda, who lives in Marsden, in the Lake District." I must have stared blankly at him then because he explained, "You know. Lake District. Blake. Coleridge. Keats. Byron." I did know, but I had no idea where he was going with this.

"I think you should go visit her. I've told her about you, and she has asked me to extend her invitation. No, I am not joking. She's invited you. Go rent a car. Go to Marsden. Brenda loves to show people around. Go."

The very next day, behind the wheel of a cute little Volkswagen with the steering wheel on the wrong side and a left-handed gear shift, I was off to the Lake District.

Driving up the M6, the feeling of being in the 51st state returned. Except that I felt like I was driving backward, and there were no toll booths, I might have been driving on the New England Turnpike. It was glorious. Driving has always energized me; being behind the wheel fills me with a sense of freedom I experience nowhere else. I love the feel of a stick at my knee, the power to upshift or downshift at will, to force raw horsepower to do my bidding. It's invigorating.

I was nervous about meeting Brenda. I was never comfortable around women. I never figured out exactly why, but I could not relax with them. I'm guessing my negative self-image disconnected me, and I was never good at being a "lady," the well-behaved woman one was expected to be in my youth. I swore. I quoted Shakespeare insults. I defied conventions wherever and whenever I could, and I made women uncomfortable by not acquiescing to feminine protocols. But I surprised myself thoroughly by finding in Brenda a kindred spirit and a delightful companion.

Brenda was both a stranger and strange, a woman with whom I got along splendidly. In fact, I could not have enjoyed anything any more than I enjoyed being in the Lake District that July weekend. Brenda would drive me to the craggy hillsides, and she would say, "I can't climb with my bad legs, but you go. I'll wait here." And then she would sit in her car until I returned from my hike, and we would visit a church or a decaying castle before retiring to a local pub.

Brenda knew everyone in town. Like Norm entering the bar on TV's *Cheers*, Brenda entered the pubs to enthusiastic shouts of hellos, warm hugs, greetings that said how sincerely the people there appreciated her arrival. She explained to me that a pub was the English version of a living room.

"Our homes 'r' small. No place for company to come and

share a pint or even a cuppa. So we go to the pubs to meet up and share lives."

Share lives we did. With the local folk – twenty-some towns-people gathered to swap stories. The weather, the day, the news from abroad. Brenda told some very bawdy tales that had us all blushing and at the same time rolling off our stools with delighted laughter. Then she initiated a game of charades, and they all guessed even the titles I thought would be esoteric. It was the best party I ever attended.

The next day, over breakfast, Brenda and I could not stop talking. We discussed everything under the sun. None of my views seemed to offend her, and I found myself talking as much as I listened, which I rarely did at home. Brenda shared my sense of language, my iconoclasm. We recited Shakespeare and dissected Donne, complained about sexism and ridiculed the male mystique. In short, while we were forging an instantly deep friendship, we mostly just had fun. Before we knew it, it was time for another tour of the area and another evening at the pub.

Much to Richard's chagrin, I did not call him at all that week-end. I didn't miss him. I don't even remember missing my children.

I asked Brenda, at some point, if she were lonely. She had to think about that for a bit before she replied.

"Naw," she said finally. "When m'Harry died, I thought I'd die of the loneliness up here in the hills. But I don't miss him s'much. Sometimes not at all. I have my friends, my amateur theater group, my books. Nah. I'm good. Real good."

At the time, I wasn't sure I believed her. I do now.

Take your life in your own hands, and what happens? A terrible thing: no one to blame.

Erica Jong

RETURN TO REALITY

Steeped in my Shakespearean fantasy, I somehow erroneously imagined my life an idyll of domestic bliss back there in Connecticut. I forgot that Stu had died. I forgot that I was desperate to have the freedom to write. I forgot I didn't know where I had put my real self, forgot I'd thought that my new sense of agency and reinvigorated zest for life would lead us back on the road to living happily ever after.

I spent a couple of days with Tony and his family in London and felt a pang of envy. Tony and Ruth had carved out a story-book family, each member gushing with love and appreciation for everyone else. Creative pre-teen kids with multiple, well-supported interests, the wife encouraged to write and paint, husband free to explore his impulses to murder and create, as it were. They had been assigned to the London campus of Tony's college for the coming year, and their flat was downright electri-fied with excitement. I thought that Richard and I should be more like Tony and Ruth. We could be this happy.

Flying back over the Atlantic, I envisioned our reunion. The kids morphed in my head from the aloof teenagers they had become into the exuberant little ones they had been when we took them to Disneyland or Sea World or Yellowstone or the

Lincoln Memorial. Richard's sanguine dispassion animated to something verging on joy. We'd celebrate our reunion with tears and laughter and a lovely dinner out.

My flight home originated early in the morning and got me back to the States before noon. Two of my children came to get me. They filled the car ride home with monologues about their summer. I smiled knowing that that was as it should be. After all, they were teenagers. When we got home, Richard was at work. I put my stuff away and spent the day running errands. In the evening, I made dinner, and Richard and our oldest child came home. After we all ate together, I cleaned up and fell asleep on the couch in the living room where Richard sat watching a sitcom. Life was in session. My re-entry was hardly acknowledged.

From there, my home life grew ever more dissatisfying, but it was my professional life that became unbearable.

My new principal and I never found our stride. She had already been the administrator for two years before the summer I spent in Stratford-Upon-Avon, and when I returned, I found her surlier than ever. She criticized every little thing I did or did not do: how I decorated my classroom, what I said at the welcome meeting for the first day of drama, the way I presented the literature to my AP English class, etc. I could do nothing right. She was stuck with me unless she could find cause, and because she was popular among the teachers who disliked me most, they sought to find one for her. A rumor circulated that I was smoking pot in the costume loft with my drama students. The assistant principal was sent to investigate. He told me, "The idea is just preposterous. Anyone who knows you or your kids knows it's a ridiculous claim. Still, you should watch your back."

Vile rumors flew. I was called so often into the principal's office for imaginary violations that I consulted my union reps. They told me to keep records. I did. The harassment did not stop.

I couldn't talk to Richard about any of it. He continually

reminded me that I was an upstart, that I lacked respect for the rules, that I was a troublemaker. It hurt me deeply that he thought so. I did question authority, and I did push back, but I never sought trouble. Since Richard and I couldn't talk about it, however, I took to calling my friend John from the Stratford days.

"In a way," John said, "he's right. You are a ball buster. That's why you do drama. You bend the rules, you test the limits, just like I do. Creative people do things like that."

It was good to have someone who understood, but I wished it were Richard. I liked John, even loved him as a friend. But he was not my mate. Nor did I wish him to be. I wanted the kind of relationship with my husband where I could tell him anything, and he would support my point of view. I wanted to be encouraged, not told how I failed to be good enough.

At the time, I had enrolled in a Shakespeare class at Wesleyan University, a feminist examination of "the Scottish play," a look at how *Macbeth* exemplified the casting of assertive women as villains and witches. Two of my classmates were out-and-proud lesbians from another town, women who knew my principal socially. I had always known my principal was a lesbian. It had not phased me. For most of my life I had consorted with gay men and women, and I never took anyone's sexual preferences into account. But sometime in the course of that class, one of the two women decided to confide in me.

"You know," she said one evening as we sipped ginger ale during our breaktime; "Ann is terrified of you."

"Me? Why?"

"You know too much. You have evidence."

"No way. I never slept with her. How would I know anything?"

"You know as well as I do that most people wouldn't get what you're getting at. Gossip is a powerful weapon in this state.". "

"C'mon. She's obviously devoted to the school librarian. They really don't do anything to hide. . ."

"The librarian is married. Has kids. People scoff at the notion that a married woman. . . . But you could come back and say you saw her at a gay bar with her gay girlfriends."

"Absurd. Why would I want to do that?"

"It's not about what you would want to do. It's all about what she's afraid you could do."

I had to admit that I was in a no-win argument. My class-mates laughed at my insistence that I would never out anyone.

"As true as that probably is, there is no way Ann would ever believe you! She's insecure."

"Insecure? All the jocks love her. And she's really good at hiding in plain sight."

"That could be true. But in her mind, you are a threat."

I cannot even imagine outing anyone. But there was no way to prove I could be trusted. Ann saw me as a free spirit, a loose cannon, a mouth that could not contain itself. I had no power to redeem myself in her eyes.

Connecticut Drama Association competitions were coming up, and my students wanted to enter a meaningful piece, as did I. We always took something out of the ordinary to the Festival, and as the vice president of the organization, I wanted that year's entry to be particularly noteworthy. After all, drama was my voice and the voice of each of the kids in that program. We worked together reading possible scripts, looking for one that I could reasonably cut down to fit the time constraints without destroying the essence of the play, a script that had something to say, a significant message that we could encapsulate in our 20-minute excerpt. We chose *Lips Together Teeth Apart*, a first-genera-tion AIDS drama by Terence McNally. The play has no real gay or lesbian content, but it is about a family collecting the effects of a brother who had died of AIDS.

I sent the play and my rationale to the principal for approval, and she approved it. I cut the play, sculpted our excerpt, and

distributed scripts to the cast. Then, the parents found out what play we planned to do.

It was the father of the boy cast in the lead role who stirred up the brouhaha. The boy was, at the time, still very young but beginning to explore uncloseting himself. We had had some conversations about the difficulties of disclosing to parents and friends, about being gay in a small New England town. Dad was the principal of a local elementary school, a colleague of our principal, her buddy. He was appalled that his son would participate in such a play, one that failed to chastise or blame or damn the AIDS patient, and he demanded that our principal forbid our using that play. She told him she had not approved it, that I was a renegade.

I protested, insisting that I had the written proof that she had approved the play, pleading to be left to it. She looked me in the eye and said, "You are evil. Truly evil." I left without responding; I was too shattered. And I could not change her mind.

"You're so dramatic," Richard chided me when he came home from work that night to find me still sobbing on the living room couch. "What does that mean anyway? She's your boss. Do what she asks, and let it go."

I waited until he went to bed and called John.

"You should have had your Union Rep with you," John protested. "I'll come up there and tell her what I think. You shouldn't have to endure that kind of abuse."

"Thanks. But anything anyone might do like that would only make it worse. I already chose a different play."

"Okay, but remember I said I'd come beat her up if you asked me to."

"You're a good friend."

"What's the new one?"

"Hunh?"

"Play. What are you going to do?"

"A Christopher Durang short play, parody of *Glass Menagerie*. . ."

"Ah! *For Whom the Southern Belle Tolls.*"

"Yes."

"Good. She'll hate that one too."

She did, but we were the hit of the festival, and she could not argue with that.

John came to the Festival. Richard did not.

Shortly afterward, I got a call from a colleague in a nearby town, the drama guru of the State of Connecticut. He told me that he had offered my name as a candidate for the director of the drama department being established in a nearby town for the new high school that was under construction. I would probably be called in for an interview.

I got the job, and I was thrilled. The principal, newly imported from a large, arts-friendly high school in Massachusetts, seemed much like Stuart, and I could not wait to get busy. He took me to the theater they were still building, which was already turning into a state-of-the-art dream theater. The school board, my new principal told me, was a hundred percent committed to the drama program, which they hoped would bring students and money from around the region. All the fundraising events I had had to run to fund my drama program, all the days of car washing, cookie selling, yard cleaning, goods rummaging that occupied so many of my students' and my Saturdays and Sundays were to be things of the past. Whatever I needed, whatever it took, I need merely ask, and it would be given.

And so began the worst episode of my teaching career.

In the first place, the school board, expecting that a theater was going to bring in instant cash, had defunded the finishing process. No lights were purchased, no sound equipment was installed. No machinery had been brought in to complete the gorgeous set shop and make it functional. In order to produce the shows, we still had to fundraise, and it was harder in this community because they had been convinced that by voting to pass the referendum to build the theater, their increased taxes

would create an income stream. The theater program was supposed to ensure that money would be coming in, not going out.

By the end of the school year, the principal was fired for embezzling funds from the sports program. Again, I had to adjust to a new principal, promoted from the assistant's position. This time, instead of being a miserable crone, she was a sweet, smart, delightful but entirely ineffectual figurehead. The Board of Education had wrested all control from the principal's office.

Luckily, at the very beginning of my tenure in this space, John and I found a way to make our dream of forming a theater company come true.

Encouraged by the music director with whom I had already been running summer theater programs for ten years, I wrote a grant proposal for the state of Connecticut requesting $140,000 to operate a conservatory-style summer and an afterschool instruction program called Sonnets and Song. The most difficult task associated with that process was naming our company, which John and I finally did, calling it the All in One Ensemble, a reference to Shakespeare's Sonnet 8, which says, ". . . Who all in one, one pleasing note do sing: Whose speechless song being many, seeming one, sings this to thee: Thou single wilt prove none."

It was to be a brilliant collaboration.

During the school year, we bussed kids from area suburban towns to a music room at the University of New Haven, where we schooled them in *bel canto* vocalizing and classical acting techniques. At the end of the year, we put on a variety show. But the summer program was our *piece de resistance*.

From New York, I hired professional actors, tech people; locally, I hired room advisors as well as kitchen and maintenance staff. I scheduled classes, rehearsals, seminars, and private coaching and made all the arrangements to house students, who were recruited from the largest urban areas of Connecticut, in the UNH dormitories along with whichever of our staff required a place to sleep.

With John, I designed a program where kids were bused to the theater from UNH every morning at 8. We fed them breakfast, and then, they had morning rehearsals, a break, more classes, lunch; then, they had afternoon rehearsals, classes, dinner, and some kind of evening program. Professional actors and tech people worked with the kids on and backstage at the same time they were coaching them. It was a fabulous program. We produced *As You Like It* and *Sweeney Todd*; I hired a talented young local actor to direct *As You Like It*, and I directed *Sweeney*.

Everything would have been swell if my music director hadn't fallen in love with one of our 17-year-old students, his 16-year-old daughter's best friend. Things might have remained swell even if he had fallen in love with her but hadn't told her and her friends and the kitchen staff and the security guards and. . . . We managed to get through the summer without a scandal, but we did not get through without meltdowns. He whined to every male member of our cast and crew, complained that I insisted that he keep his hands off her. My trust was sideswiped. I had heard a rumor – a rumor I had naturally ignored – that he had a history of falling for his students. I was aware that the mother of his children graduated from the high school where she was his student the June before their summer romance made them parents. I allowed him a pass. Past is past. Besides, in the ten years I had known him, he was a divorced man who dated age-appropriate women. His revelation of lustful yearnings for a child in our cast shocked me, and I told him so.

We parted company at the end of the summer. He could not forgive the fact that I had the audacity to call him an idiot. That I refused to tolerate the egregious indiscretion he daily begged me to sanction. He was hell bent on telling the girl in question, and I knew her to be fragile enough to be traumatized. Acting on the girl's behalf, the music director's daughter asked me if the rumors were true, and I answered honestly. She moved out of his house and in with the girl in question. All the girls' friends

rallied around her and kept him away from her. Children should not have to do such work.

The summer program ended, and I told the music man he must apologize for his behavior or find someone else to work with. He flew into a rage and never spoke to me again. He did not, however, refrain from besmirching my name. Anyone who would listen got an earful of how I had cheated my staff out of their rightful pay, how I had cheated the system and had made money on the program. He sent word that he would keep his accusations from state assessors if I paid him hush money. I laughed. I have no idea whether he actually made such a report. It didn't matter. I was heartbroken – he was a brilliant music director and a wonderful artistic collaborator, but there was no way I could ever work with him again. Neither was I surprised to learn that many of the students and their parents believed what the music director said about me. Spectral evidence is plenty on which to hang a woman's good name.

I did not report him to the authorities. His behavior was not necessarily illegal, especially because he had not, after all, molested the girl. It was enough that everyone knew he had made a fool of himself. If I had gone to authorities of any kind, I knew I would be the one interrogated and suspected. He was a very influential man.

There was no point in applying for refunding the following year. All the good work, all the wonderful accomplishment of the program were aborted. John auditioned for a New England repertory theater and was cast, and I went back to teaching. But not for long. In the aftermath of the conflict, I came to the only possible conclusion I could draw: I had to retire from teaching.

FROM SONNETS & SONG TO BAGEL FISH

I met Daniel Fine in the spring of 1998 as I prepared the conservatory summer program. I held recruitment sessions in a number of inner-city schools in greater New Haven, Bridgeport, and Hartford, and one of the places I focused a lot of attention was the Educational Center for the Arts in downtown New Haven, a performing arts magnate program where one of my children had studied. ECA was (and remains) a school I trusted to have disciplined, talented young actors who would jump at the chance to be part of such a program. I spent several hours there one day talking to the kids, exchanging ideas with the teachers, explaining the audition process, etc. As I was leaving, a young man with a face as earnest as a promissory note approached me.

"Hi," he said gently but not obsequiously. "My name's Dan Fine. If you're recruiting students, you must also need teachers. I'd be great for your program."

I was immediately enchanted and accepted his offer to go to a cozy little café called Koffee on Audubon Street and talk.

Marathon talk.

About Ibsen. "I feel like Nora," I laughed. "Not in a good way."

"I get that," Daniel commiserated. "I think being a wife must be like getting a job with a theater company to direct a play then being told by the artistic director what your choices will be."

About Shakespeare and how sad it was that Shakespeare was so mass-produced in America. "There should be a moratorium on doing Shakespeare for at least fifty years," Daniel proposed. "Then when he's brought back, maybe theaters will have figured out a new way to present his genius, and it won't seem so hackneyed."

And then he said, "Are you hungry? Let's go to the market and get some Chinese."

We strolled the few blocks to the market on Chapel Street with a buffet. I had never bought food there because the food seemed old and unclean and very meat-intensive. But Daniel did something I didn't know was possible. Before anyone could ask me what I wanted to eat, he said to the woman taking orders, "My friend is a vegetarian. Could you ask the chef to make an order of mushroom noodle soup, without any meat, in a vegetable broth?" The woman nodded, and I told Daniel it had never occurred to me to ask such a question. "Lots of artists eat here," he replied. "We need pampering, and they comply. That's why we like them."

Artists. Come here. Me too. I am an artist. I had not used that word to describe myself since I was in high school, and the thought of it made me positively giddy.

Four hours later, I wrested myself from Daniel's company only because I had to get home. It was clear we would work well together, that he would be an asset to the program, that we would learn from one another. I had hired him hours earlier.

We talked nearly every day and began to collaborate even before the summer commenced. I was astounded because here was a man a third my age, who saw me not as a maternal figure, not as a teacher but rather as a co-creator. He recognized my need to produce, to engage with the arts, and he fueled me,

encouraged me, made me feel smart and talented and worthy, like I had a professional presence that mattered.

It seems odd to me now that I didn't see myself as any kind of an artist until then. I directed school theater, wrote poems, composed soulful letters and op/ed pieces, constructed dialogs. But I never got rid of my mother's voice ringing in my teenage ear, the Saturday morning voice that angrily scolded me for "scribbling" in my room when I should have been cleaning or watching kids or running errands or. . . .

"Artist " was an honored moniker in my family. My cousin Peter had achieved it. His father maintained it. But I was "just" a teacher, a mother, a wife. . . . Allowing myself the luxury of re-imagination was a huge gift I owed myself, and I gratefully accepted the challenge.

That winter, searching the Yale library for a unique play in which to direct his advanced acting students at ECA, Dan found an obscure anti-Fascism play written during WWII by Croatian surrealist poet Radovan Ivšič. Daniel saw in the play an opportunity to engage a variety of media and approaches, and he was determined to direct that play. To get the rights to do so, he had found, it was necessary to contact the playwright, who lived in Paris. Since I was planning a trip to Paris to settle my daughter, who was about to study there, and because I could hold my own in French, Dan proposed that, as his newest producer, I should find the author and get the rights. A producer! How could I refuse?

Radovan was thrilled to have his play produced in an educational setting by a new generation of prospective acolytes. He and his wife, feminist writer Annie LeBrun, traveled to New Haven for the show and stayed at my home for the week. It was intoxicating being a driver on that exciting journey.

In the ensuing months, working first on Radovan's play and then on another project, Dan and I nurtured our friendship and our professional collaboration, and both deepened as we became immersed in the summer project. He worked very hard to help

shape and reshape every aspect of both shows, the educational components, the instruction; then, he assisted me in reshaping my life.

I was grateful to be recognized as an artist. I inhaled the validation and felt revived.

Rumors flew about Dan and me. Jealous accusations mostly from observers who could not have known better. Nothing was illicit about our relationship, but it still made me wonder that Richard never questioned it. I confided in him that there were rumors, and he shrugged them off with his usual, "You're overreacting" line. As had happened in England two years before, I felt unfaithful, and I was made guiltier by the fact that Richard and I never talked about the fact that I felt that way. I never knew whether he simply trusted me or was indifferent. He was no more and no less explosive than ever; he continued to ride roughshod over the finances, to belittle my extreme restlessness with teaching, to be an ardent lover but an indifferent companion.

Summer arrived, and John moved into our house for the duration of the Conservatory Program, and still Richard never so much as raised an objection. He went to work, came home, made the same small talk, watched the same nightly television, acted like everything was just as it had ever been. He ranted and raved about all manner of insignificant things, but I was making a lot of extra money that summer, so he toned done his personal critiques of me and simply let me and my fellows be. John contributed to household expenses, and that mattered too.

The best part about having John there was that every night was like a slumber party. John and I would get into our comfiest clothing and settle into the living room to talk about the day, batting ideas about *Sweeney Todd*, in which I had cast him in a major role, or *As You Like It*, which we had both seen in England two summers before or about some person or event that stood out from the day. Our musical director was a source of much amusement.

It's strange to think how glib we were about the music director. The whole "boys will be boys" mentality governed our reactions in the early days of our awareness. I know now that I waited too long to take it as seriously as it needed to be taken.

"Well," John would say to commence a typical conversation about the music director. "Did you see how Joseph Henry, Ph.D. had to keep running to the men's room today while he was working with Dara on her solo?"

I gasped and then laughed. Neither of us was much of a gossiper, but I think we were both conflicted as to how much we should worry, at what point we should intervene.

"Credit where credit is due," John said in one of our conversations. "He made me go with him to lunch so he could tell me how much he's holding in. I gotta hand it to him. He does manage to keep it from her. He promised me he won't tell her what he's feeling, but he acts like a preteen in love every time she is around."

"Yeah," I grunted, no longer amused. "And I notice he's wearing a lot of long, loose tops these days. Over very loose sweatpants. Every day. Creepy."

"No doubt about it. "

Richard was sitting nearby.

"I thought you liked the guy."

"Not since he turned into a pedophile."

"Oh." He left the room.

"Did we offend him?" John asked.

"Nah. He just doesn't like to talk about anything unpleasant. "

I vacillated between gratitude for Richard's abiding trust and anxiety over what felt like my dispensability. When I think about that time, I feel real empathy for Richard and a modicum of guilt. He did not understand what I needed from him, and he was trying his best. I was unable to articulate my feelings, my misgivings, my confusion, and he lacked the empathy or the sensitivities to make any educated guesses. Nor should he have

had to. It was another sign of our basic incompatibility. Another sign that we had a marriage built on assumptions made by children who didn't know themselves or each other well enough to make a lifelong commitment. Still, it was hard not to feel taken for granted.

When we were engaged, we had no money. There was no engagement ring. He had long ago convinced me that to spend money for a ring was a waste of resources. We had greater needs that demanded our limited funds, he insisted. Years later, in that insecure place where I wondered how important I really was, I initiated a conversation about a ring. Our 25th Anniversary was approaching, and I wanted to be courted, to have my value articulated. I asked for a ring. Richard was enraged.

"You hypocrite," he screamed. "You said it didn't matter whether you had a ring."

"It didn't then. I just want a token. . . "

"We have three children. That should be token enough."

It was not. But I let it go. I questioned myself. I rarely wore any kind of jewelry. I asked myself why I thought I needed a ring as proof that I mattered.

Some months later, on the eve of the anniversary, I pointed out that our wedding bands with the little turquoise studs were showing the signs of wear. Without the little stones that had fallen away, the bands looked dull and lifeless. I suggested that we go to a jeweler and pick out a new set. Again, Richard flew into a rage.

"These rings are the symbols of our love. Why would we want to replace them?"

I could have done my English teacher thing and pointed out the way in which the damaged rings were metaphors for our marriage. But I was too tired of begging for validation. I let the matter drop.

I did not, however, forget about it. The thought of those crumbling symbols of our union looped endlessly in my head. Why did I care? Maybe I thought buying new rings would be a

sign of recommitment? Maybe I thought if we patched up the symbols, then our marriage would stop gasping for breath. I haven't yet found a satisfying explanation for the weight I ascribed to those rings. I only know I hated wearing the bedraggled remnant of my lovely band. In the end, I dismissed the rings altogether and focused on the new direction my work was taking.

Having John around was an elixir. Running the program boosted my self-confidence. I needed no ring, no mere symbol of love to prove my worth to me.

John left when the summer ended, and then, in September, a catastrophic illness descended on my family. It came at the moment our afterschool Sonnets and Songs program was also experiencing a bit of a crisis. Thanks to me.

The summer of the All in One Ensemble, a composer friend of Daniel's approached him and asked for assistance revising an opera he wished to turn into a musical show. The summer grant extended into the school year, and we needed something exciting to produce with our students. Naturally, we decided that the friend's musical, a Native American myth brought to life with music and dance, would be the ideal way to spend the money. We had visions of taking it to the Fringe Festival in Scotland. Our kids were good enough, and the music was strong. Unfortunately, the composer didn't have much heart. What heart he did have, I managed to kill.

My mentoring style in the classroom was always encouraging, positive. My students came to me for reassurance, for reinforcement. But suddenly, I found myself baffled by mentoring this adult, who had never written anything before. Though he was a talented musician, the man had an office day job in a very non-artistic capacity. He had no facility with words, and yet he insisted he knew all there was to know about writing. Since he was unreceptive to gentle critique, I became sharply critical. I lost patience, became short-tempered. No matter what

suggestions I made, he pushed back, and he fought me about every facet of the work.

I stood my ground, insisted that the changes I was suggesting would make the script more vibrant, more relatable, more accessible to our audiences. I was right, but he resisted with yet more force. He might have responded better if I had given Daniel my notes and let Daniel convey them. The male ego is far more likely to accept suggestions from a respected "bro" than from an older woman. I was unwilling to let go of my newfound ability to insist on being heard.

But then I made a mistake that caused the project's instant death.

In exasperation one day, I asked the author, "Do you want this play to be produce-able, or are you satisfied to be writing like a 4th grader?" Something to that effect. Entirely out of line and contrary to everything I wanted to be as a mentor, teacher, producer. The sentiment was right. The approach was disastrous.

Daniel didn't dump me, as I supposed he might have. The composer did. In truth, the script was subpar, and no matter what we asked of him, we weren't going to make it a viable piece because he was never going to revise competently. I was sad that our students would not have an original work to premier, but they were not cheated in the long run.

After the composer left us, we went on to do a successful abbreviated production of *A Chorus Line*, and Daniel asked me to collaborate with him on a more permanent basis.

At first, it was just an invitation that required going to Washington for February break. Daniel shared a company called Bagel Fish Films with a partner who lived in DC, and they had written a screenplay that needed some doctoring. They brought me in to do some writing, and we got along so well that by August all three of us had quit our jobs, had re-written the company charter to include me as a partner, had re-christened it Bagel Fish Productions, and were on our way to our very own writers' retreat in Saranac Lake, my hometown.

This time, I didn't ask Richard.

Too much was happening on our home front, and I was reaching a point of total exasperation.

A few months earlier, after collapsing at a college sports practice, our child was hospitalized in New York City. My students and I were rehearsing a production at my suburban New Haven area high school campus. In order to visit the child, who was technically not a child anymore, I had to drive to the city each night after play rehearsal then drive home, usually after midnight, and then I had to be back in school every morning before 7:30. One night, terrified by the waves of fatigue-induced nausea and dizziness, I begged Richard to drive with me.

"I'm afraid," I moaned. "I can't keep this up."

Today, my hindsight reveals that he was terrified of the situation. He loved his child. Of that I am very sure. But he was never good in a crisis. And he thought of me as impervious. That he could not recognize my fragility was not his fault. It was his youth at the time of his becoming a father and, moreover, the result of a societal preconception that the mother is the one responsible for fixing what needs mending when it comes to children; fathers fix what needs mending when it comes to cars and houses. When one of the kids was ill or injured, he deferred entirely to me. He panicked. From where I am now, I can see that I should never have expected anything else. He collapsed in rain, felt paralyzed by snow on the roads, froze solid when we missed a turn on the highway. On a camping trip early in our youthful courtship, our tent was deluged by a sudden storm, and we had to paddle our canoe through the rain in a thunderstorm to the mainland from the site where we had pitched our tent. For every second of the fifteen-minutes I paddled that canoe, he screamed and carried on, "We're going to die. We're going to die."

I should have been more understanding. Richard was being Richard. But at the time, I was spent. And I found myself tempted to hate him.

At that point, we had been married for nearly thirty years. I

was used to being a low priority. This was, after all, the same man who refused to have our air-conditioning serviced even after the ob/gyn told him I could die of the heat at the end of my last pregnancy. The same man who insisted we celebrate our 25th anniversary camping in my hometown instead of in any way I requested. The man who promised he'd support me while I wrote and then refused year after year to take on any additional work when we needed to augment our income and relied on me to take on more and more responsibility. That my belief that he would change, that he would make the ultimate sacrifice for me, that he would demonstrate his love persisted was waning, but still I begged. He was obdurate and repeated an old refrain. "I don't do New York," he said. That was that.

Later, driving in the dark to the city, I realized I was angrier and more disappointed than I had ever felt in my life. Bad enough this man rejected my plea. Bad enough he had no need to protect me. He was a father. He had always been a good enough father. Though he mostly deferred in most decisions we needed to make about them, he had never indicated to me that he would walk away from them when they needed him most. Wasn't that what he was doing now?

I tried to imagine what my own father would have done in this situation. He was throughout my childhood tyrannical about many things. We had fought one another tooth and nail. Yet he never failed to be there when I needed a father. I found myself revisiting an event I put him through the year after I dropped out of college.

It was early summer, and I needed to move. Never an easy daughter, I had moved three times in a few months, and each time Dad helped me, and each time I promised it would be for good. Once again, I called my dad and asked if I could borrow his van to haul my stuff from one end of Manhattan to another.

The van in question was a brand-new VW van. In those days, the VW was still new to the US, and Dad used his for business. He hauled toys and sundries around the North Country in his

company truck; in summer and at holiday time, he needed a second vehicle, and he hired my brother or me to drive the van alongside him as he made his rounds.

When I requested the loan, Dad did not hesitate. Of course I could borrow the van. I could come out to Saranac Lake on Tuesday, drive back on Wednesday, and move my stuff on Thursday. But he needed the van back by Saturday morning.

I executed the move with the help of a friend and, earnestly determined to get the van back ahead of schedule, I took a nap, packed up my things, and headed north. The friend who helped me move came with me as far as his parents' place in Monticello, NY, where I dropped him. As I was about to drive away, he brought me a huge branch of lilacs.

"This will sweeten the road ahead," he gushed as he placed them on the dashboard. "Drive safe!"

I got as far north as Schroon Lake, and I could not stay awake, so I pulled over into a rest area on the Northway, and I slept. How long I slept I'll never know. However long it was, I thought I had slept enough. I pulled out onto the highway, and very soon thereafter I was suddenly catapulting into a small ravine. The van was rolling over itself, and I must have blacked out because I inexplicably found myself sitting on the floor of the van. The windshield had popped out onto the road, and the lilacs were standing upright in its place.

"Am I dead?" I asked myself. "I don't think I am."

I got up and walked dazed into the road. The sun was just beginning to peek through the early morning rain clouds that were gathering, and I lucked out. A motorist stopped and assessed the situation quickly enough to take me into town, where I was able to call the police and my father.

"Daddy," I sobbed when he answered the phone. "I did a terrible thing. I ruined your brand new van and. . . "

"Are you okay?" Dad interrupted.

"I think so," I said. "I might have some bruises, but. . . ."

"That's all that matters," he said. "I'll leave now, and I'll see

you in an hour or so. Stay where you are. Everything will be okay."

The van was totaled. Dad bought another one, and he never chastised or recriminated me for the accident. All that mattered to him was that his child was okay. Everything else was inconsequential.

How could Richard not feel that way about his child? I wanted to call my father and ask him to talk to Richard. But even if he had been alive, I would not have called him. I was too embarrassed. I could never admit to anyone that I allowed myself to be in this position. My anger settled into my stomach, where I knew it would fester. So be it.

My brother's wife Lisa and my young business partner Daniel saw what was happening, how frazzled I was. They alternated driving duty. Each of them chose a day to drive with me.

"You're not going alone anymore," Daniel told me. "I can't deal with hospitals, but I'll gladly drive you into the city; then I'll find a place to sit and occupy myself until you're ready to go home."

When it was his turn, he drove to New York and found a place to read or study while I visited in the hospital, and then he drove me home in the wee hours of the morning. On most of those trips, we didn't even talk; he just drove and provided a strong, protective presence I had no trouble leaning on. When we did talk, however, we inevitably talked about our work.

Long after the nightly trips to NY stopped, home life was painfully challenging while we dealt with the illness. And I dealt with the smoldering resentment that visited me in the form of searing stomach pain, chronic constipation, itchy skin. I didn't want to feel disappointed anymore. Or to wish I were loved. I wanted an active, helpful, affectionate partner.

Shouldn't my husband have felt at least as protective as my friend and my sister-in-law? Shouldn't my husband have understood I needed him now more than ever? Yes to both questions, I reasoned. A resounding yes.

When Lisa accompanied me, she never left my side. She drove, sat with me, then drove me back, nursing, as she did, a bottomless Starbucks espresso drink. Clearly, my brother was better at choosing a loving mate than I was. What was wrong with me?

The back-and-forth went on for two weeks. Then, by the grace of our family pediatrician, we turned a corner.

The remarkable doctor came to New York and arranged for my child's transfer to Yale New Haven hospital. Then, he rode with them in the ambulance while Lisa and I followed behind. I wept all the way to the emergency entrance. Tears of relief. I had not realized how terrified I was until then.

After that, recovery was slow, but recovery did happen.

My child's recovery. Not mine. I was just beginning to fall apart, but I didn't know yet that I could not forgive Richard this time. So while I formulated no concrete plan to leave and kept doing what I had been doing, I grew ever more detached. I wasn't ready to walk away. After all, I was waiting for that most wonderful thing to happen. He would suddenly change, become my champion, save me from my escalating disintegration. There is no way I can explain why I remained so deluded. I only know that I still felt tethered.

I was already over 50, not as youthful and resilient as I needed to be. Those devastating nights during the worst of the illness, if I got home from my New York hospital visits by midnight, I could catch five hours of sleep before I had to go back to work. But I often didn't get in until one or two in the morning, and because I routinely exercised before I went to school, I rarely had more than three hours' sleep. I couldn't be the kind of teacher I wanted to be. I couldn't be any kind of teacher. I felt like a character in a bad film about bad teachers; I would plan my lessons around films, and then, I would fall asleep while my students watched. It was a terrible arrangement. I complained to Richard, and he assured me I was over-reacting,

that this would all get better. We'd go back to the way things were before, and we'd forget this ever happened.

Yet, long after the siege of illness ended, the fatigue persisted.

"I want to leave teaching," I confided. "I'm tired of being tired, and I want to write."

"You can write in your spare time," Richard offered blankly. "And you'll have plenty of time for that when you begin collecting your retirement."

"You're kidding, right? I won't be eligible for retirement until I'm nearly 80," I groused. The state required a minimum of thirty-seven years of teaching to reach retirement pension. I didn't sign a permanent contract until just before my forty-second birthday.

"Don't worry," he replied. "You're healthy."

"Okay," I finally reasoned with myself. "Maybe the wait for that 'most wonderful thing' is nothing more than literature."

"Ah, Torvald, I no longer believe in miracles. . . . "

In my mind, then, I finally gave in to the inevitable and began the process of leaving.

Unfortunately for Richard, I did not share my revelation with him. I simply withdrew and encouraged him to believe what I tried to believe myself: that if I made some basic changes, our marriage could be saved. If he felt stunted in some way, perhaps he could join a gym or take clarinet or guitar lessons on the instruments our kids left behind. He had once been a fair accordionist – why not join a community orchestra? He could learn to play golf or study a new language. Anything he might do to enrich himself could possibly enrich our marriage. As for me, I reached out to the local newspapers and offered my services as a reviewer, which led to some jobs covering local productions. He remained static. Went to work, came home, ate, watched sitcoms. That is when I joined a film production company and headed out into the unknown, safe in the knowledge I could

come home again but secure in the solace I probably never would.

(From below is heard the reverberation of a heavy door closing. Fin.)

It was never hard for me to construct walls between myself and others.

From the time I was a youngster, I lived in books. My first real crush – a serious one – was on Mercutio, Romeo's star-crossed best friend. I was nearly twelve before I accepted that he was a literary character, who, at play's end, "melted into air, into thin air." I persistently existed in worlds of my own creation, sequestered from the mainstream with Mercutio and my other literary friends. After our move to the Adirondacks when I was nine, as I grew up in our sprawling white elephant of a house, I felt safely ensconced on an island of warm security in the frigid tundra. Though not entirely antisocial, I preferred to be home long after the other kids my age had begun hanging out with peers more often than with families. Later, as a young woman, an older student returning to college in the big city, I found perfect happiness whiling away my weekends reading the multitudinous books assigned to me as a Comparative Lit major and imagining myself as Molly Bloom or Mother Courage. I had friends and lovers and never needed reality because I was always capable of fashioning my own.

Thus, once I decided to build a wall between Richard and me, I had no problem living comfortably on my side of it, paying as little attention as possible to what had become less than a skeleton of a marriage. Richard acted like he was in a maze. We were apart, but we were still in the same house. He cooked more of his own meals at times. But mostly he just wandered through our life as though he were lost but didn't know what he was supposed to do. Physically, I stayed, certain I would never leave. In my head, the lines of Elizabeth Bishop's poem, which I had

read so many times with my AP English class, reconfigured with a new verb in my head. "The art of leaving's not too hard to master, though it may look like (Write it!) disaster."

I didn't even tell him what I wanted to do. I just announced it as a done deal because I simply could not keep up with teaching any more. The year before my principal had been fired, I had endured yet another year of cake sales, carwashes, and leaf raking; the acting principal was unable to offer any hope for a better year. The drama department I had been hired to head was disbanded, and I was assigned to teach sophomore English. In the move from one community to another, I had lost all seniority. The drama classes I had initiated were cancelled, and I had no claim on the AP English I loved or the World Literature class for which I had designed the curriculum in my old school. I even lost my troubled, challenging seniors and was relegated to bored, uninspired sophomores. Years earlier, I would have found ways to get those sophomores on their feet, eager to read and perform the great literature I shared with them. But by this time all I could do was go through motions and then go home every night and cry. I was 51 years old, and I could not shake the sense that I was actively crumbling, dying.

"I've become the kind of teacher I can't abide," I told the acting principal when I quit. She argued strenuously, claiming I was a credit to the school. "No," I replied emphatically and with complete sincerity. "I have become the featherbedder teacher no district deserves. It's time for me to leave."

Richard would not approve. I no longer cared. I felt depleted. I wanted to feel whole. I felt abandoned. I wanted to feel wanted. I felt useless. I wanted to feel valuable. Richard did not know how to deal with me, and his confusion came across as disinterest. I never responded well to disinterest. I'd rather be despised than uninteresting. I was beginning to hate him. But I wanted only to love.

It was time to be done seeking anyone's approval but my

own. I was sick of contending with double-dealing school politicians and squeezing myself into boxes I could not fit into no matter how much of me I filed off. My children were grown and finished with college. I wanted to do what I wanted to do. I wanted to be me.

I thought perhaps if I put some distance Richard and me, our marriage could continue. My Bagel Fish partners and I needed some time and space to create some screenplays and prepare for our first production. We decided to leave our jobs and head north to my home town for a few months of writing and scheming.

A realtor friend arranged for my us to rent a house that was on the market but not attracting buyers, which is a dangerous position for a house in that winter wonderland to be. We agreed to pay for water, taxes, and utilities, to keep the house warm, and to protect the pipes from freezing until March. I registered with the town school district to substitute teach a couple days a week, and Cliffs Notes hired me to write a new *Hamlet* guide; Michael fulfilled his obligations as a military reservist, and Dan took on some freelance videography. We lived well enough.

The house was a four-bedroom monstrosity, a fixer-upper for any buyer but a palatial find for the three of us. As an extraordinarily early riser, I would get up before sunrise, make coffee and stoke the woodstove to get the day's fire going; then, I'd either go to school to fill in for a teacher, whose day would end by 2:30 or 3, or I would work on my *Cliffs Notes* until 1 or 2. Daniel and Michael, who were extreme night owls, joined me for collaborative time sometime between noon and 3, and we would divide the work, which we would pursue until 8 or 9, when we would have dinner, and I would retire. A heavenly schedule. Each of us wrote an individual screenplay, mine being the story of my alter ego Lea Richardson and her desperate run from her humdrum life.

Until I wrote that screenplay, I had no idea how negative my feelings toward my marriage had become. It was only as I sat

down to confront the story I wanted to tell that I actually confronted all the feelings that were brewing about my life. I had begun to pull away, had begun devising the exit plan, but I hadn't realized it. Fictionalizing it, putting it into visual terms made me see details I had missed. Journal writing, memoir writing, story writing can help a creative person sort through unsorted feelings and reactions, but making a screenplay made my inner self come to full-blown life. I could see me running, and I began to understand why I needed so desperately to do just that. Slowly I was gearing up.

But not yet.

Even as I recognized my straits, I was not ready to be the Lea I had created.

The morning I finished writing the synopsis, as I prepared to create the treatment, I laughed. "I'm a Lea wannabe," I told my computer. "I'll never leave. How would I ever take care of myself?" I sighed and coughed, suddenly realizing that there was smoke coming from somewhere in the house.

It was not yet 5 a.m. I had not yet gone down to the kitchen to make coffee, and I was a bit hazy. But it was clear to me that somewhere in that house wood was burning. As the smell grew stronger, it increasingly resembled a campfire after someone had thrown into a plastic wrapper.

I opened the bedroom door and went onto the landing to look downstairs, thinking that perhaps Michael and Daniel were still up from the night before. No one. Quiet. Except a faint crackling sound. Then I saw the small flickering light of a nascent fire, but it was in a very odd place. I tiptoed downstairs to get a better look.

In a neat corner of the kitchen, on the wooden floor, a small garden of flames was swiftly blossoming around a large paper bag that had somehow not yet been engulfed. I screamed, but no one heard me, so I put on a pair of boots one of the boys left by the doorway and made several trips outside and back, carrying buckets full of snow and mud in large quantities, which I packed

onto the burning area. Apparently I had arrived in the kitchen just as the contents of the bag, having connected with the wood floor, combusted, before they were able to comprise a full-fledged fire that could kill us all. I woke Michael and Daniel when it was over and let them clean up the mess.

Before I went to get them, I sat on the floor, exhausted from the effort, and I had a sudden epiphany. Though I was not responsible for this fire, I could have prevented it if I had stood my ground with Michael. I loved him. I admired him. But that did not justify my willingness to forfeit my better instincts to his insistence? Perhaps I was still so afraid of rejection – of disinterest – I just let him have his way. Or maybe, as I was coming to terms with my need to leave Richard, I was afraid to alienate the men I had become attached to. Whatever it was, I gave in to a nearly fatal act of egoism.

The evening before, as we had prepared to go out drinking, Michael had decided he needed to clean the woodstove. He brought in several large brown bags and layered them to make a thick paper container, into which he shoveled the ashes from the stove.

"That'll burn through, Michael," I suggested meekly.

He laughed. "It's just ash."

"But it's still hot."

"I know what I'm doing. I've been tending wood stoves all my life. What do you know about them?"

I shut up and deferred.

We could have burned to death.

What a metaphor for my life. I had given Richard control of our money, let him make our decisions, choose our destinies. Was my life in danger of burning?

Then one more epiphany dawned. I had to learn to put my foot down and then, put that one in front of the other and.

Very abstractly, I began to devise a plan. I was enjoying Bagel Fish, so I would stick with that. I could teach acting and writing.

Could substitute teach until I establish something more secure. I could move to . . . where? Am I ready for New York? Dunno. But I will leave.

Instead, my mother died.

I knew what it was like to lose my mother long before she died.

One evening when I was a teenager, I was waiting for her to pick me up from a voice lesson in Lake Clear, when a neighbor arrived to tell me my mother would not be coming at all. The news was brutal. An unlicensed driver had plowed head-on into the van she was driving. He was a blind drunk, she told me, the man who left my mom a mess of shattered bones and profuse bleeding.

At first, I felt nothing. Then, the initial numbness wore off. I succumbed to a seething, bottomless anger that sharpened the pain. I thought the only way to overcome my voracious ire was to kill the driver or kill myself. The impulses passed, but not easily.

Fortunately, my mother did not die. Neither did she come home. Not for a long time.

The drunk driver was apprehended, fined, incarcerated. It satisfied me to know that his children would be kept from him the way I was kept from my mother.

For the first few weeks, I saw her intermittently, for brief intervals. I stood silent at the foot of her bed as she meandered between the black void of her unconscious and her small, rectangular room. I didn't try to talk. That would have been futile. She was absorbed in her healing, and I did not want to intrude. Also, I really didn't know what to bring up at that point. She did not know me or any of her seven children; she could not see us through her haze of pain and medications. Even when she was awake, she was unable to focus for more than mere seconds before she lapsed back into her quasi-comatose state. I longed to have the kind of dad who could settle my fear, hug me, tell me it would all be okay. But he didn't believe it would be okay and

would not lie to me. Doctors could not be sure that she would survive, but they were certain she was in imminent danger of losing her leg.

My anger turned inward as I shifted into ersatz adulthood. There seemed to be no other solution but to become my own mother and care for my siblings. I was fifteen, at best a poor imitation, a second-rate surrogate. I failed miserably, which fueled my self-loathing. There was no one to guide me. I began to fantasize that I and not my mother was the one in the bed, that I and not my mother was the one who needed to be cared for. But I knew better. I was hale and hardy and would carry the world on my shoulders, even if I wobbled as I did so. I learned to steer without a rudder, but I never became a skillful pilot. Even today, when I am faced with overwhelming responsibilities, I freeze for a time, force myself to think elsewhere, to avoid the problem at hand. I wish for guidance, wish for my daddy, then grope my way out of the difficult situation. That desire to be cared for fed my illusion that eventually Richard would step up. It certainly fed my reluctance to leave him.

At the time of Mom's accident, my father, paralyzed by his fear of losing his wife, sat endlessly by her bedside, holding her hand. He only occasionally left her to eat or to shower or to make perfunctory, fruitless attempts to find us assistance. I applauded, even assisted, the demise of each erstwhile caretaker. They intruded, made me feel incompetent. My parents expected me to take care of things, and each one of the people who came to care for us was less skilled than the one before. I could not tolerate that, and I felt it was my responsibility to make things right. I talked back to them. I got up earlier than they did and did laundry and made breakfasts; I defied them when they gave me instructions. One of the women who came to stay with us chewed snuff and spit it into a soup can. I hid her soup cans hoping it would make her quit; she took a coffee cup and used that instead. I screamed at her that I hated the smell. She packed her bags and left that day. Eventually, there was no other solu-

tion but to temporarily entrust the care of the younger children to friends and relatives. Two sisters went to stay with my grandparents. Our baby brother moved in with a childless couple we knew from church. That left my brother David, then 12, m ten-year-old sister Helen, and our hyperactive brother Al, then 7, and me. I was in charge.

For twenty months, Mom lay between life and death. She survived the initial danger and then the second, invasive surgery to save her leg. Once the kids were safely ensconced, I wandered dysfunctionally through my rudderless adolescence. I ate too much, read too much, cried too much, and talked to no one. Without a mommy, I did not matter.

She was alive, I kept reminding myself. She will come home. The assertion did nothing to alleviate the emptiness. Finally, nearly two years after being cut out of her car by the jaws of life, she returned home and set up a command post from the hospital bed installed for her on the first floor. She martialed our activities, relying on me to potty train my baby brother, to quiet the restless quarreling and mischief of the others, to maintain order. I brought her bedpan and emptied it. I did laundry, cooked meals, and drove everyone to their appointed rounds. I was no better at it than I was before, but at least I had guidance. And some companionship.

In the evenings, when Dad was late returning from his sales routes, and the kids were asleep, Mom and I talked. We argued over the symbolic implications of *The Brothers Karamazov*'s Grand Inquisitor. We compared Kennedy assassination conspiracy theories. We listened to music and planned for the week ahead. For the first time, Mom allowed herself to open up, to share the details of her life she had kept carefully concealed: her childhood in Europe, her escape from the Third Reich, her myriad losses, her dream of becoming a physician. I felt trusted for the first time, almost her equal. Without realizing it, however, I had lost the ability to trust her.

I did not tell her about the man on whom I had a serious

crush. Nor did I confess that I was terrified of the drinking among my peers, which defined all social engagements. She was impatient with my "scribbling," the journaling I did on weekend mornings when chores needed doing, so I shared little of myself. I won speech contests, wrote prize-winning essays, starred in our class plays, sang solos in glee club. She came to all events on her crutches to applaud me. I could not tell her that I was desperately lonely and, despite my outward extroversion, inordinately shy. I wanted to explain – but how could I without suggesting recrimination? – that those two years without her had robbed me of my ability to make friends because my carefully constructed emotional walls blocked out the sunshine of healthy attachments. When I chose a faraway college I had never seen, I lied. I said it was the only school that would have me. I did not have the words to confess that I needed to escape her omnipresent limp, the dizzying reminder of that devastating message. "Your mother's not coming."

I am still ferreting through the rubble of those two years of motherless self-destruction. Her very unexpected death in 1999 took me all the way back to that awful time.

This time, I was totally on my own.

1999 - MILLENIUM
REVELATIONS

After my mother died, one of my children wryly scolded me, "You weren't nice to her, you know. You could have been better."

True. Mother/daughter relationships are complicated at best, and my mother's and mine was a doozy.

In her youth, Mom had two dreams. First, she wanted a career as a concert cellist. In Europe, she was hailed as a talented musician, sat in the first chair of the cello section of the Zagreb's prestigious National Youth Orchestra. When the Third Reich forced the family to flee, she lugged her cello with her to Kingston, where they settled. She practiced diligently, but there were no teachers of appropriate skill and caliber to take her on; she chose the English Horn and joined the Kingston High School Marching Band. And she discovered biology.

From the time she sat in her first biology lab, she knew she wanted to be a physician. She was not naturally good at math, and she struggled with chemistry, but she was determined. At the University of Vermont, she even managed to impress her physics teacher, who wrote her a recommendation that got her accepted to two medical schools in a time when women – especially Jewish women – were subjected to strict quotas.

On her way to medical school, however, she enrolled in a

Columbia University summer organic chemistry class. Though she aced the class, she met my father, who was being pulled apart by the tension between his knowledge he needed to leave a bad marriage and his desire to have a mother for his 12-year-old daughter Dorothy. The two fell in love, and they were married just days after the ink on his Las Vegas divorce was dry. Mom believed she would take on the motherhood duties until Dorothy left for college, and then, she would go back to school. All was on track to get her there in two years. Then, I happened.

Dad wanted children. Mom was ambivalent and was, frankly, relieved when month after month her body cooperated. When she did finally become pregnant, however, having a baby seemed like a great idea because dad's teenage daughter needed something to anchor her to the family. A little sister was the answer to everyone's prayers. Except Mom's.

Dorothy calmed down. She moved into our apartment with us, and she only visited Dad's sister, who had taken her in during the adjustment period, in the summertime. She applied to college, and Mom was confident that with Dorothy out of the house, she could now pursue her medical career and manage to care for one child. However, once again, she had to realign her hopes.

Two years later, Dorothy dropped out of college to become engaged. Dad's sister disowned Dorothy, who returned to us and stayed for a year to plan and execute the wedding. Mom became pregnant, and my brother was born before I turned three and a half. At that point, Dad became restless, and he could not stay in one place, so Mom could not very well tether herself to a School of Medicine. Instead, two years later, she became pregnant again. After that she had children every two years or less until there were seven of us at home.

I was a separate entity in the complement of children, the only one without a sibling close to my own age. Therefore, from the time her third child arrived, she would refer to us as "Carla and the kids." The titles stuck. I became a surrogate mom, the

assistant cook and bottle washer, the Responsible One. I see now that, in many ways, I was more like a sibling for my mother. She learned mothering with me. She experimented on me. She learned to deal with my father's eccentricities with me as her only sounding board.

In 1955, as we prepared for the 5th or 6th move in my 8 years, Dad inadvertently but insensitively broke her cello. Packing up the household goods, he had grabbed the instrument by the neck, and it snapped. I was the one who understood how catastrophic it was for her. I could feel her peace, her joy when she played, which she did every night when she had put her children to bed. Daddy was often gone for days at a time selling and repairing hospital equipment in faraway cities, and I sat up with her reading, discussing what we read, talking about adult concerns. I was already attuned to her sharply enough to recognize the sorrow and the pain in her music. I saw her agony when the cello was gone.

Through high school and beyond, I was at her beck and call. I took care of her children, which meant disciplining the unruly ones though I was ill-equipped to handle such a task. I treated them badly. Despite enlisting my brother's very inappropriate willingness to mete out corporal punishment to help maintain a modicum of order, I chased after small children who climbed out of windows and ran barefoot in the snow, or separated combatants who were all too willing to kill one another if given berth to do so. Dad fell off a roof and could not work for a year; Mom went out on the road for him. She had her car accident, and she was in bed for two years. She leaned on me the way she might have if I were a sister or a nanny. I was never her little girl. From my earliest childhood, I was expected to be an adult, to take care of Mom and siblings. By the time I was a teenager, I was inevitably *in loco parentis,* and everyone's needs came before my own. I took it for granted that that was how things were meant to be. Every friend I ever had in my young adulthood was someone who needed my care in some way or another.

When I was 20 or so, a psychiatrist helped me acknowledge that my codependency had to stop. I pulled away. I moved, I married, I kept Mama at arm's length. I did things to poke at her like saying incendiary things to argue with her naïve liberalism that presumed that women were considered equal to men, that this United States could eschew Capitalism and be a more humanely socialist country. A few times, I childishly tried to punish her by telling her how profligate my behavior was, how drunk I could get, how many boys I could

When I was briefly in my unconsummated marriage and my non-husband became ill, he stayed with my parents for three weeks so I could return to NY and my job. It was generous of them, and I was grateful, but it did nothing to cleave the distance between us.

We began to keep our conversations general. Yet, I talked to her almost every day.

When I moved to Arizona and had children, we rekindled some of our old relationship. When my firstborn was tiny, she could not get enough Grandma time. Dad was a fun grandpa – especially later when we had children old enough to appreciate camping trips at the ocean, which Dad loved intensely.

When I went into labor with my second child, Mom came and took our firstborn home for a grandma-grandpa sleepover they all enjoyed. Mom was especially delighted – and I was thrilled that she was so happy – that my second-born was left handed, as Mom had been until the nuns at school forced her to rely on her right. Number three came soon after, and again Grandma/Mom was happy to occasionally babysit for an evening, pleased to have us share holidays, excited to be their beloved grandmother along with my dad who was their silly Papa. I was genuinely grateful to have my mother nearby, someone to call when a colicky baby refused to sleep or when someone was sick, and I found her company more reassuring than Richard's. I even reassessed our decision to move to Arizona, and I called it good. Until I needed her. For me.

In 1980, I had three kids under six, and I needed a hysterectomy. My doctor assured me that the method he would use would only require a single night's stay in the hospital and a few days of rest, and I would be fine. It seemed like an easy thing. I expected Richard to take a few days off to help me, and my mother was less than ten minutes away.

Richard went back to work the second day I was home. He said he had tests to run and could not take more time off. The kids were not in school that week, so they required no ferrying, but they were antsy. The television blared, and the house reverberated with their yelling and running about. I was exhausted. I called my mother and asked – begged – her to come over and take the kids for the day. There was a dread silence after I posed the question.

"Carla," she said slowly, deliberately. "I raised my seven children. It's your turn to raise yours."

I felt abandoned once again. That same feeling of inadequacy, of panic, of terror that I had felt on the night she had her accident returned. Richard was more effective going to work than trying to help me. Well, maybe. . . I had to think about that one. He could be okay in a moment of crisis if I kept calm, but once I had things under control, he was likely to withdraw. When my second child was an infant, and my first was still a toddler, I collapsed with a stomach ailment that had me spewing from all orifices. I had taught the older child to dial Daddy, and Daddy rushed home, filled the doctor's prescription, waited for the worst to abate, then went back to work. That night, when I was exhausted and couldn't get the infant to go to sleep, I asked him to take over. He could not. Maybe I enabled him to withdraw, but I didn't recognize an option.

That left my dad, who was, well, Dad. He was not the guy to take the kids to the park and keep them out for the day.

It was Mom I needed. It was Mom who, it seemed to me, owed me some time and attention. The disappointment was staggering. I never asked her for assistance again. She continued

to interact with the kids when and where she chose, and after they were grown, they each spent time with her without me. I was pleased that each of my children had a deep connection to my mother. I never quite trusted her again.

One afternoon, sometime after my surgery, I told her I was hurt, that I wished she could have helped me. She began to cry and to level at me a litany of my faults. I gathered my children and prepared to leave.

"You know, Mom," I said over my shoulder on the way out the door, "just once I wish you'd tell me what I do right, how I succeed. I just want you to tell me you are proud of me. Just once."

She stared and closed the door behind me.

After that, we maintained our relationship as it had evolved. So long as I did not depend on her to be in any way parental, we enjoyed some great times together. She traveled with the kids and me to Zion and Bryce and the North Rim of the Grand Canyon one summer, a glorious trip until my youngest caught a bacterial infection as the kids cavorted in the Virgin River. That passed, and then Mom became deathly ill. That illness signaled that something was wrong, but at the time, she chalked it up to altitude sickness. Whatever it was, it ruined the mood.

Two years later, my father died, and a few weeks later, we traveled together one more time. On that trip, perhaps because she had just buried Dad, whose death was stultifyingly sudden, or perhaps because she was recovering from major orthopedic surgery and glad to be out of the hot Phoenix desert, she was a delightful companion.

She flew from Phoenix to Yuma for the State Swimming Championships, where she leaned on her crutches and cheered for my kids. Then, we drove north to Yosemite, to Sequoia, to San Francisco, and Palo Alto to visit my sister and cousins. On the way home, we stopped for a day and a night at Disneyland. Disneyland was especially exciting because, on account of her recent surgery, she let me get her a wheelchair, and we waited in

no lines whatsoever. That is no small gift for three excited children. Whatever else passed between us before and after, I will always cherish the memory of that trip.

She continued to have a series of troubling symptoms for years, and her HMO continually treated her haphazardly, symptom by symptom. Her blood pressure was too high; then, the meds brought it down too low. She seemed to have high blood sugar, but diabetes medication only made her sick. She was dizzy and had been to the North Rim of the Grand Canyon, so they treated her for altitude sickness, but when her liver function seemed abnormal, they played with her cholesterol meds. It was a vicious cycle of treatments that only sank her further into illness. I talked to her at least once a week, and I begged her to check into a hospital for a complete work-up.

"I'm so tired, Carla," she told me one morning. "I am constantly exhausted. I wish I didn't have to go to work." She taught biology and special ed, and she ran an afterschool enrichment program.

"You don't have to, Mom. You're 76 years old. You can miss a few days of school. Hell, you can retire."

"No. I can't. If I did that, I might as well be dead."

"That's ridiculous, Mom. Your students love you, but they could get used to –"

"No. You don't understand. You can't. You're a writer. Your art wakes you up, gets you out of bed, motivates you. My art is teaching. I get my energy from the classroom."

I was 52 years old, and my mother had never acknowledged me as a writer, an artist. I was moved to tears. All the mornings of my youth when she screamed at me to stop scribbling and come out of my room to do the work that needed doing in the house melted into this moment of validation. Even now, when I replay that moment in my head, my eyes fill with grateful tears. In that moment, though, as soon as I received the attribution, my heart went cold. She never would have issued such praise had she not been gravely ill.

My mother's condition must have been more dire than I had allowed myself to imagine.

The first week in October my fears were confirmed. They found a tumor in her bile duct. It was most assuredly malignant, Mom told me, and the doctors' prognosis was, at best, grim. "They think if they can remove the growth and resection the duct," she explained with her typical clinical dispassion, "and then they might be able to fix it so I have a couple more years at least. But they're not sure. . . . "

I called Richard and asked him to release the money for a flight to Phoenix, which he granted me. He asked few questions, and I understood. I knew he loved my mother more profoundly than he loved his own. I was surprised he didn't ask to go with me. My brother picked me up at the airport, and we went directly to the hospital, where she was already prepped for surgery.

"I'm glad you got here," she said, gripping my hand as she drifted off. Now I knew she was in even worse shape than the doctors had said. This mother never thanked me for being there; she simply expected it.

I had just found her again, and now I was about to lose her. For good.

We gathered in the waiting room, five of the seven children, none of our spouses. Two brothers were still *en route*, not sure they would make it before she was out of the O.R. Her oncologist addressed us as a unit and told us that if the surgery was successful, she might have another year, possibly two. But if the surgery failed, her death was imminent.

The surgery failed. The doctor returned to say that he was pretty sure that what they had been able to do was to slow the bleeding; he predicted that she would have another six months to a year. I stayed for a few more days and returned to Saranac Lake.

Two weeks later, my brother Alfred, a nurse with lots of O.R. experience, called me. "Listen, Carla," he said flatly. "Mom's

going pretty quickly. If you want to see her again, you should get back here."

Shocked, confused, dazed, terrified, I called Richard.

"Mom's really bad. Dying. I need to go back."

His reply was immediate. "You were just there."

"I know. She's dying."

"What can you do for her? You just saw her. What's changed?"

"I want to be there. I would have expected you to want to be there too."

"There's nothing anyone can do. It's a lot of money to spend . . . for what?"

"I need to be there."

"We can't afford it."

"We have reserves."

"We have nothing. I just made a tuition payment, and taxes are due."

"I'll work extra days next month and put the money back into the bank. Just borrow it from savings."

"I am not jeopardizing our retirement for you to go gallivanting to Phoenix for nothing."

I hung up. I had no words, no energy to find words. I was defeated and went to my room, burrowed under the covers and forced my brain into total darkness. I couldn't even cry. I was too deeply demolished.

At the time, I was sideswiped. But it's clear to me now that I probably should have expected it to go that way. Richard never really liked confronting what he could not accept. When his favorite grandmother, the woman he adored more than anyone in the world, died, his father offered to send money if Richard would come home for the funeral. Richard refused. It hurt him too much to admit to himself that she was dead. Now, he was enacting the same lack of empathy. He loved my mother. He could not face her illness, her impending death. I cannot be sure why he did not want me to go, but money was always some-

thing to hoard. It was never meant to be spent. After I hung up the phone, all I could think was, "I hate you, you bastard. Money is more important to you than my mother or me or family or love. . . ."

Sometime later – I had no idea how much time had elapsed, just that it was dark, and I was cold – there was a knock on my bedroom door. Without waiting for a response, Michael opened the door and said, "Put some things together. We're leaving."

"What? Where? Why?"

"We're driving to Phoenix. Dan and I've figured out the time-line, and we gotta leave immediately."

Michael had to report to his reserve post at a very specific time and date, and he and Daniel had done all the arithmetic to show that if we left right away, he could fly back in the nick of time. I was overwhelmed.

Forty-eight hours after closing up the house, having driven straight through, stopping only for food and bathroom breaks, we arrived in Sedona, where we stopped and allowed ourselves the reprieve of a glorious sunrise before we descended into the bowels of hell, the Valley of the Sun.

Daniel stayed with me, integrating himself into my family as we kept our vigil and awaited mom's departure; he was a bulwark for us all. Michael left us his car and reported for duty as assigned. My gratitude remains bottomless.

Richard did not hear from me once. I had no words for him.

Mom was home, and we – her children, grandchildren, neph-ews, nieces, her sister, brother-in-law, her friends and colleagues, those of us who could get to her – gathered in her small living room while she lay in her bedroom, drifting in and out of consciousness. My brother, the emergency nurse whose pragma-tism never flags, suggested we have an early Thanksgiving. He assigned every one of her closest friends and relatives a dish to bring, and when we were all assembled, he wheeled her into the room to greet us. She was ghostly, only partially present in body or in mind, but she seemed pleased to see us.

I remember thinking how terrible it would have been to have missed this moment. This, I thought, is her memorial service, and she gets to witness how well loved she is.

Just before she died a few days later, feeling sideswiped, terrified and cheated, Mom asked me if she had done enough. No one could have done more, I told her. She accepted that, returned to her silent sadness. Then, sometime later, she squeezed my hand.

"I don't care where you put my ashes, " she said, answering a question two of my siblings had asked her. "Just promise me one thing." She motioned for me to give her some ice chips before she continued. She swallowed painfully before she took a long, labored breath, and said, "Promise me I won't wind up anywhere near Ellenville." She closed her eyes and slept.

Ellenville is shorthand for the Fantinekill Cemetery in Ellenville, NY, where my father lies among his myriad blueblood ancestors. I watched her sleep and found myself weeping for the first time since the doctors told us the terrible news about her. I walked outside to her little backyard and let the tears flow. Imagine, I thought, hating the father of your children – seven children! – and the man you slept next to for over fifty years so much that you don't want your ashes touching his in eternity. She had her reasons, and I was entirely sympathetic. But I did not ever want to feel that way about my kids' father. I knew then that even if I found a way to forgive Richard for all the hurt and disappointments, I would never forget the cold, dark tunnel his words had taken me to when he denied me the trip to my mother's deathbed. I had to extricate myself soon.

I had begun the long journey to forgiving my mother and releasing myself from my own guilt. And I was moving with ever more momentum toward consigning Richard to my disdain.

RESTRUCTURING THE SELF

Two weeks later, I was back in the mountains, subbing at the Saranac Lake Central Middle School. The present middle school is housed in what was, in my youth, the high school. My job that day was to supervise the library, which is in the school basement, near the boiler room. All day I was aware of a smell, an aura that was familiar, but I could not place it. Images of dirty socks and sweaty armpits smoldered in my head, and I felt strangely unnerved. At lunch time, I left the desk and set out to explore the area; suddenly, I was struck with *déjà-vu*: though this was the library, it had been the high school gym locker room for nearly a century before the conversion. The old atmosphere persisted, and I understood my discomfort. This is the room where, for four years, I sat defiantly refusing to play gym, anxiously awaiting the moment when the gym teacher and/or the principal found me and handed down my inevitable sentence, then sighing resolutely when the waiting was over.

I had to laugh. My high school self would be appalled at what I had become. In those days, I hid my introverted side well. While I had few friends and did almost no socializing, I was well known for having a strong need to speak my mind, to advocate for all who needed a voice. The self I was as a girl at school was

the one who stood up in an assembly and yelled at our speaker from the UN. "But the Red Chinese are people too. Why should they be excluded from membership? Chiang Kai-Shek is just as much a dictator as Mao Tse-Tung." I won great respect from my World History teacher when I made an impassioned case in class for the fact that Communism was actually an idealism made void by human nature. And I won speech contests by breaking the rules, creating my own parameters, and then crossing even those. That girl, the one who walked away from her lucrative babysitting gig because she could not tolerate the man of the house, who eschewed dating, delighted in debunking the propaganda perpetuated about happy-ever-aftering, never acquiesced to merely men. Where was that fearless girl?

Would she have allowed some boy to tell her how to run her life? I still wonder what the answer would be. The situation never presented itself.

The Christmas holidays came and went. Michael and Daniel invited their significant others to join us, and I invited Richard. We partied to the music of Prince like it was 1999. Which it was. And even as I slow-danced with my husband, even as I enjoyed our love making in my creaky borrowed bed, I knew that with the millennium, a chapter of my life was ending. I was on my way out of my present into a vast unknown. I slept that night with Stephen Sondheim's" Little Red Riding Hood" singing in my head.

I had no idea what that premonition might mean. I had no definitive idea of what was on the horizon. But I knew I could not stay put where I was. I also knew that any change would have to wait a bit longer.

First, I needed to finish what I had started when we created Bagel Fish Productions.

A NEW MILLENIUM

Daniel and Michael and I decided that if we were going to get any traction as filmmakers, we must make a short film. Co-writing and producing a film empowered me to begin planning my liberation, and when I pitched them the idea that we deconstruct Chaucer's *Wife of Bath's Tale*, they loved it.

The Wife of Bath is a feisty woman, whose tale is about a knight who deflowers a maiden. Deflowering is strictly forbidden by the King and Queen. His punishment, instant death, is postponed by the Queen, who promises him that if he can tell her, within a year's time, to her satisfaction, what it is that a woman really wants, she will let him live. The knight sets off on a quest, interviewing everyone who will talk to him, asking, "What does a woman really want?" An ugly hag follows him wherever he goes, offering to tell him the answer if he'll marry her. Disgusted by her looks, he continually refuses until the 11th hour, when, afraid that all is lost, he acquiesces to her demand. "A woman wants to control her own destiny," the hag tells the knight. "That's all." The queen commutes his sentence, and the hag comes to collect her booty. "Now, sir knight," she says to him. "Because you kept your promise, I offer you this choice. You may have me young and beautiful, but often unfaith-

ful, or you can have me as I am and as faithful as the day is long. You choose." The knight, having learned his lesson well, replies, "You choose. I will take you as you wish to be." "Ah, dear knight," coos the hag. "Because you have learned so well, you may have me both beautiful and faithful, and I will be yours until your dying day." So, says Chaucer, she spent the remainder of their lives together doing wifely things."

We hated the ending, so we set about creating a modern fable, which we entitled *G-SPOTS?* It seemed preposterous to us – especially to me – that the hag would be so willing to grant the knight his male fantasy. I identified – perhaps a bit too much – with the old woman. In my mind, she was someone who wrote her own destiny and needed no man to define her. I chafed at the idea that she would offer to contort herself into a version of womanhood that a true individualist, which is how I defined myself, would abhor. If I had been the hag, and I had granted the knight such an absurd reward, I would have resented him for the rest of our lives. Therein, I saw a truth: I had become a wife and had been resenting my knight for nearly thirty years by then. The time had come to crawl out from under the self-deception.

Contrary to all expectations, I inherited a little money from my mother; my father had died in 1984, leaving her nothing, and she was a teacher, who managed to squirrel away enough to leave a tidy little sum to each of her seven children. I divided 2/3 of my portion into equal sums for each of my three kids and invested the rest in *G-SPOTS?*. I was now a full-blown producer, and my life as a filmmaker had begun in earnest.

The year before, on my way to Paris and my meeting with Radovan Ivsic, I had flown Icelandic to London, where I stopped off to visit my former landlady friend in Stratford-Upon-Avon before taking the brand new Chunnel to Paris. Somewhere between New York and Heathrow, I met Terry Flaxton, an engaging British cameraman, and we struck up a conversation that evolved to long, philosophical email exchanges. Eventually, Terry wrote, "Hey, we have to work together sometime."

Naturally, when I had the script for *G-Spots?*, I sent it to Terry, and he immediately replied, "I want to shoot that!!" Our budget soared.

By the time we shot the film, we had spent over $60,000 and had lost Michael, who got cold feet halfway into the project. The whole business proved too unstable for our risk-averse partner. He went back to school to pursue a career in psychology while Daniel and I pressed on.

It was clear that what we lacked in business sense, we made up for in a natural acuity for choosing good people with talent and expertise to take the project to fruition, and together we made a truly professional-looking film, a lovely little movie, despite the fact that the shoot itself was a series of comedic disasters, mostly my own.

The day before we began, Terry joined us from England. We spent the day taking him and all the department heads to inspect our locations around the state of Connecticut, and we were all celebrating our mutual excitement for the project. At some point in the evening, someone noticed that the sky outdoors was crystal clear, and the moon was full. We all went out to feel the beauty. But it was cold, and I suspect I might have been a bit stoned on the celebratory ingestions. I began to jump up and down to get warm, making a little dance of the movement. Suddenly, I felt my feet go out from under me, and the next thing I knew I was face down on a clump of ice. When I stood up, my face was bleeding, and I had the beginning of a black eye. Daniel's then girlfriend (now his wife) Dana, our production photographer, took no stills of me for nearly the entire week of production because I was so battered. I thought it might be a good omen. I really believed in the old wives' tale that suggested that a bad dress rehearsal meant a great show, and this was our dress.

The next day, we were on location out on a gorgeous property in Shelton, where our production designer had fashioned the sumptuous vision of a knight's lair in a tree. The maiden,

dressed in a flimsy gown, had to lie in that tree for take after take waiting for the director to be satisfied with her deflowering scene. Between takes, to get her warm, we had activated a large propane heater, and I would wrap my arms around her maternally to speed the warming process. During one of these respites, just as I was smelling the foul scent of burning rubber, one of the production assistants screamed, "Oh my god, Carla. You're on fire."

I was. My coat had gone up in flames, and had it not been for the astute observation of that assistant, I would have been engulfed within seconds. The fire was extinguished, and Dana's resolve to leave me out of the archival footage was reinforced.

For the third day of our adventure, we rented the underground cavern beneath the Old Newgate Prison in Glastonbury. When we had taken Terry to inspect the site, he had shaken his head and muttered, "I can't fukin' light this." To compensate, we had exceeded budgetary constraints and rented additional lights and hired additional grips. Soon, the dark stone walls were converted to what could have equally passed as a medieval palace or a moonscape, and Keith David and Sandy Duncan, our King and Queen, Denise Lute, our Hag, and our nearly fifty extras were luminously executing their roles when Terry took me aside and said to me in a tone dripping with disapproval, "You're going to have a whole troop of dead grips in a minute." He pointed, and as I followed his hand, I saw immediately what the producer should have seen much earlier: the grips were standing in three feet of water, holding ungrounded lighting instruments. That no one died that day is nothing short of miraculous.

Against all odds then, the film did turn out to be a gem. DuArt, the postproduction facility – the only major post production facility east of Hollywood – that cut most of Hollywood's films since 1922, gave us a good deal on their services in return for which they got to use our little film, the first narrative film

shot on High Definition video, on their show reel. We had the piece converted to film, and it is exquisite.

G-Spots? was the only real success Bagel Fish Production had. We made the rounds of the festival circuit, won a few prizes, and accrued some nice recognition. It was an expensive venture. One that we hoped would lead to many more. We took the film to Cannes, hoping to curry interest in our work, but all we managed to achieve was the theft of our video player.

Back in New Haven, the dearth of offers persisted. We came close to selling one of our scripts, which we were able to get to a few big stars for a read, but mostly we were rejected again and again. We made a couple of short films, and we opened a studio where we taught acting and screenwriting to local aspirants, but we struggled consistently with financial woes and somehow managed to maintain equilibrium. For a time.

It was after we wrapped *G-Spots?* that I moved out. Out of our house. Out of our marriage, our life. Out of the world, which I had inhabited for thirty-plus years.

Because of the Bagel Fish retreat, we had already lived apart for months. When I returned to our house, I brought Michael and Daniel and our film cast and crew. I had told him often that I was going to get to where I could not live with him anymore, but he never believed me. He attributed my declarations to examples of my flair for the dramatic, my insignificant sound and fury.

I had set myself up for him to be incredulous. When we were first together, Richard would sulk if he disagreed with me. He would brood when he disliked something I did or said or suggested. I could not tolerate the simmering rage, and because I had seen him explode over things like bad weather or making a wrong turn on the highway or forgetting some item of camping equipment, I suspected that eventually I would be in the line of fire anyway. So I pushed him to fight when he was upset, to express his anger as it occurred, to stop bottling it up to stare at me accusingly. He became, then, a volatile lover, and we fought

over the most insignificant of nonsense. Then we would kiss, make up, and fall excitedly into bed.

When something real and looming came up, however, and we found ourselves at an impasse, he would rail on and then shut down. One of our kids needed medical attention that he did not approve of. Or something in the house needed an upgrade. Or a major decision had to be made about our immediate future. He would simply yell until it was clear he was not going to change my mind, and he would storm off, refuse to engage. I would be left feeling powerless, which made me walk out. When we lived in NY, I would simply take the keys and go for a long walk; later, I would take the car and go for a drive. Each time I would sputter and curse and swear I was never going back. But an hour or so later, I'd walk back in, and he wouldn't even notice that I'd been gone. In his mind, my saying I would leave was simply an empty threat.

Bringing the cast and crew into our home was an act of defiance. I knew he was not happy about it, but I also knew that he thought if he gave in, I would forget about wanting to leave. I would owe him. There is a part of me that regrets that he was deceived. I am not sure I knew exactly what my next move would be. I only knew I was suffocating.

My mother's dying wish was omnipresent in my consciousness. I loved the memory of my happiness with Richard and our family. Even if it had been an illusion, I wanted to hold on to it, and I never wanted to be as angry as my mother became. I was angry enough.

I made one last attempt to salvage a life together. I thought my words were clear, that he should understand when I implored him to "please get some help," that I still believed that we could put ourselves back together. But what he heard me say was, "We need massive counseling, and I may never be able to find what I saw in you." In any case – and we both remember this piece – his answer was, "I don't want to work that hard."

I had only been as hurt by one other pronouncement in my

life. That time when I begged my mother for help after my hysterectomy and she told me she had raised her children and was not about to raise mine, I felt murdered. And I am not good at feelings. I don't cry easily except at the end of sappy movies or when a fictional character suffers a loss or celebrates a reunion. Then the tears come in torrents. Deep hurt leaves me hollow. Disappointment activates my pragmatist center: life just is what it is. Move on. I do not express emotion well. Even today, when I tell my grandchildren that I love them – probably too often and too earnestly – I feel the sense in the pit of my stomach that I didn't tell my own children often or earnestly enough. I most assuredly did not provide sufficient hugs. I somehow lack the emotional vocabulary to express myself adequately.

I had tried to tell Mom how deeply she had wounded me. I yelled at her for other things over the years, and I had tried to talk with her about her refusal to help me when I was desperate, but she was unreceptive, dismissive. In the end, I pushed the pain into my gut, where it festered and caused me to act out over inconsequential disagreements with her. Now, facing Richard, as he spoke these words, I was trampled. We had by then been together for thirty years, and I know I was not the easiest person in the world to live with, but neither was I difficult. Although both my mother and Richard found me so.

I always did what I was expected to do. But I made it clear that I hated being forced into fulfilling duties I did not feel should have been mine. Neither of them ever admitted that they imposed their wills on me, and I simply acted out when I resented them. I should have been more like my brother David.

"David," Mom would call out from the first floor of the house, knowing he was behind the firmly locked door to his bedroom on the second floor. At first he ignored her. Every time.

"David." Still no answer. She'd climb up to the middle of the long stairway and call again.

"David. Do you hear me?"

"WHAT?"

"You didn't take the garbage out. Do it now."

"Okay, Mom. In a minute."

She would go about her business. The garbage was forgotten. Hours later, I would go to the kitchen and see that the garbage was still, in the pantry, and I would drag it outside.

No one was ever angry at David. I should have been more like him in my dealings with Richard. If I had smiled and nodded and ignored him, maybe we would have lived together in peace, and I would have felt less compromised.

Until the death of my mother and the devastation I felt after that, I had accommodated Richard in every way I knew how. When I said we could try counseling, perhaps my intention was not clear, but I truly wished we could find a way to come back to the place where we could love Mahler together.

"I don't want to work that hard."

That was that. Like I said, I was no good with emotion. I could not beg or plead or appeal to his sympathies. I could only do what I had always done when things felt bad. I closed myself down. Erased my engagement with the pain and prepared to move on.

I was finished.

EXT. GEORGE WASHINGTON BRIDGE – PRE-DAWN

O.S. SOUND of rhythmic, athletic RUNNING FEET and HEAVY BREATHING. Into the darkness, a ribbon of light bleeds across the sky, as morning yawns awake. [REVEAL LEA RICHARD-SON, a fit woman of indeterminate middle age, running reso-lutely. Around her middle is a large fanny pack, and on her back is a baby carrier out of which a small, bald head bobs. Ahead of her the New Jersey Palisades slowly comes into view; she crosses the GW Bridge, headed west. Infrequent cars pass her; none takes any notice, nor does she take notice of them. She is simply running. Headlights obscure our vision as the CREDITS ROLL.

Lea Richardson, has somehow reached her fifties thinking she has it all, only to find she wants none of it. She is married to Curtis, a tall, impressively handsome Af/American man, whom she married when they were both undergrads at UCLA, and he was a second string point guard for the Bruins, a dazzling man who wined and dined her and treated her like a princess. She entered wedded bliss believing that Curtis would be recruited to play for a professional team, that she would be the bejeweled wife of a second string Walt Frazier. Clearly she didn't under-stand the game. In any case, Curtis has evolved into staid, conservative CPA, and he is baffled by Lea's creative impulses. At work, Lea, a high school drama director, feels thwarted. Every effort she makes to do a show is undermined by cheer-leaders or jocks or nasty principals, and she can't go into the teachers' room without suffering the slings and arrows of outra-geous gossip. Her son has just come out to her by flaunting an affair with the high school hockey coach, whom she believed to be in love with her; and her daughter, an Army grunt, has just been hospitalized for walking into an enemy compound and yelling, "Come and get me!" It's all just too much for Lea. She can't bear to live another moment longer. Problem is, she has always had a weight problem, and she can't stand the thought of

dying unless she can go out fitter than she's ever been in life. So she packs the vestiges of her life into a fanny pack, puts her beloved yappy dog into a backpack, and sets off across country, planning to jump off the Golden Gate Bridge. Of course, the film is about the run.

Too Much of Nothing: A Screenplay by Carla Stockton

Nora: Marriage is cruel
And it destroys women's lives
Really

We do a lot of things that aren't good for us,
Things we do because our parents tell us
From an early age – our parents
Our churches
Our leaders
Everyone
Tells us that we need it, so we believe it,
And the idea gets etched inside our skulls
But you only think you need it because it's all you've ever been
told.

They tell us: "It's an expression of love,
The ultimate expression of love,
The one that we're all woring towards"
But how does that make any sense --?
To say "I love uyou, therefore you should tie yourself to me,
And you can never leave me, you can never love anyone else,
You're off limits, I own you."
I own you
That's what marriage says – to me that sounds more cruel
than kind

Also, also –

When people marry,
They say, "I choose you,
And I choose you forever,"
But who is this 'you that they're choosing?
Because people change, over time
People change into different people,

So how can you say that I want to be with this person
When "this person" is not going to be "this person"
3 or 5 or 10 years from now,
But there you are committed
Forever
Til death
Stuck,stuck either with a person you don't want to be
Or with a person pretending to be a person they no
Longer are.
A Doll's House Part II by Lucas Hnath

IDYLL

I moved to Morris Cove, a quiet little seaside corner of New Haven and set out to make a new reality for myself. It was a good move.

I loved my life in the Cove. Every morning I went for a run past the mouth of the Quinnipiac River, following a path next to Long Island Sound, around Light House Point, and back before breakfast. A few days a week I substitute taught at a local alternative high school, and the rest of the days I spent my time writing or working on promotional materials for our Bagel Fish endeavors. I wasn't sure if this was a long-term solution, but it satisfied me in the moment. I would assail the future as it descended.

Bagel Fish hosted a few events, such as a Hallowe'en screening of *Nosferatu* with a local composer's performance of the score he'd written for it and a one-day screenwriting seminar; we taught acting and screenwriting, and we had a core group of artistically-minded locals who faithfully attended anything we hosted. Additionally, Dan and I hired ourselves out to do theater productions, we each had individual gigs teaching in one venue or another, and we worked for the Connecticut Film Commission organizing a filmmakers' consortium. Things

were going pretty well for us and our business until we crossed *Chicken Road*.

When I taught a beginning acting class at the New England Academy of Theater one winter, several of my students asked if I would teach a private intermediate class. Dan and I talked it over, and we designed a class specifically for that group. We advertised and found additional students, and it was successful enough that when that class wrapped, we taught an advanced session. Then, we expanded again and designed a class called Acting for the Camera. After a few of these sessions, the students asked why couldn't we make a film.

Of course, the experiences of *G-Spots?* and our subsequent short *Uptonanda*, a dog Yoga mockumentary short, had taught us that there is nothing quite so addictive as the self-inflicted pain of writing, producing, directing, and cutting an independent film; we could not wait to do another one. We agreed and designed a budget that included minimal salaries for each of us, money to hire some technical people and to provide food and transportation for our cast and crew. Even so, the film did cost money, and we set the students' tuition in accordance. We made each of them producers of the film, and we promised that if we ever sold it, they would be the first to be paid. So far so good.

Daniel and I wrote a script, a cute little romantic comedy, which we entitled *Chicken Road* – the fundamental question at the heart of the film asks the proverbial question regarding the proverbial crossing – about a woman flirting with the *idea* of an affair, looking for an outlet for her creativity. She is an egg farmer, a childlike woman, who has not yet ventured outside her insular world. Every one of our cast members got lines, and we all agreed to do a local search for an actress to play the lead. The woman we found was great. Everyone was great. Except for me. I really failed as a producer.

First of all, the investors, who were cast members and who also made up the bulk of the crew, had problems with many of our plans. Dan and I denigrated their input, and I did not insist

that we incorporate some of their requests for changes. My own failure lay in my inability to reign in the production. We bit off way more than we could chew, and I did not recognize the consequences in time.

My success in *G-Spots?*, largely the result of beginners' luck greatly enhanced by the advisement of some erudite professionals, had had one fatal flaw. My respect and admiration for Daniel clouded my judgment. We went over budget because I believed that whatever Director Daniel wanted, Director Daniel should get. We didn't get the film coverage we needed to tell the story adequately because I did not insist that we print after fewer takes so that we could cram more shots into a day's filming. Our audiences disliked the ending because even though I was the lead writer, I allowed my producer persona to listen to my co-writer Dan's insistence that the ending be as he envisioned rather than as I saw it. Overall, *G-Spots?* could have been far more successful than it was if I had been a more seasoned, savvy producer. If I had realized that as we ventured onto *Chicken Road,* that film might not have failed as miserably as it did.

The real inadequacy and inexperience were mine. As lead producer, I was too vulnerable to my own imposter syndrome, and I convinced myself that my insecurities were accurate. I began to believe that my only real purpose was fielding complaints from our company. I know now that the reeking presence of a looming divorce, the failure of my marriage, seeped into every pore of my consciousness, and it soured my stability. I trusted none of my intuition, none of my skills, nothing about me.

I yelled at everyone, snarled even at people who had nothing to do with our production, and I cost us hours of valuable time just by being surly. The worst offense was that instead of cutting expenditures by curbing the acquisition of props and the accumulation of equipment, I allowed us to rely far too heavily on our non-professional crew and offered them far too little validation. They all had jobs in the "real" world, which necessitated

that we film over three weekends. Our call was typically at dawn Saturday and Sunday, and we never wrapped before midnight. Some folks had long drives to get home to catch a few hours' sleep before heading off to work on Monday morning. Everyone was frayed. They felt used, abused, misunderstood, underappreciated, disgruntled, dissatisfied.

To some degree, their displeasure was warranted, and I exacerbated their malaise by saying we needed to raise more funds to finish the film, to make the animation right. No one wanted animation. They asked to see dailies. We didn't think that was a sound idea because the raw footage, while pretty to look at because of Daniel's and Dana's artful camera work, did not reflect the script adequately, and we thought that that would dismay our producers. We were right and wrong. We should have shown them the footage.

A revolution was inevitable. Our now savvy company of players yanked the rights to the film, pulled all support, popped our balloon by saying they would not allow us to show the film even if we were able to raise the funds to finish it. They vowed never to sign releases enabling us to use their images in any part of the film.

I was too inexperienced, too raw from the ongoing stress of my divorce, and too insecure about my newfound profession to take it well. Had I been even a mere acquaintance of me at the time, I would have been able to see what a folly it was to have had the hubris to believe Daniel and I could win the battle of *Chicken Road*. Or perhaps I wanted to lose, to punish myself, to punish the people who believed in me. I was a mess. As a result, so was Bagel Fish Productions.

Daniel had begun taking on more and more independent videography and production management work, and our landlords raised my rent to what was reasonable for the amount of space but seemed unreasonable a sum for me to pay to live on the outer edges of New Haven. I had come to a place where I wanted to be free of suburbia.

So. I finally did what I had always hoped to do.

I returned to New York City.

Divorce is odd to the undivorced. In certain circles, it is looked on with severe disapproval, or, at the very least, benign disdain. It's a terrible threat to those who consider it but fear it more than they desire it. Still today, when I talk to women who complain that their marriages are unendurable, and I ask why they don't leave, they inevitably reply, "My life is too entirely interwoven with his. I wouldn't know where to begin to separate out what is mine. I mean who gets to keep our friends?"

The social aspect of our divorce was the first one Richard and I contended with. It was less complicated for us than for most, thanks to the fact that Richard was reclusive. He had had little interest in building a network of friends.

Except for gatherings with my brother and his wife, who lived fifteen minutes away in the town immediately to our north and some obligatory events we went to for Richard's work or my school, we kept to ourselves most of the time.

Fortunately for him, Richard had remained in touch with his best friend from high school, a man who had urged Richard to dump me years before. At that time, the friend was living with one of his students at the small liberal arts college where he taught. They lived near the campus of the small college in Santa Fe, and we visited them from Phoenix. We had driven over with my parents to visit both the friend and my half-sister and her family in Los Alamos. I was still nursing my third child.

After a long day that included the 8-hour trek across the Southwest, wrangling the kids, appeasing family, making decisions about what we should do, I was exhausted. I wanted to sleep, and I begged Richard to help me by reading to our older children while I nursed the baby and fell into slumber. He refused. "I'm here to see Bill, and we have to leave tomorrow. You go to sleep if you want."

I went to lie down, and I heard Bill say in front of the other

dinner guests he'd invited to meet Richard, "Good god, man, that woman is a shrew."

Richard laughed. Bill went on.

"Man, you don't deserve to be treated the way she does you. You better get out from under her while you can. Don't let her get her claws in too deep. You'll never extricate yourself."

Richard laughed again. Which hurt. Why did he not defend me? Oh, well, I reassured myself, at least he had the presence of mind to dismiss the suggestion that he walk out on his dependents.

When we finally did break up, that same Bill, now married again and himself the father of two small children, swooped in to assist Richard in his transition period. I was glad for Richard and even gladder to be rid of any attachment to Bill.

I suspect – but have no substantive proof but for my very strong hunch – that Richard's confiding in our children was a move friend Bill encouraged. Early in our separation, my children confronted me.

"You really did it this time," charged the first.

"What?"

"You told Dad you stopped loving him. Geeze. I knew you guys were always fighting, but you stopped loving him? How does that happen? Now that I'm a grown up, you gonna stop loving me if I disagree with you?"

"Don't be ridiculous."

"He's pathetic," added the next. "And you made him that way. He can't even think for himself."

"Yes," the third chimed in. "He's too insecure to start dating. But you've probably already got a boyfriend."

I guess the fact that they pitied their father speaks volumes about how well I seemed to be faring, how much younger I seemed at the time than Richard, who was, I reminded them often, nearly four years my junior.

Perhaps I seemed, by contrast, far too happy. People who didn't know me well thought I was simply divorcing for a lark,

frittering my stable, long-term marriage away for the dalliance I appeared to be having with my young business partner. I was never one to pour out my heart to others. I had never confided to anyone how miserable things were for me; I had always played the role of the ridiculously contented house-wife/teacher/mother, and I was just as good at playing the role of the Gay Divorcée.

Somehow, it is a common assumption that when a female liberates herself, she falls into the arms of a man to save her. While it is now considered un-PC to pay homage to the white savior of the oppressed, the notion of a woman's male savior persists even today. Twenty years ago, when I decided I would take myself out the door, even my own children assumed I had to have a man waiting in the wings. I did not.

I did have a ready, willing support system had I sought to engage it. I had Daniel and his wife Dana, who were surrogate children and parents at the same time. Thanks to the summer experience in England, the Connecticut Drama Association, and the classes I took at Wesleyan, I had assembled a coterie of buddies, among whom were a few true friends. But I only rarely reached out for comfort of any kind; I was stalwart, resolute, firm in my belief that if I cried or whined or felt sorry for myself in any way, I might talk myself into begging Richard to take me back. I was as I had always been, convinced that no one would ever take care of me but me. My thirty-three years with Richard were testament to that truth.

When I told Richard I was leaving, his first reaction was disbelief. I had threatened often in our thirty-plus years together. His knee-jerk reaction was usually to laugh at me. "Where do you think you can go?" he would taunt. "Do you really believe you would know how to take care of yourself?" During the years that we had small children, I was overwhelmed and believed him absolutely. As the kids got older, I still believed him, but I was less intimidated by finances than I was by the thought of ruining my kids' lives. I would take the car and head off to

nowhere in particular and then realize how pointless my grand-standing was, and I'd return to find Richard already absorbed in whatever he had been doing before I left, untroubled by my momentary absence. He had no reason to think I would carry through this time. When I did, he was gobsmacked.

"What will I do?" he moaned. "I don't want to be alone."

"You won't be. Not for long." I knew he'd get snatched up very quickly. He was by any standards a good looking fifty-year-old with a great job and a big house all to himself. "Join an online dating site. Go to church. You'll be hooked up in no time."

THESE VAGABOND SHOES

When I left New Haven, I knew exactly where I wanted to live in the City. As a youngster in New York, I had lived in several apartments in various neighborhoods. After my grandmother's cozy, dark basement in Queens, I moved in with three women my age in a swank building on East 86th Street, Joe Namath's building. Joe Namath, then star Jets quarterback and a heart-throb ladies' man who never failed to smile at us in the elevator. But I didn't last long in that place. I was there at the invitation of a co-worker, a very mixed-up young woman who found ever nastier ways to punish me for having introduced her to a man who got her pregnant then abandoned her. I accepted her invitation because she was desperate for a third roommate to offset the high rent cost and, moreover, to have a mother figure she could dump on. Living with her was torture, but I benefitted by realizing that I was altogether too codependent and needed to find friends who didn't need me. I also learned very quickly that the Upper East Side wasn't for me; the fake eyelashes and smile I wore all the time were exhausting.

So I moved temporarily back to Queens, this time into my aunt's basement, up the street from my grandmother's, until a window dresser at Van Cleef and Arpels, a friend of a friend and

a great dancing partner, invited me to share a suite at the Marlton Hotel on 8th Street in the Village. The Marlton was a quiet hideout where queens like my roommate could be out without incurring the wrath of the unforgiving tourists. Our arrangement was cozy and cramped.

I wasn't there more than a few months. I got lucky. A fire gutted much of a building on 18th Street, where another friend lived, and a damaged railroad apartment became available. I moved in with the mice and the cockroaches and spent three years bathing in the kitchen while the vermin held raucous parties under my refrigerator; my rent was less than $45 a month.

When Richard and I became a couple, he had suggested I just move into his room at John Jay Hall. Not a perfect arrangement. We shared a room with his roommate, a classmate from Regis, still a virgin and terrified of what we might be doing behind our tightly closed door. I spent the entire spring semester unable to pee between the hours of 9 p.m. and 7 a.m. when that boy was in his bed; to go to the bathroom would have necessitated walking by him. The great advantage of our getting married that May was that we qualified for married student housing and were able to go from a summer sublet on Riverside Drive to a fabulous studio on 112th and Broadway.

I loved living in that neighborhood. It was diverse in every way, so no matter what I looked like on any given day, I was never out of place. I could be equally inconspicuous dressed up or dressed down, and whatever color or configuration my friends and family were, they just blended in. I loved the anonymity of my street and the secure assurance that there were friends and neighbors all around me. When I was out on the sidewalks, I felt beautiful, in control, confident. I could be outspoken, flamboyantly social, or I could blend into the cityscape and disappear. There were people to chat with who knew how to avoid small talk and make conversation about subjects of import, and there were people who were more than

happy to smile and nod and only barely acknowledge my presence. In short, I could invent and re-invent myself at will.

Every sound, every sight, every smell of the neighborhood reinforced my knowledge that I had found a microcosm of the city I had loved all my life, and I could not get enough. There was an electricity beneath my feet, over my head, in my heart that gave me a burst of smiling buzz every waking minute of the day and night. When I slept, the street played a lullaby that assured me all was right with the world. I was alive in an effervescent present where my past was behind me and the looming question mark of my future was a blossoming surprise.

Naturally, when I returned to New York in 2004, I expected to find what I left behind when I was led into exile.

On Craig's List, I found the perfect place, a sublet next door to the Manhattan School of Music, across the street from the Jewish Theological Seminary. It was a large rent-stabilized studio with a step up to a small "dining" area with a large window overlooking a sylvan courtyard. The building was populated by musicians and artists and some professorial types, and it was in the throes of a major renovation, converting to a co-op building, which meant the landlord was doing everything that could be done to eradicate the low rent payers to make room for sales money. What my sublandlord did not tell me was that the arrangement between us was illegal and grounds for immediate eviction if the owners got wind, a situation that was easy for her as she was living in Washington and, apparently, not paying her rent to them. Still, for six glorious months, I was delighted enough that I even took on a cat to ward off the rodentine visits from next door.

The next challenge was to find a job.

I had been living on the dregs of the one-year's salary severance I got when I left teaching plus the sums I derived from my itinerant directing work, but my bank account was nearly depleted. Richard and I had not yet divorced, but I had no support from him, of course, and I wanted to work in the city.

I stopped commuting to Connecticut, and my job search began in earnest. I applied for jobs all over the city, mostly in the public education sector and in areas that sponsored theater education, jobs my training and experience should have made me a perfect candidate for. I applied for three or four educational directorships at theaters; then, I put in a bid to be hired as a liaison between a local public school and a professional theater blogs writers, PR writers, copy writers. I even applied for teaching jobs. There were only a few responses of any kind to my many proffered resumes, and I only got two interviews. The first was at Lincoln Center, and within five minutes of my arrival there to apply for an assistantship to an education director, it was clear I was unsuitable; I could tell by the squint my interviewer aimed at me that she had expected someone younger, prettier, hipper. The second was for an education directorship of a Bronx girls' choir. The choir administrators offered me the job on the spot, but then told me I would need a car. It was apparently too dangerous to walk the mile and a half from the subway to their school. Having taught AP English, I thought I should be able to find a job teaching Freshman Comp, but no school even responded to my application; an adjunct instructor I knew in New Haven told me that the likelihood was that I didn't get called in for interviews was because my Master's in English was not a terminal degree. "You oughta get an MFA," she posited.

I was already nearly desperate when I applied for a part-time teaching job in a Manhattan school, where, after I passed the tests that had to be administered, after I had been vetted, after my references were checked, I got called in for the first round of interviews.

It was the perfect assignment for me, teaching kids at risk for dropping out, the kind of kids Stuart Elliot had hired me to corral when I began at my backyard school. The pay for half-time would be almost enough to live on if I were frugal, and I could look for freelance work to enhance the income. After the

first two interviews, I was sure they wanted me; they invited me and one other candidate back for the third and final go.

I had never considered sexism or ageism would stand in my way in New York. It was, after all, a city of enlightenment. But I was soon set right by one of the third-round interviewers, a woman nearly my age, the assistant principal or the English department chair. She ushered me into her office and closed the door then pulled her chair out from behind the desk and rolled it up as close to my chair as she could get without being on top of me.

"Listen," she said in a hushed mumble I could hardly hear. "I will deny we had this conversation. But I want you to know. You are my first choice. This is a job you should have. But they won't hire you. You're too old; you've got too many years in."

It turns out that even for a part-time position, the city districts are obliged by union agreement to pay a teacher for whatever experience has been accrued. In teacher parlance, the new hire must be brought in on the appropriate step. The powers in charge were looking for a step one teacher, one whose pay would be about a third of what they would be required to pay me.

"Besides," she continued whispering. "They'll use the excuse that you're at burnout stage. They like to insist that older teachers must be weeded out."

I was incredulous. Shortly thereafter, I had dinner with a new friend, a designer, who had been doing the lights and sets for many of the local schools' productions for years. He not only agreed with the woman's assessment; he added to my chagrin at not being called in for the interviews for other jobs.

"You have two things going against you. First of all, you're a teacher. Remember the adage those 'who can do, those who can't teach'? Well, it's not just a saying. It's true, true, true. Get used to it, girl, it's only just begun for you."

"What's the second thing?"

"You already heard it. You're old. Too old. You'll be lucky to

get a job in a bookstore. You'll be running back to your husband in no time."

That I was determined not to do. No minute particle of my being had any intention of returning. I woke every morning with a knot of fear in my belly, and I had no idea how I would survive on my own, and yet I regretted nothing. I felt no pull toward Connecticut or Richard or to any of the life I had left behind.

I did need a job.

Then I saw another Craigslist ad. "We are seeking natural born teachers, those who love NY, revel in its history, and want to share it with others. If you qualify, we provide training, and uniforms, including winter coats. $25/hour."

The ad did not identify the employer; it provided a phone number, which I called, to a personal phone; the young woman who answered asked a few questions then suggested I come to an interview at a bar in lower Manhattan. $25 an hour was a lot of money at that moment. I was determined to get this job. . . whatever it was.

My anxiety was immediately quieted by the man conducting the interview in the dark corner of the deserted bar. He was older than I, had a face full of straggly white hair, and a wet mouth that caused him to slurp often as he spoke. He said he was assembling a staff of qualified sightseeing guides for a brand-new company, and the work would be perfect for me. It was, to my amazement, a real job even though he was not yet ready to give the company's name. First, he told me, you must take the licensing exam. We cannot consider you for employment until you have the license. "But don't worry," he assured me. "I'll train you well."

Beginning the next evening, in a meeting room he had booked in a hotel on the Far West Side overlooking the Hudson River and the Palisades, for a full week of evenings, he ran classes covering the history of New York, the laws governing tourism and buses, the quirks to be expected when one was offering guide service to double decker bus patrons. By the end

of the ten sessions and after reading Phillip Lopate's *Waterfront: A Walk Around Manhattan*, Pete Hamill's *Downtown: My Manhattan*, and much of *Gotham: A History of New York to 1898*, by Edwin Burrows and Mike Wallace, I aced the exam and earned that license. I started work the following Tuesday, in August 2005, nearly a full year after I had arrived in the city. I was ecstatic.

In the first months after I was hired at CitySightsNewYork, I had the same feeling I had had as a neophyte teacher and drama director. I got paid to do this? Something was wrong in a world where being this happy could be called work. It was the end of summer already, which meant that the sun left the city early each day, and the movement of the air on the top of the bus was pure joy. When it rained, I laughed and kept on riding. I was on top of a bus, seeing New York from angles I hadn't even imagined before, learning every day something new because I could not stop reading, investigating, studying. My customers were multinationals, so I got to speak German or French; sometimes I even got through whole conversations in Spanish and Italian and occasionally a halting but satisfying connection in Serbian or Croatian. My tips were hefty, my brain was exercised, and the running up and down the stairs of the bus kept me fit. Everything about this job was a novelty, a pleasure, and I was making a lot of money. Because the company was new and understaffed, our small group of guides worked as many as 12 or 14 hours a day, six or seven days a week, and I was flush for the first time since I left "home." I could breathe.

Citysights was a breakaway firm. It had been founded by a small group of disgruntled drivers, guides and administrators, who had left the behemoth GrayLine tours to form their own company. It was exciting to be part of the revolution, an upstart company creating jobs and making competition available, and we all shared in the benefits of their fuck-you attitude, which led them to staff the company with others like me. We guides were

mostly over-educated and under-skilled, and we represented all age groups. I began to make what I believed to be real friends.

My first friendship was with a woman with a bestselling book. That's how she introduced herself to me, "I'm Felicia, and I wrote a best seller." *Older Women, Younger Men*, it turns out, is a compendium of other people's research, which Felicia's writing partner assembled, for which Felicia wrote a series of interconnecting remarks. I didn't know that at the time. I was just totally impressed that she had published a book. We made plans to write a book together.

Mandy was my other favorite person.

Mandy , who was in those days still called by what would become her dead name Stephen, was saving up for gender reassignment. Divorce from a greedy wife, mental illness in a daughter whom Mandy would never abandon, and frequent gender transgressions that led to her being fired, left Mandy with no money for the surgeries. Instead, Mandy made powerful self-assertions by wearing, in all weather, Bermuda shorts fashioned in bright orange sweatshirt fabric, frowzy blouses and tops that plunged below her prominent and rapidly graying chest hairline, and neon-colored sneakers. Her hair and mouth were a whirling forest of bright tangerine curls and a soft, pillowy hot pink triangle.

"I'm a lesbian," Mandy explained to me the first time she asked me out to dinner. I was actually flattered. No one I had ever met was smarter or funnier than this person, both qualities I have always found irresistible in a man. I had no interest in being romantically involved with a woman, even a woman who was, anatomically at least, still a man. Of course, I didn't want to hurt Mandy's feelings, and though I turned down the invitations to dinner, to movies, to theater, we often sat together as we waited between buses, and I never tired of listening to the stories she told. The personal stories were harrowing, beginning with a Lower East Side childhood, and the professional stories were infuriating. This person had tolerated more than anyone's fair

share of abuse by the system over the years, and if I had been differently wired, if I were capable of loving Mandy as she deserved to be loved, I would have spent all kinds of days and nights with this remarkable human being.

Winter returned as I rounded into the end of my first year on the bus, and with it came the end of the idyll. Eventually, Mandy ended too.

But first, I had to move.

The young woman from whom I was subletting not only neglected to tell me she had stopped paying the landlord. She also declined to share with me the information that she had been evicted, that she must vacate the premises or all the belongings that she had left, which comprised the entire compliment of furniture in the apartment, would be trashed. Fortunately for me, the superintendent of the building was fond of me. He knocked on my door one morning to ask if the girl had been in touch to tell me the news. When I asked what news, he sighed and said, "You gotta move, Miss."

"Oh, I know, Jose, but I still have three months left on my agreement with Anna."

"No you doesn't, ma'am," Jose said solemnly, shaking his head morosely. "The crews are coming in two weeks to clean everything out."

Two weeks!

I began to search frantically, looked at more apartments than I would have imagined available in my neighborhood, but there was none I could afford among the even fewer that were immediately available. Somewhere I found the name of a broker who said she specialized in Harlem and Washington Heights; she had nothing in Harlem that would work, but in the Heights, now there I could move by the very next day.

The apartment I chose was a sixth-floor walkup on what appeared to be a remarkably quiet block of 180th Street in a grand old building with marble stairs and a formal lobby. My neighbors were sweet, the landlord lived on premises, there

were stores and buses and subway reasonably close, and, the broker assured me, I could rely on the fact that I would be at my CitySights bus depot in midtown in less than twenty minutes.

She lied. I lived there for three years. Three horrible years. A horrible that was not entirely because of my apartment.

In fact, my immediate misery came from my job. The same job I had loved so deeply just a month before. The novelty had worn off, and I was plumb exhausted. I now realized with absolute certainty that this was not a job I could do long term. It was, however, a job, and I had to protect myself from losing it.

The man who had founded the new company was young and inexperienced, and he knew nothing about running a bus company. His father, who owned a successful airport shuttle service and a commuter bus line, bought the bus company for his son without educating him first. An old school immigrant who had pulled himself up by the proverbial bootstraps, the father was sure his boy would learn fast. The guys on the street, who ran the business in those early years, all thought sonny was stupid because his learning curve seemed really slow. He eventually showed them how wrong they were, but while he got the hang of things, he just let the toughened bus cronies run things for the time being. They ran the business like a B-grade gangster film.

The bearded sage who hired me only showed up to do the ongoing mandatory training sessions. I often punched into work in time to man the second or third morning tour, which went out before 9 a.m., and I was rarely home before 10 or 11 PM, after two or three night tours.

We had no office, no break room, no place to sit down. Dispatchers habitually filled the buses so we could not sit even while we were touring; it was illegal and dangerous to stand on the moving buses, but the dispatchers were instructed to leave no seat without a customer in it.

There was no bathroom for our relief. For a while we were allowed to use the rest rooms in the Hilton Garden Inn, which

was less than a block from our post, and the management there even encouraged us to buy goods in their gift store and food mart by giving us a twenty percent discount.

One day Mandy farted and sighed in a stall in the women's room at the Hilton, and some tourist seated next to her, the woman in the next stall, securely separated by a metal wall and a locked door, freaked out at the sound of a male-sounding voice sighing on the tail of a roaring fart. She complained to the Hilton management. After that, all guides were banned from the place. No more comfy lounge seats, no more cheap candy bars, no more toilet. There was a rest room at Battery Park, where we generally had a three-to-five-minute stop, and if a guide could hold it long enough to get there (days with heavy traffic on the streets were the worst), they might be able to sneak off the bus and take a leak. But if the company moguls found out, the guide was reprimanded, threatened with firing or at the very least subjected to public humiliation. We were strongly discouraged from taking breaks of any kind.

As it got colder, it became apparent that customers didn't want to be on top of a bus in what was essentially a rolling freezer, and the owner began to divert coach buses from his father's business to run the tours. Visibility was poor, and customers, feeling ripped off, took their disappointment out on the tour guides, who were expected to be grateful they weren't on top of an iceberg. There were only a few coaches, the heated wonders, available. Mostly we froze.

Felicia, my best-selling author friend, played her asthma card. I had never known her to have asthma in the summer or fall, but as soon as she was cold, she said she would die if they made her go up on the bus. She insisted she had to ride the coach bus. Only. For a time no one got a coach but Felicia. Until Mandy put a stop to that.

Mandy knew the law, and Mandy showed how the company was under no obligation to protect the sightseeing guide, whose only legal recourse was to stay home until it got warmer. That's

what Felicia then had to do, thanks to Mandy. She had a small trust fund; she could afford to simply stop working for a few months. The rest of us got intermittent opportunities to ride the warmth, but mostly we continued to freeze.

As the fatigue wore me down and the temperatures dropped, the rains came, and the wind. If it is windy on the ground, the top of the bus feels like it is tunneling through an icy tornado. I was often blown off my seat. The company gave us parkas with removable wear-alone liners, and some guides, who happened to be on the street at the right time on the right day at the right corner got hats. But there was nothing warm enough to protect the sensitive ear lobes or the fingertips or the toes. We were bound by policy that required if there was one customer who wanted to be on top of the bus, that we, too, stay up there.

As the elite members of the CitySights crew, we all felt we should be treated with respect, with consideration. In truth, we were treated abominably. In the very early days, when there was only a handful of us, and we carried the largest share of the burden for customer service, management was, at least, grateful. In the winter, they parked unused coaches on the street so we would have a sheltered place to await our assigned routes and distributed hand warmers. In the summer, they brought ice cold water. When it rained, they took us across the street to the covered area of the Worldwide Plaza so we could remain dry. By now, however, we were in the second year of business, and they were suffering from buyers' remorse. In their estimation, they had overpaid us, and they deemed us a profit drain.

We were despised by the ticket sellers and the drivers. Ticket sellers made no salaries at all in those days; they had to subsist on their commissions. Many of the salespeople were immigrants, fresh off a plane from Africa or the Caribbean, and they had families to support here and in the old country. In order to boost sales, they lied.

"Yes," they would promise customers, "The bus is equipped with a bathroom, and you can go downstairs to get warm."

"Don't worry about finding your way to the waterfront," they would say to encourage the customer to purchase a Circle Line tour. "The bus stops right at the boat landing."

"Oh, you can use the bus as a taxi," they would tell people who had trouble walking. "Just tell the driver where you want to be let off, and he'll stop."

I rarely intervened but once was forced to subvert the worst lie I ever heard a seller tell a customer. A man pushing a much larger man in a wheelchair stood looking wistfully up at the top of my bus, and a ticket seller approached him.

"You wanna take a ride?"

"Oh, I would," the man nodded vigorously. "So would my brother. But. . . "

"Good choice," said the seller. "You can ride uptown, downtown. We stop wherever you like."

I shook my head. "No," I corrected him. "We will stop at designated stops. You choose which ones you want to disembark at, but the stops are preordained."

The ticket seller glared at me.

"You'll get all around the city. Best way."

"When's the last bus?" the man in the wheelchair asked. "Will we be able to take the bus back to our hotel after the theater?"

"Buses run all night," the seller assured him.

"No, I think you're mistaken," I said, trying to be gentle. I understood how important this sale was, but this man was equally needy. "The last bus leaves the last stop at 7 PM," I said. "You'll have to rely on public transportation or taxis. . . . "

Despite the inconsistencies, the customer was ready to buy a ticket, and the seller lied again to finalize the transaction where I could not overhear. After he made the sale, he brought the pair back to the bus and left them on the line of waiting passengers that had, by now, formed in front of me. I began punching tickets and letting people aboard. Then, I got to the wheelchair pair.

"Where's the elevator?" the chair's pusher asked me.

"Is there a ramp leading up to it?" asked the passenger.

"Oh, sirs, we don't have a ramp or an elevator. You will have to fold the chair and stow it under in the space behind the driver, as you can't have it on board; you'll have to get yourself up the stairs. "

"But the stairs are steep, how am I gonna. . . ?"

Both men were flabbergasted.

"Well," the man in the chair said to me. "You'll just have to carry me up the stairs."

This kind of thing made our jobs horrific. We were the customer service face of the company, and customers routinely yelled at us, called us names, let us know that we were responsible for everything they endured in New York City. Whenever it became apparent that they had been lied to, the customers preferred to take their frustration on us rather than to file formal complaints with the company or the city. When I was not too tired to be circumspective, I was amused by the way being a tour guide was in so many ways similar to being a classroom teacher. We imparted knowledge that not everyone wanted, and when the system seemed to fail, we were the ones who took the brunt of the blame. However, no matter how snarky our charges, no matter how angry the parents, no one had ever asked that I carry any person anywhere.

When I said there was no way I would ever consider carrying anyone up the stairs and after the driver also refused to do it, the customers went to our street capos and complained that we were lazy. Luckily, labor laws and simple common sense protected us. We could not be held responsible to carry any man, let alone a heavy one, up a steep flight of stairs; our bosses refunded the tickets, and the customers left very angry. The ticket seller never forgave me.

Drivers were absurdly underpaid, and they resented that we made more than twice what they made. In order to get drivers to sign on for subpar wages, management told prospective hires that there would be plentiful tips, that the tour guides would

make sure that they were compensated for the difference in their pay, a difference management gleefully disclosed to the drivers, so the drivers came to believe that if there were no tips either we had stolen them or we had somehow deliberately tried to thwart the drivers. Drivers routinely stood next to the tip jars as customers exited the bus, sure that if they did not, the tour guide would rob its contents. The fact is that few tour guides made much in tips after the first year. I am not sure why we did so well the first year, but it never made sense to me to expect much in tips. Most of our customers were Europeans, and tipping seemed barbaric to them. Still, we were hounded by our drivers.

On a particularly stormy November day, I had a family from the UK who insisted on staying outside though I knew there was a coach behind us that would have taken them on. They wanted to see the city, despite the heavy rain and bitter cold, and so we stayed atop that bus. I was huddled in the back of the bus, under my rain gear, shivering and offering commentary on what bits of the tour I could actually see, and they were all the way up front. The rain had turned torrential when they got a phone call. Suddenly, they were all standing up, pacing back and forth, wailing. I made my way toward them, knowing something must be terribly wrong, wanting to help; I was so concentrated on their situation that I failed to see a streetlamp headed toward my face. I did not duck in time; my glasses were smashed, my nose cracked, and my eye swelled. Things only got worse from there.

The companion of the couple whose phone had rung told me that the call had come from a police person in the UK informing them that their daughter had been killed in a car accident. I knew they needed to get off the bus immediately, to get back to their hotel, to be anywhere but where they were at that moment. I tried to communicate with the driver, whose camera should have been capturing all the action, including my injury, as it was going on. By law, he was supposed to stop the bus if people were walking around, and by rights, he should have stopped when I was whacked. But the camera was – as was often the case – not work-

ing. The PA system, designed as a communication from the top of the bus to the driver, was also out because of the storm. We were stranded on that swaying balcony, they keening and I bleeding, and there was no way we could hold out until we came to the next stop. I instructed all six of them to join me in stomping on the floor, which I knew would get the driver's attention and possibly give him a headache. It took another five minutes before he finally jolted to a stop and stormed up the stairs to yell profanity at me. He never even looked at me or gave me a chance to explain, and the family exited the bus while he was throwing his tantrum. Understandably, they didn't leave a tip. The driver launched into a second tirade upbraiding me for having failed to make a tip speech. I told him he was not my pimp and walked away. I got my nose to stop bleeding, washed my swollen face, put my poor demolished glasses in my backpack, and went back to work. Three hours later, I found myself on the same driver's bus.

I wanted to quit. But I knew that the prospect of finding another job was slim at best. I was tethered. I consoled myself by writing elaborate stories – finely woven historical fictions, apocryphal tales of the city, expanded history lessons, colorful character studies – to use on my tours. I was writing, I told myself. That was good. The money dwindled steadily down. My first winter, 2006, there was a bus and subway strike and two blizzards; our buses were crippled, and we were routinely sent home without work. I was coursing through the meager leftovers of my savings without having a great time. By spring, the equipment we were working on was in ill-repair, and the company was not solvent enough to fix things. Customers won't tip at all if they feel ripped off; our customers routinely felt that way. And yet the company added sales staff, added routes, added more old buses to the fleet, and they began to hire young, often uneducated guides at half the salary we "old timers" were getting. We were assigned fewer days, fewer trips. I was barely making enough to keep myself alive.

I got lucky. I broke my hip.

One briskly cold, gloriously sunny February morning, at the end of a month-long bout with a nasty bronchitis, I had gone into Fort Tyrone Park for a run, my first in a few weeks. I felt energized, healthy, grateful to be out in that gorgeous day and not on the top of a bus. I was running strong, feeling invigorated, when suddenly my toe caught something, and I went down, my entire weight centered on my hip, which landed with blunt force on a rock. I heard the bone crack. I knew the sound – it was the same sound my son's nose had made when it had connected with a baseball he was trying to catch at age 7 – but doubted the result.

I lay there for a moment, trying to assess the extent of my pain, deciding what to do. The sunshine notwithstanding, the morning temperatures had not risen much above 0°, and having grown up in the Adirondacks and read Jack London short stories, I knew how easy it would be to just lie there, go to sleep, and die. I had to get up, regardless of the pain, which was, when I tried to stand, nearly unbearable. I sat, then kneeled, then stood and leaned myself against one of the park's stone walls so that I could survey the territory. It felt like walking was not an option, so I sought help.

A pair of women appeared within shouting distance, and I screamed to them, begged them to help me. They kept walking. I slumped; the ground was looking really attractive, and sleep beckoned. The will to move prevailed. I trudged uphill for nearly a mile and lay down to rest on a bench at the periphery of the park. Finally, a savior appeared.

A very ordinary middle-aged man saw me, asked me if I was okay. I could not reply.

"Your face," he told me, "is as gray as the melting puddle of snow beneath that bench."

I tried to smile. He told me to stay put. "I just came from the other side of the park," he said, patting my head gently. "There

is a team of paramedics parked in the lot there. It's where they breakfast every day. I'll go get them."

I didn't really trust him.

"Do you have a cellphone?" I asked him. I felt like I was being rude. "I left mine home, and I would like to call my – "

He seemed to intuit my dubiousness, and he handed me his phone. "Hold on to this until I get back," he said. "Call anyone you wish. I'll be back as quickly as I can."

Thanks to that man, I was soon on my way to the hospital in an FDNY ambulance, and less than four days later, I was walking up my six flights of stairs on a new hip. The best part of it all was that my doctor told me I should not return to the bus for at least a month. I would be obliged to apply for unemployment.

Fortunately, though my divorce had been finalized a few months before, I was still covered by Richard's insurance. Paying rent and buying groceries was going to be a challenge, but I trusted that I would figure it all out. Just months before, I had been able to set up an annuity with funds from the projected sale of our house; the money in that annuity was my assurance I'd get through a few months, when I hoped I would return to work, and, with any luck, renew my ability to tolerate the job.

If I had had a good divorce attorney, I might have had a better safety net. Women have traditionally fared ill in divorces because they lack the resources to get adequate legal advice. Like my cohorts, I had very little financial substance, and Richard, the master of low-cost alternatives, engaged a mediation team from his church. What I did not know was that he had also hired an attorney to guide him in making his concessions and demands. One of the ways in which his attorney saved him money was advising me rescind my health insurance. And, because I earned significantly less money than Richard did, I got a smaller portion of any assets we shared. A good attorney might have fought and won some compensation consideration for all the years of child and house care, but none was offered. I was incredibly lucky to

break my hip when I did because I was still protected. Two months later, my insurance policy ended, and I was uninsured for the next six years, until I was eligible for Medicare.

I stayed at CitySights until 2012, never happier about the working conditions, never less resentful that I was dependent on the company. But I managed, over the seven years, to take a hiatus here and there to do other jobs, some writing, some editing, and some traveling, and I got involved in Union organizing. In the end, I am proud of my staying power, my ability to wait for things to improve, to lack the need for instant gratification.

At this juncture, I had a freaky experience that enriched my life and gave me a sense of direction.

My friend Charles, a best-selling author of popular celebrity biographies, hired one of my children to do some light editing and research for him. The two of them were uncompromisingly incompatible with one another. Charles offered me the job instead, and I gratefully accepted.

At the time, Charles had begun working on a book about Marilyn Monroe and Joe DiMaggio. At first, he asked that I do simple proofreading, some minor copy editing. The material was fascinating, a delightful diversion from the grinding realities of the bus job. As we went along, David trusted me more, and the work became more challenging, more satisfying. I got to do some research, more editing. When he gave me the chapter that I found fraught with inaccuracies, and I said so, exasperated, Charles finally said, "Well, if you know so much, rewrite the damned chapter yourself."

I did. When I gave it to him, he was impressed. "Hey," he enthused. "It sounds like me."

"Of course," I laughed. "It's your book."

"Good," Charles joked. "If I die before it's completed, you can finish it."

A month later, Charles did die. His widow hired me to complete the two remaining chapters and to work with his editors at the staid, well-established publishing house that

published all his work. His widow astutely ushered the book to publication, and I am told that it is impossible to tell that Charles did not write it all himself.

Once the book came out, I promised myself that I would find my way back to writing. And I would find a way to support myself without riding a bus. Remembering the advice to obtain a terminal degree, I googled MFA programs and found myself tearing up at the thought of returning to Columbia. That's the ticket, I thought. An MFA program to help me polish my skills and a degree to enable me to teach college writing.

I was on my way to being me.

THE SPOILS OF THE THIRTY YEARS WAR

On the day I packed my things and left Richard, he made me promise I would not divorce him. He said he did not want to deal with the finality, did not want to cope with finances, his parents, the world. I was amenable; there was nothing impelling me to divorce, and I was in no hurry to find another man. As long as I was still married to him, I was included on his health insurance plan. True to his pattern, then, Richard was the one who would decide, without consulting me, when the arrangement would terminate.

In early November of 2004, Richard called me. Since the separation, we had talked periodically when there was something to discuss, and of late, the conversations were happening more frequently. He had begun to see a therapist, which he had resolutely refused to do in the past, and I actually thought we were on our way to forging a new friendship. Each of us called the other now and again just to talk as he did one November morning.

"Hi." he said when I answered the phone. "When's your next day off?"

"Wednesday," I replied, perplexed. "Why?"

"My therapist thinks I should tie up some family ends, find some closure, and I thought. . . ."

"You want me to give you permission to burn the house in Clifton down?"

He laughed. Nervously. He probably thought the comment was nonsensical. His parents had moved to Florida years before, and we had seen them only very infrequently. His sister was married and also living in Florida. When she traveled to New Jersey to see friends, she did not bother to call or see us. They had all become a kind of peripheral family.

"No. I want you to go to the cemetery with me."

"Cemetery?"

"Yeah. Where Babci is."

I smiled. Babci.

"I need to say goodbye."

Richard had had two babcis, but when he used the name with a capital letter, it always meant his father's mother, of whom I was especially fond. Like me, she was a first generation American; her parents emigrated from Poland to New York City, and her mother died when she was a child, leaving her and her sister to take care of each other. Her father, a milkman, remarried and had a large number of offspring to whom she referred as her "halfs," and every one of the relatives I met seemed to me a caricature Pole with a kind of comic book hatred for Jews and Blacks. Not Babci.

Babci had a penchant for humorous self-deprecation. A story she told often with great pride recounted a time, when her husband was off fighting WWI, that she and her sister had a strange encounter on a NYC subway train. Across the aisle from them sat a well–dressed Black man, and the two very young women giggled loudly and tittered in Polish about how good looking he would be if he were white, about how well dressed he was for someone like him, about how glad they were he couldn't speak Polish. Babci dropped something, and the beautiful man picked it up for her. She thanked him in English, and

then, she said, he stood in front of her for a very long moment looking at her, making her very uncomfortable.

"I couldn't imagine what he might want from me."

After the prolonged silence, the man bowed gently to her and said in perfect Polish, "Lovely lady, never make assumptions about what others can or cannot understand."

"I sure learned a lesson that day," Babci would brag.

As a mother, Babci had been demanding and strict to the point of cruelty. She was not ashamed to say that as punishment and to show him how critical it was that her son obey her, she would dangle Richard's father by his ankles out their 8th story apartment window until he promised to be good. As a grand-mother, Babci was indulgent, permissive, and she doted on Richard and his younger sister. When I entered the picture, not only did Babci insist that the family accept me, but she took me under her wing as well. From her, I learned to make kielbasa, pierogi, krschiki, and "golumpki," some of Richard's favorite foods. Babci was eager to accept me, to love anyone or anything her Richie loved. She was not happy I wasn't Polish, and she was especially disappointed I was Jewish, but she forgave me. Thought she was without rancor toward anyone on the basis of stereotypes, she was a product of her upbringing, of her environ-ment, of her generation. She came from a family of Polish peas-ants, for whom the shtetl Jews of the Mother Country were terrifying. They were fed stories about Jews kidnapping children for their Passover meals, and the iconography and symbols of their religion reinforced the fears. In America, Babci never treated others unkindly because of their ethnicity, but she natu-rally reverted to them. She used to say of my mother, "She's a prince. Even if she is a Jew, she is a prince, and I love her." Babci, too, was a prince in her own right.

"At the cemetery?"

"Well, you know, she died so suddenly when we were in Phoenix, and I never did get to the funeral." At the time I was confused by his response to the family's pleas that he attend. By

this time, already several years after my mother's death, I had more of an inkling, but I was still somewhat perplexed.

"Yeah. I remember. So what's changed?"

"I think maybe she was the only one who ever really loved me. I want to show myself that she's gone, see where she's buried. You know. Get closure."

I don't believe in closure. It's a fictitious construct. I don't expect the book of my emotions ever to close, as I understand that the tide of time will not cease until I'm dead myself in the only real closure.

"What does this have to do with me?"

"Well, you and Babci. . . "

"We liked each other."

"Yeah. I thought. . . . "

"You want me to come with?"

I could hear him nodding before he said yes, and I was truly pleased. After all this time, after all the reasons to be angry with him, after all the disappointments, I still wanted to love him.

"I'll pick you up —"

"Wait. You? You're going to drive to the city?"

"It's on my way out to Jersey"

Perhaps this was the most wonderful thing? Perhaps Richard had experienced his recognition, and now he was heading into reversal at last? The man who vowed he doesn't "do New York," is picking me up at my apartment, and we are driving down the West Side Highway to reach New Jersey.

The day was delightful. We didn't do anything except drive to the cemetery and search for the headstone.

It was I who found her, in the maze of Polish Irish, and Italian names on various sized stones with no special markings or indicators. Her name was just there like the title on a dusty book jacket spine standing among the others stacked randomly in disparate rows in a seedy old bookstore. Before I saw it, I felt myself drawn to her grave as though I were carrying a divining rod.

Richard was grateful, and we sat there with her for what seemed like a long time, talking to her and about her. He retold me a few of his favorite stories – how she took him to the theater to see *Fiddler on the Roof*. How she took him and his sister on vacation every summer and let him eat sugar and butter, which his parents kept from him.

When Richard had had enough, we went back to the car. It was getting late already, and we both had to work the next day. He left me at my door after we hugged deeply and affectionately for a very long time.

"I love you," I said. I meant it.

"I'll always love you," he replied.

The next day he asked me for a divorce.

I knew it the minute I answered the phone and heard the tone of his breathing – of course I recognized it. We were married for thirty-three years after all. I just knew it: we were not where we had been the day before. Without bothering with polite niceties, without any preamble, he came right to the point.

"I have decided we should divorce."

"Just like that? Now? When we are actually beginning to like each other again?"

"It's time. I found a mediation firm through my church, and I thought. . . "

I didn't know it then, but the fact is that he had found a lot more than just a mediation firm at his church. He had been attending a local chapter of a large church network for a few years already. Lapsed Catholic as he was, he needed the communion of other apostates, and it was through his church he found his therapist, through his church he found a community of his own, and through his church he had been dating.

A week or so before our cemetery date, my daughter, frustrated with something her father had said or done, said to him accusingly, "Yeah, well, you'll remarry, and then you won't care about any of us anymore."

"You are so wrong," Richard told her emphatically. "I have

no intention of remarrying. I'm not even dating anyone seriously."

He lied.

In fact, Richard had already replaced me, and he was trading up. Divorced once and widowed once, his "new" love had done well in her last settlement and owned a little house on the beach. I was happy for him. I wanted him to feel safe and secure. But I could not help feeling a bit hurt too. After all, he could have said something to me when we were getting along so well. Instead, when I suggested we see each other more often and work on this new relationship, he smiled and agreed. When he sprang the divorce request, I wondered if he had come to NY to soften my heart and make me feel guilty enough to give him the divorce now that he was ready for it.

At first, I was taken aback by his duplicitousness. I never took him for a liar before. He had evolved. Or devolved. I got to see a lot of his transformation over the course of the next several months, and it was shocking to see how much like his father he was becoming. Here was the first outward sign. It preceded my knowledge that he had hired an attorney, that he had squirreled money away where it was not part of our community property, that he lied about the details of our earnings. I wondered if I had pushed him to be a sneak or if that side of him had always been there under cover. I didn't know if I should feel guilty or just plain angry. In the end, as with all the baggage I had accumulated in our life together, I threw it away, discarded the anger and the confusion. It took some time, but I succeeded, and I eventually felt lighter than I had for most of my life.

It's hard to believe I was so naïve. But I was busy looking for another apartment – the place in Washington Heights was fraught with problems, not the least of which was the fact that the A train was less and less reliable on weekends, when I had most of my CitySights hours.

People complain that the outer boroughs are neglected, and I can understand their frustration. They are not alone. Living on

the fringes of Manhattan felt like living in another town far from legislative or executive branch consciousness. Travel to and from anywhere north of 96th Street is a lesson in what it's like to be a stepchild in a dysfunctional home.

In the fourth year of my newest NYC residency, I was just such a stepchild. I needed to be closer to work in a location from which I could walk to midtown.

I knew exactly where I wanted to be. In the vicinity of Morningside Heights, near Columbia. I found it restorative to walk around campus, to have coffee in the accessible cafes, which featured reliable WIFI, self-service, and no pressure to buy anything. Great spots to write, think, observe. I knew that when school was not in session, the streets and restaurants were uncrowded, and there was quiet.

I landed in Harlem. At the time, I was happy to be a mile from Columbia and two blocks from City College in the heart of West Harlem. Columbia has since charged into this neighborhood, and they have changed the demographics for better and for worse. I've been here long enough to call it home.

As I was burrowing into my new apartment, Richard and I were officially divorcing. To my surprise, he had become greedy. He had always justified his refusal to buy me a ring, his reluctance to buy furniture, his unwillingness to stay in hotels by saying material goods did not matter to him and should not matter to me. I believed him. Now, for reasons I did not comprehend, he would not part with any of the antique furniture and other possessions we had inherited from my parents. I didn't fight him. After all, I left. I had not worked through my guilt. I doubt I ever will. I did, however, push back on his insistence that I did not deserve half of everything we had bought and paid for together.

At first, he did not want to sell the house. He and his new wife were happily ensconced there, and he was in no hurry to move. He did offer to have it appraised.

"That seems fair," I agreed. "We'll split it down the middle then."

"Oh, no," he laughed. "That would not be fair. Your salary was only a third of mine at best – I have all the records here of what you made and what I made – so you should only get a third of it."

I was astonished. "What about all the cooking, cleaning, laundry, schlepping, child rearing, school conferences, etc., I did alone?"

"I was supporting you. That was your responsibility."

I looked to the mediators for some support. They offered none.

"I chose not to go to graduate school because you didn't like Berkeley or New York. So, in essence, my decision to become a teacher and make that lower salary was predicated on your having insisted we stay in Santa Barbara and then that we move to Arizona."

"You made choices. You cannot hold me accountable for your choices."

This time, I turned on the mediation team. "He can get away with this? You will allow him to get away with this?"

The woman on our team looked me in the eye while the man looked away. "You did leave. You did let him keep the furniture. And you did earn far less than he. He is within his rights."

The moment was cinematic for me. I saw myself removed from the scene and dumped into an interior monologue. If I fight this, I thought, I'll cause vitriol, and my kids will get dragged into it. I will also have to hire an attorney, and the fees could eat up whatever gain I might hope to make. He's still working for a major aeronautics corporation, and he's still drawing a three-digit salary; he can afford to fight me. I can barely pay my rent and buy food on what I make at CitySights. Who could help me with this? Nobody. I just have to bite the bullet.

Then, the bullet got more lethal. I was still refocusing on what was happening in the room as I realized Richard was

saying, "Now. . . about the parent loans we took for the kids' education."

Despite the fact that my making a third of his income deprived me of a portion of the house assessment, it did not exonerate me from the parent debt. I was expected to pay half. It would be deducted from my share of the house.

I was defeated. He won it all. I had nothing to fight with, and what I did not know – I learned it much later – was that he had a lawyer on the side, a friend from his church, who was giving him advice. I was alone. He kept many of my family's heirlooms. When he eventually sold the house at a considerably higher price than he had reported in the assessment, he abrogated all responsibility for any of the difficulties our children might encounter from that point.

Suddenly, I felt swept into a 70s B Movie. The room swirled about me. Colors swept by me and my face contorted in various expressions of pain.

"You bastard," I shouted at him in my head. "I let you have my happiness, my agency, my balance, my self-esteem. And now. . . . " As I tumbled through the whirling vortex, I suddenly spied a jar of mayonnaise.

The scene shifted. I was standing in my first Arizona kitchen, looking down at my feet. A light came on.

I was seeing a scene from the days when I was pregnant with our first child. We had fought about something – something I wanted to buy or something I wanted to do that would cost money. We only fought about money in those days, but we fought a lot. Fights inevitably gave way to his tantrums. I watched the moment as our fight escalated, and I heard myself yell, "We have to stop. This cannot be good for this baby I'm carrying."

His wrath flared hotter. He resembled a cartoon character having a meltdown, steam emanating from his ears and head. The sound of a steam whistle wailed behind him. Next to his left hand stood a large, full jar of Hellman's mayonnaise. Fuming, he

lifted the jar and dashed it toward the ground, landing the full force of the glass bottom on the big toe of my right foot. The jar bounced off my toe and landed in a splat of glass-infused glop a couple of feet away.

Richard stormed away, locking himself in our bedroom, and I set about cleaning the mess while my toe swelled to three times its size. The pain throbbed and soon was unbearable. I had no choice.

"Could you please come back?" I pleaded through the door.

No reply.

"I need your help."

No reply.

"You need to take me to the emergency room."

Finally, he emerged from the room. When he saw my toe, he started to cry. "I shouldn't have done that," he moaned. "I didn't mean to hurt you. Why did you make me do this? Why did you make me so angry?"

"Just get me to the ER, will you please?"

The scene dissolved, and I simply remembered the incident as it happened. The hospital visit was humiliating.

My toenail had to be removed, and when the doctors asked what happened, I replied, "I dropped the mayonnaise jar. It landed on my toe."

We went home, and we never spoke of it again.

The toenail grew back. There was no sign of its having been lost, no remaining pain. I was able to let go of every part of the experience.

Back in mediation, the room stopped spinning, and I nodded at Richard and his team of advisors. Then I pivoted on my heel, went to my car, and drove away.

I turned on the radio, and there was Leonard Cohen singing "Hallelujah." The song always made me cry. It still does. But I stopped as I sang along on the last verse, "Now I've done my best, I know it wasn't much. . . . I'll stand right here before the

lord of song, With nothing, nothing on my tongue but Hallelujah."

Aha, I thought. *No wonder I remembered that scene. Our marriage is the old toenail. My life-after-divorce the new one. And here I am to sing it. . . Hallelujah!*

Everything I gave up – even the things that should have been mine, like my mother's furniture, my share of the house, the Raphael facsimile my mother encased in a gold leaf frame for us – were gone. I was in a new place. No empty spaces on the wall, no absence of furniture stood to remind me of what I lost. I could live just fine without any of it. I could not live without my children.

They were convinced that he was faultless, that I left him for naught, that he had suffered. He had their sympathy. Their judgment of me would only worsen if I did not let go of my anger. I had to learn to stop caring about him one way or the other. By this time, we had a grandchild on the way, and I wanted rapprochement. Peace. If we were to be any kind of a family, I had to paint on a loving face.

I was deeply grateful for the epiphany of the toe. Over the years since, I have learned to love the memories of our moments of happiness without holding on to any of the bitterness. That was the moment when I knew for sure that I was far better off without him. Even on my worst days, standing on top of the bus, feeling my ears ache and my toes go numb while my fingers turned brittle, I never once wished I had remained within his stifling suburban protection.

It was time to take possession of my own quest for happiness, and happiness, I knew, meant finally freeing myself to write, to be the writer I had always wanted to be. And I had to get off the bus.

My options were not great. I had to get back to teaching – as a way to support oneself, it's nonpareil: the money is fair, and

the opportunity to do good is great – but not to high school teaching. I clearly needed that terminal degree.

Part of me wanted to pursue the Ph.D. I had abandoned in 1973, to revisit the research and the deep explorations into Croatian literature. But I was 68 by then. How much time could I expect to have? And how much longer did I wish to forestall my writing? I was sure I wanted that Columbia MFA. If I didn't get into the program, I'd seek another way to re-route myself, but for the moment, Columbia seemed like my ticket to the world.

After that, the waiting for my fate to reconfigure would have been excruciating except for a superb opportunity that fell into my lap.

For a short time, I dated a fascinating, globe-trotting narcissist from Switzerland, who was staying in a sublet in New York but owned a loft condo in London, a cottage in Tuscany, and a farm in his native land. I asked him to read my Columbia materials, and he gave me expert advice on ways to fine-tune the writing. He liked my work, and he introduced me to a client of his, a man named Vincent Cobb, who was just finishing a book for which he was seeking professional advice.

Vincent's book was about a Londoner, who, after miraculously surviving a plane crash, finds himself reincarnated as a New Yorker. I read it, and after I did, I suggested he hire me to edit it.

"This is not believable, Vincent," I said matter-of-factly. "Your New York settings are inauthentic, and no one in your version of my city speaks American English."

Vincent was delighted. He asked me if I would edit the book to sound American and write a screenplay version as well. We agreed that I would swap apartments with my Swiss boyfriend and settle in London at the end of the year, to meet with Vincent each week and to produce the screenplay.

I flew over on the 16th of December, in the middle of what is now called the London Big Freeze. It was a cold, dreary winter,

and I loved it, especially the way the nights suspended time and led to days of new discoveries.

Each evening, I would sit by the woodstove and read or just stare at the warmth or watch videos while the fire blazed. Then, I'd sleep in total silence under the huge skylight that let starshine twinkle over my head with deliciously gentle, reassuring light. Each morning, I would wake long before sunrise and work on the bed while the city around me continued to sleep, only reanimating when the sun was up after 9 a.m., by which time I had put in a five-hour writing day. I'd walk on the canal or go sightseeing or wander over to the West End or Sadler's Wells and get tickets for something wonderful; once a week I had lunch with Vincent. My best friend joined me for Christmas, and we had a delightful British yuletide. The best part of all was that I was paid for doing what I truly loved doing. I was writing and editing with the freedom to indulge my reclusiveness or not. I had the affordable theater scene and the breadth of London to entertain me.

I returned to New York in March, just in time to fulfill my jury duty obligation.

I was in the Federal Courthouse when I got a call on my cell from a number I did not recognize. As I listened to the message, I could not keep myself from shrieking and dancing. People stared. The security guard walked cautiously toward me. I did not care.

"Hello, Carla," said a soft female voice. "This is Lis Harris at the School of the Arts here at Columbia. Please call me back to talk about your admittance to our program."

Anne Marie: *What'd you write?*

Nora: *Books about women*

Anne Marie: *Okay -- ?*

Nora: *And the things women do and want and don't want and don't do. And the way the world is toward women and the ways in which the world is wrong. . . .*

At first I wasn't sure what to write
So I wrote the first thing that came to mind
Which was a story about a woman, who lived in a house like this house
And had a husband like Torvald
And lived in a marriage which – by all appearances was a good one
But for the women, for my heroine,
She felt suffocated, she felt like she had no options,
That her life was his little wife and – that this was set in stone and there'd never be
The possibility of anything else ever.
And so she left her husband
And she started a life of her –

Anne Marie: *so you basically wrote your own story*

Doll's House Part II by Lucas Hnath

HAPPY EVER AFTER, A.K.A. RESOLUTION

I've lived in New York City for more years than I was stranded on the desert or languishing in Connecticut. I've lived in the city even longer than I lived in any home as a child. My granddaughters are teenagers, and the grandson who was born the year I earned my MFA from Columbia has completed first grade. I have friends who think that my being single is a sad thing, that I must be lonely. They encourage me to seek male companionship, to subscribe to the new and improved dating sites.

In weaker moments, I have taken their advice to heart. After grad school, I did make a few more attempts, much to my ego's chagrin.

I'd write about the experiences, but they were inconsequential. I have always been attracted to men who were smart enough to know where my triggers were, and when I realized I would never break that pattern, I had to stop.

In all cases, the men started out insisting on moving forward, vowing constancy far too soon, and then, when it was clear that I was 1) not receptive to condescending explanations and 2) not willing to change my mind just because they told me what was what, they decided that they could dismiss me by calling me

physically repugnant. As though any of them – septuagenarians all – was Adonis reincarnate.

Now, every time I get a note from a prospective admirer, even someone who proposes to be a new male friend, I am pulled in their direction until I think what incredibly difficult work it is to keep a man happy, to maintain his interest. I don't have it in me anymore, and I don't need it.

I am grateful to all the men who have entered and exited my life. Every encounter provided me one more opportunity for closer introspection. Each has validated my unfailing faith in the absolute primacy of the Absurd.

A portrait of Samuel Beckett watches over me from the wall facing my bed. I greet him every morning and wish him good rest every evening. While I am a fan of Beckett's writing, he is not there because he is my favorite author. He is not. He is there to remind me not to take life too seriously, to laugh often and laugh well, even when life is kicking dirt in my face. He is my constant companion, my bulwark, my inspiration. The only man I shall ever need.

I look back at the characters who have lived in me. None of them were Beckett's. And all of them dissolved into what I have become. Mercutio showed me the promise of the perfect man ends tragically, and Nora taught me there are no miracles. Molly Bloom shared with me her delightful libido, and Isadora showed me that finding the zipless fuck does not ensure happiness. I never warmed to Virginia Woolf, but I do thank her for pointing me to a room of my own.

My final curtain will soon fall. Dramatic, yes. But apt. In the end, I have not written as much as I would have liked to. Teaching requires time and creative input, which saps the writing resources. So does parenting, even parenting of grown children. And the time I have given to my grandchildren has enriched me more than any book I might have written could have benefitted the world. I am grateful. For all the moments I

have shared, for all the love I have received, for all the opportunities I have had to make amends.

I owe my resilience, my strength to my mother. She made me capable of finding my voice, standing on my own.

And I owe my children to Richard. Though I may never write the *magnus opus* or the plays I might have written if Richard had made good his promise to support me while I wrote, without him I might not have had the life I've had.

And I wouldn't have it any other way.

ACKNOWLEDGMENTS

Without Caroline Topperman, this edition of *Too Much of Nothing* would never have happened. Caroline was already my friend and decisive editor when she brought me to Mountain Ash Press and her business partner Andi Cumbo. It could have taken more years than I have left to get this book done had it not been for them.

Before Mountain Ash, I had the benefit of E.B. Bartles' editing wisdom, and I had encouragement from dear friends and loyal readers, who convinced me that I had something to say and a modicum of talent. My gratitude is boundless, but there is a special pocket of thanks to my sisters Thelma Adams, MaryAnne Aubin, Sashy Bogdanovich, Mari Alkus Bonomi, Meghan Maguire Dahn, Gail Gallagher, Sheri Nemerofsky, Lisa Swett.

Special gratitude as well to Daniel Fine, Dana Keeton, Peter MacIntyre, Alana Newhouse, Beatrice Schwarz; also to Livia Lakomy, Andrew Lewis, Elizabeth Walters, Lacy Warner, and Mahad Zara.

Finally, but most importantly, to Abigail, Elonne, Hannah, Isaac, Kevin, and Rachel, whose presence on this earth is the impetus for everything.

www.ingramcontent.com/pod-product-compliance
Lightning Source LLC
La Vergne TN
LVHW052015080426
835513LV00018B/2037